Cecil Beaton

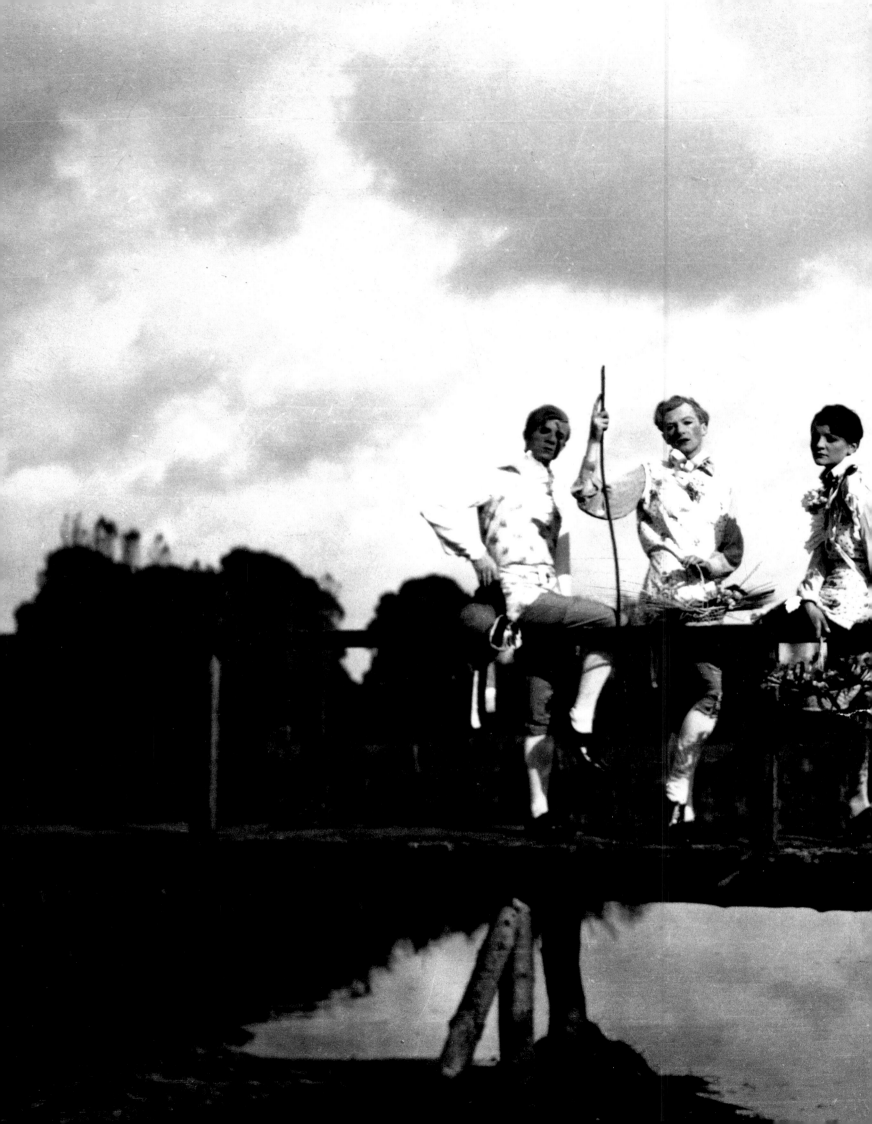

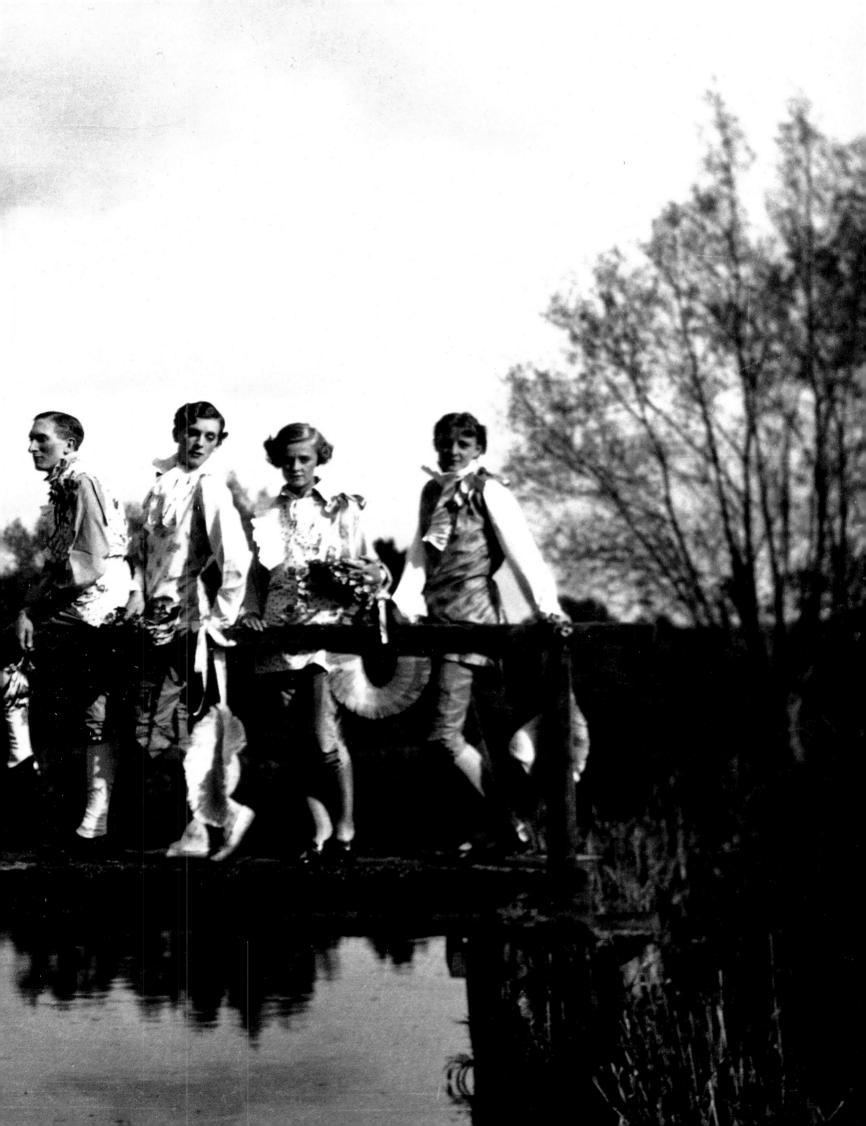

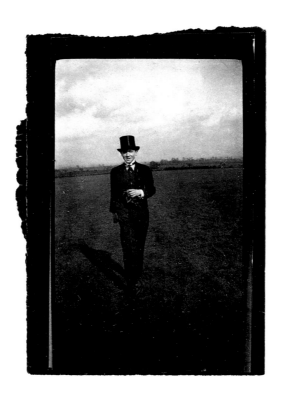

**Cecil Beaton in his school
uniform,** c. 1918

Previous pages: **Cecil Beaton
and friends,** Wilsford.
Left to right: Rex Whistler.
Cecil Beaton, Georgia Sitwell.
William Walton, Stephen
Tennant, Zita Jungman.
Theresa Jungman, c.1928

The Essential

Cecil Beaton

Photographs 1920–1970

Philippe Garner
&
David Alan Mellor

Schirmer/Mosel

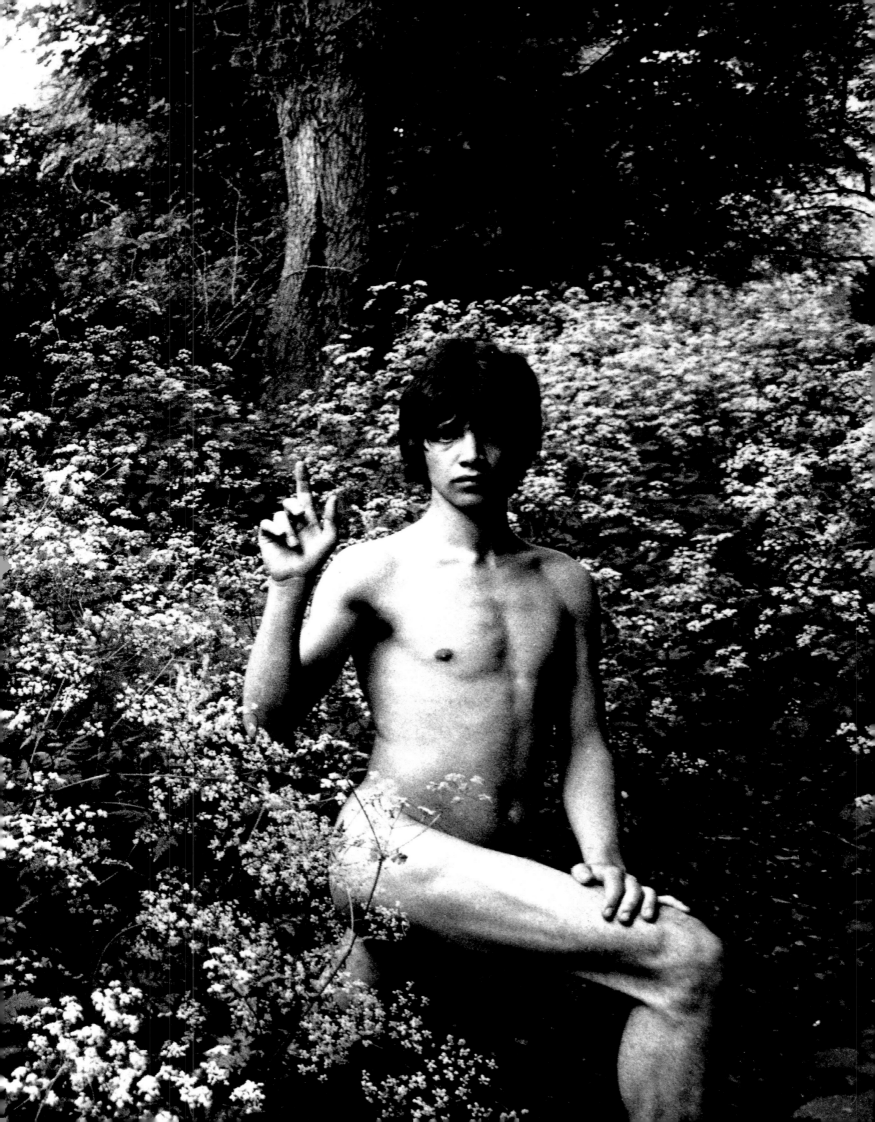

'Though I saw few
"actresses" ... in the flesh, their
photographs were for
me an absorbing interest and an
almost entirely satisfactory
substitute ...'

'The Story of an Exception', *Photography as a Career*, pp.28-32

Beaton's Beauties

David Alan Mellor

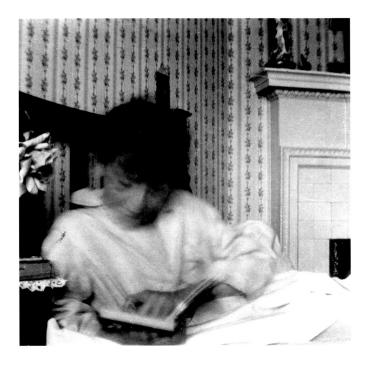

Cecil Beaton in
bed reading,
c.1910

Cecil Beaton in
bed reading,
c.1910

1. Cecil Beaton,
Photobiography,
1951, p.13.
2. *Ibid.*, p.14.
3. Salvador Dali,
*The Secret Life
of Salvador Dali*,
New York, 1943.
4. Max Ernst,
*Beyond Paint-
ing*, New York,
1948.

I / A Precious Object

Cecil Beaton's beginnings, as he narrated and
published them, start with the founding act
of his formation as a photographer – and
there stands a story which inaugurates all
Beaton's histories. This is the memory of the
first fixating moment when his childhood
desire and an object – a photograph – came
together. For Beaton's personal history, to
use the title of his first 1951 autobiography,
is a photobiography: a life pre-fixed upon
the photograph.

'When I was three years old I used to
be allowed to scramble in my mother's large
bed and nestle close to her while she sipped
an early morning tea and opened her letters.
One morning during this customary treat, my
eyes fell on a postcard lying in front of me on
the pink silk eiderdown and the beauty of it
caused my heart to leap. The photograph
was of Miss Lily Elsie... I started to make a
collection of picture postcards of my

heroine.'[1] The discovery of this photograph
of a musical comedy actress initiates Beaton's
history of himself dedicated to a precious
object of desire which must be glorified, pro-
tected and collected. The photograph (and
photography itself) becomes a point of ori-
gin, a transcendental signifier for Beaton.
But the first chapter of *Photobiography* is
also a record of idyllic pleasure in the shared
maternal bed, looking at the precious photo-
graph, the effect of which was 'unbearably
beautiful',[2] and acted as a supplement to
his mother.

Beaton's account of this experience
bears a profound similarity to those biogra-
phies narrated in the form of pastiche psy-
choanalytic case studies of childhood by the
Surrealists Salvador Dali[3] and Max Ernst[4].
In another autobiographic fragment, this
time from 1944, Beaton dwelt upon the
theme of the photograph as a double and as
a compensation for a woman's body:
'Though I saw few "actresses"... in the flesh,

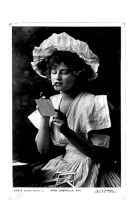

**Gabrielle Ray
posing as if
signing postcard
portraits of
herself,** photo-
graphed by
W. & D. Downey,
a postcard
published by
the Rotary
Photographic
Co., 1905

Cecil Beaton,
early 1920s

Cecil Beaton,
photographed by
Paul Tanqueray,
1937

5. Cecil Beaton,
'The Story of an
Exception', *Pho-
tography as a
Career*, ed. A.
Kraszna-Krausz,
London 1944,
pp.28-32.
6. 'If Fetishism
exists it is not a
fetishism of the
signified, a
fetishism of sub-
stances and
value...it is a
fetishism of the
signifier. That is
to say that the
subject is
trapped in the
factitious, differ-
ential, encoded,
systematized
aspect of the
object. It is not

their photographs were for me an absorbing interest and an almost entirely satisfactory substitute.'[5] This initial displacement from the woman's body to the fascinating photograph, a displacement which began close to mother, was channelled into a 'passion' for theatre and musical comedy. And so a phantasy is installed which links Beaton to a pleasurable and scenic universe of 'Beauties' from theatre and society, and later, film and royalty. And this, arguably, defined Beaton's photographic project until the close of this life.

As Beaton narrates his story, the history of photography is rescued from relative decadence by an encounter between himself and the lowly genre of the theatre publicity postcard. Fixated by it from infancy, Beaton was imprinted with the institution of the publicity photograph from theatrical and society magazines. He had a 'passion for the code',[6] that is the British cultural codes of female dress, the stage and Empire – the codes of his Edwardian childhood – but a passion for them

under their guise as photographic representations, a passion for an entire world made up of photographs. His jubilation was understandable, therefore, when at Harrow School he received from his parents the present of a folding Kodak 3A camera, which produced postcard-sized negatives. Now he could produce his own postcards of desire: 'It was a great moment.'[7] In Beaton's written beginnings we may picture him as a lover of photographs to the point of being a photophiliac, that is to say, one who is utterly fascinated by the image of the photograph itself and continually seeks his phantasies from within that artefact. Once more in bed, this time in his New York hotel bedroom in the thirties, Beaton photographed himself smothered in newspapers and news photography – a veritable filmy bath of the media. On another occasion, also in the thirties, this time portrayed by Paul Tanqueray, he was represented with 10 x 8 inch photographic prints adhering to his suit – a photophiliac's body; a site

the passion for
substances which
speak in
fetishisms, it is
the passion for
the code.' J. Bau-
drillard,
'Fetishism and
Ideology: The
Semiological
Reduction', *For a
Critique of the
Political Economy
of the Sign*, St.
Louis, USA,
1981, p.92,
pp.108-10.
7. Ed. A Krasz-
na-Krausz, *op.
cit.*, pp.28-32.

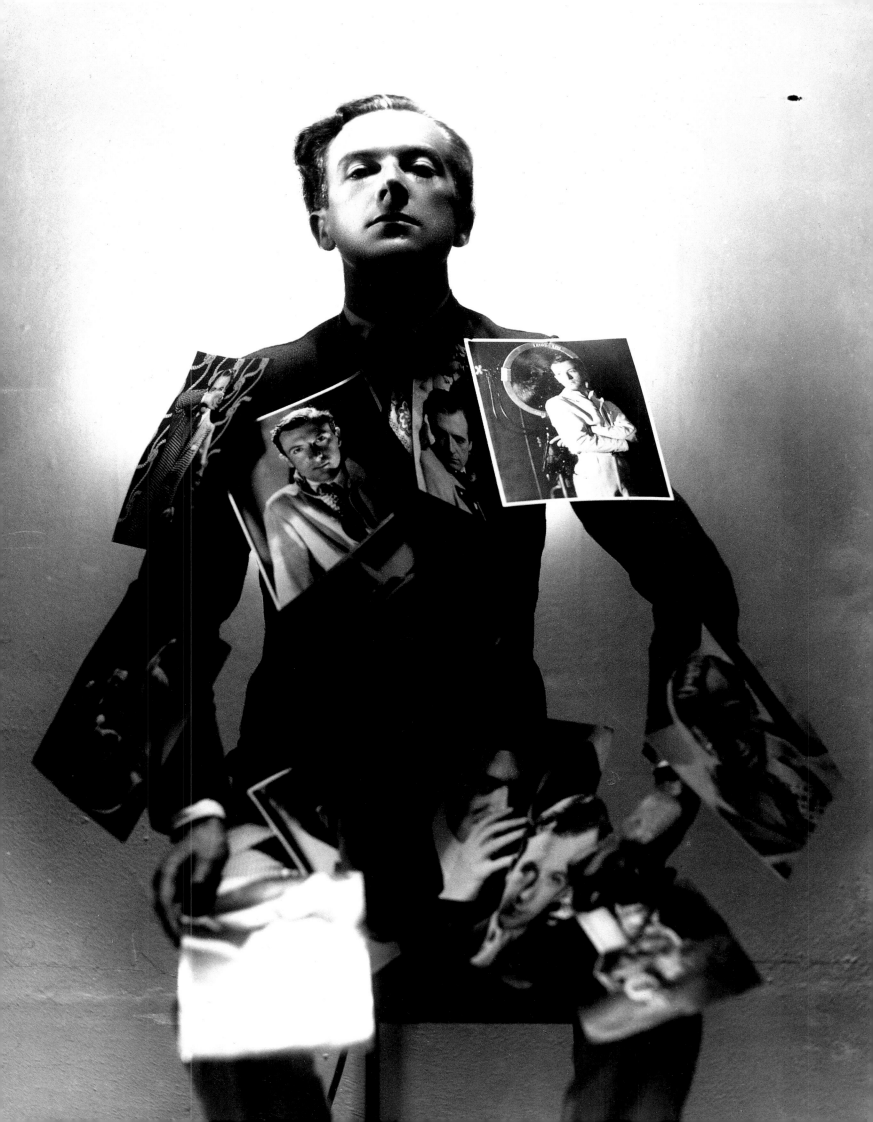

where photography writes itself across the body with self-reflexive portrayals.

Yet the argument should go beyond Beaton. We would entirely fail to grasp Beaton's context if we were to perceive him as being unique in this fascination for the photograph. This fascination was a cultural issue of the first magnitude, and one which was continually reflected upon at the time of Beaton's entrance into professional photography in the 1920s, from Noel Coward plays to Walter Sickert's paintings.[8] In 1930 the glossy society weekly, *The Sphere*, coined a term to designate those figures of High Bohemia and the *beau monde* who were Beaton's sitters – 'The Photocracy'.[9] They formed a complex social mixture of heiresses, lionized artists, leading theatrical figures and the residues of a patrician class – the leisured inhabitants of a new world created by the mechanisms of publicity. The photocracy were themselves translated into photographic fictions, and they, in their turn, were fascinated by the photogenic.[10] Among those who composed this photocracy, some were indeed the connoisseurs of the popular and mass-circulated photograph, such as Beaton's friend and companion, the Hon. Stephen Tennant. The latter possessed a revolving picture-postcard rack, which stood like a cult object or fetish on an ornate table amongst the mid-eighteenth-century furniture and statuary at his home, Wilsford Manor.

The chief focus of such connoisseurship was perhaps to be found in the use of the photo-album and scrap-album within the micro-culture of the photocracy. In this case Beaton was himself an exemplary figure, and absorption in photo-albums was a recurrent topic in both his writing and his portrait studies. At his country house, Ashcombe, Beaton represented his weekend guests sprawling with photo-albums both indoors and outdoors; albums and scrap-books were as indispensable for his construction of

thirties *fêtes champêtres* as the portable gramophone, and were always to hand. The introduction to *Photobiography*, entitled 'The Author, Self-Portrait', discloses Beaton as a nocturnal peruser of such albums: 'his hobby is poring over scrap-books',[11] the magazine *Illustrated* pointed out. In the rituals of country house culture, browsing through albums was continually reported by Beaton, especially in his published diaries for the twenties and thirties. Here he describes scenes where figures are enraptured by the power of the photograph,[12] scenes which call for a narrative, which in turn calls for a text. In *The Wandering Years*, Beaton describes a visit to Stephen Tennant in the summer of 1937: 'We looked at scrap-books of old photographs and he rhapsodized suitable texts. Some very ordinary photographs of Garbo were brought to life by "rapt ecstasies"'.[13] Used like this, the album took on mnemonic form, and in the case of the Garbo pictures the reader of the diary is called upon to witness the witty appropriation of mute publicity stills from Hollywood's mass culture by the vivifying discourse of an ecstatic elite.

Beaton's scrap-books of the twenties show him extending his first project, begun at infancy, of collecting photographs of stage and film stars. This motif of collection, of the photophiliac's erotic desire for possession, was certainly present in press notices for his first exhibition at the Cooling Galleries in November 1927. As usual the society magazines listed celebrities present at the opening alongside those photographed and framed on the walls: 'He has collected most of our beauties,' the *Tatler* eulogized.[14] His albums grew to be more heterogeneous than his early clippings of celebrities taken from *Vogue's* 'Hall of Fame' series in the mid-twenties. By the thirties they had become running montages governed by comic rules of

8. The display of framed portraits in Coward's plays and stage discussions which originate with them, is very much a phenomenon of his dramas at this time. Walter Sickert's new identity as Richard Walter Sickert denotes his interest in photo-generated painting, which began in the latter half of the 1920s.
9. *The Sphere*, 6 December 1930, p.456.
10. Cf. Roland Barthes's gloss on Edgar Morin's *Le Cinéma ou L'homme imaginaire*, Paris, 1956, in his essay 'The Photographic Message', *Image/Music/Text*, ed. S. Heath, 1978, p.23.

11. *Illustrated*, 3 March 1951, p.18.
12. Cecil Beaton, *The Wandering Years*, pp.20, 227, 316.
13. *Ibid.*, p.316.
14. *Tatler*, 30 November 1927.

Mrs Harrison Williams, 1936

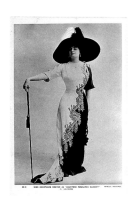

Constance Drever as Rosalinda in 'Nightbirds', photographed by Bassano Ltd, 22 December 1911, production opened 30 December 1911, published in *The Play Pictorial*, vol. XIX, no. 115

representation about history and fashion. Beaton took up photomontage as a means of ironizing those juxtaposed images which he culled from the photo media. He produced a dense intertextuality of reference, as on a 1940 album page where he joined photographs around the theme of *ancien régime* monarchy. He began this with a low-relief profile of Louis XIV, his face looking at a film re-creation of George III, while above, an image of *Life* magazine shows Marie Antoinette, impersonated by a film actress, who 'trips down the step of a moonlight Versailles-in-Hollywood'. These floating film simulations, souvenirs and impersonations, created a media-version of that *ancien régime*. The scrap-book form was operative in many of Beaton's publications, often through assemblages of re-made magazine articles. For example, *Cecil Beaton's Scrap-book* (1937) was launched in New York with an exhibition of his photographs which were not framed, but pinned instead to the gallery walls as a large environmental version of a scrap-album.

Beaton's scrap-books and albums carried connotations of leisured image-scavenging, which disavowed the status of the photograph as a commodity and an industrial fragment. The album became a customized, crafted and ornamental piece, resuscitated from an earlier, nineteenth-century culture of leisure. Beaton maintained, in an essay on scrap-albums written in the late thirties, that this was a product of the social elite of 'elusive' and 'exceptional' persons who were connoisseurs of scraps that 'they had thought fit to enshrine'.[15] Thus, in Beaton's imagination, the photograph returned to that especially adored and protected position as a precious object, where it was collected and revered almost as a Proustian keepsake, as a magical souvenir snatched from mass culture and transmuted by phantasies of origin, authority and love.

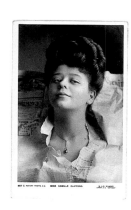

Camille Clifford, photographed by W. & D. Downey, a postcard published by the Rotary Photographic Co., c.1904

15. Cecil Beaton, 'Scrap Albums', *Vogue, n.d.; Cuttings Books*, vol. XIV.

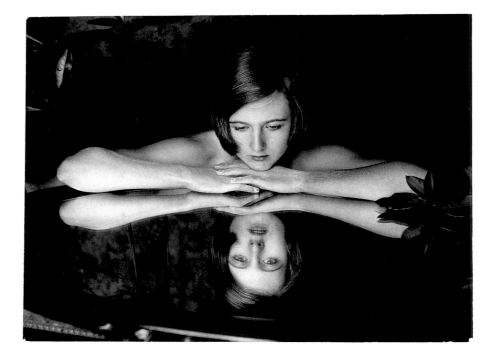

Previous pages:
**Cecil Beaton in
his lodgings at 47
Bridge Street,**
Cambridge. 1924

Right:
Baba Beaton,
1926

II / The Mirror Gazer

To find Beaton's context, we must return to his own account, his self-representation of his early years. In 1926 Beaton definitely stood outside of the circle of the privileged photocracy since he had been enrolled by his timber-merchant father into a City of London business life. But his diaries, constructed as a *Bildungsroman*, portray a youth's conflict with a bourgeois patriarch. They are built around a flight from the stigma of business, of 'trade', which had been imposed on him as a social identity. Beaton represents himself instead as struggling to adopt and be adopted by art, theatre, photography and design. This entailed entering the realm of High Bohemia, and his diaries and photographs embody this sole strategy. To quit middle-class patriarchy for that exotic, quasi-aristocratic and largely matriarchal milieu was his wish: to enter that ornamented scene of 'Beauty', a confined and much-photographed world like that glimpsed

in his mother's bed, a world of pictures into which he could be inserted and in which he could see himself. His diary entry for 24 April 1926 recounted his wish to dine at the Eiffel Tower restaurant in Soho: 'the people who go there are smart, arty and the set I must get in with.'[16] These, then, were Beaton's elected social group, and we might speak of his narcissistic group identification with them, since he rapidly took the interests, anxieties, wishes and values of High Bohemia to heart. And beyond them he glimpsed representations of another group, the British patrician class, who also were a 'set I must get in with'. Allegorically just so, for Beaton was not only to depict them, but was also to get into the picture with them, as the Narcissus of High Bohemia, transmitting and magnifying this narcissism until it became the dominant element in the pictures for his first exhibition in November 1927.

In the catalogue for that show Osbert Sitwell wrote of Beaton's sitters: 'Even though

16. Cecil Beaton,
*The Wandering
Years*, p.86.

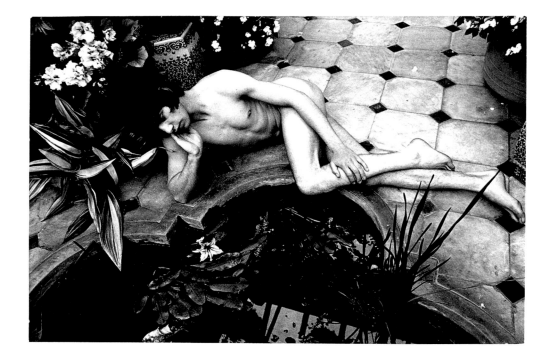

Gervase as Narcissus, the conservatory, Reddish House, 1968

17. Osbert Sitwell, 'Appreciation', Cooling Galleries exhibition catalogue, November 1927.
18. *The Sunday Herald*, 27 November 1927.
19. *Everybody's Weekly*, 14 January 1928.
20. *Ibid.*

they lack utterly what is known as the "narcissus complex", they can hardly help falling in love with their own reflection after the magic is complete.'[17] *The Sunday Herald* reported that at the opening, 'There was the enthralling spectacle of thrilling beauty trying to look exactly like its picture.'[18] And in his many press interviews around the time of the exhibition, Beaton undoubtedly replayed Osbert Sitwell's half-repressed invocation to Narcissus.[19] In his mother's drawing-room, he had found that the polished top of the grand piano 'makes a perfect reflection for a modern Narcissus',[20] a device used in his portrait of the Jungman twins (1927) and of Baba, Nancy and Mrs Beaton (1926), both of which appeared in the exhibition. To the mirroring lure and allure of the polished piano were added further reflections from tinsel, silver paper and oilcloth.

This system of portraiture, with the reflection of the face redoubled, opened up enigmas of representation. One example, a photograph of his sister Baba in 1926, arms akimbo and gazing at her reflection, pool-like, below her, was published with the caption 'The Secret of Beauty'.[21] This led Beaton directly to those specifically Surrealist images of Narcissus, as in his portrait of Dali's wife Gala, which adorned the front of Dali's catalogue for his 1937 exhibition at the Julian Levy Gallery in New York, entitled *The Metamorphosis of Narcissus*. Like those 'Beauties' of the photocracy who had been 'trying to look exactly like (their) picture' at his exhibition, Beaton himself had become fascinated by the theme of Narcissus. As Dali himself described the process with which Beaton had been concerned for ten years in his portraits, 'The body of Narcissus flows out and loses itself in the abyss of his reflection.'[22] Beaton obsessively drew sketches on the theme of mirror and double while working in the city office to which his father had farmed him out in 1926, making schemata for doubling his sisters in photographic compositions that

21. Unidentified press cuttings from Cecil Beaton, *Cuttings Books*, vol. I.
22. Text by Salvador Dali in *The Metamorphosis of Narcissus*, 1937, unpaginated.

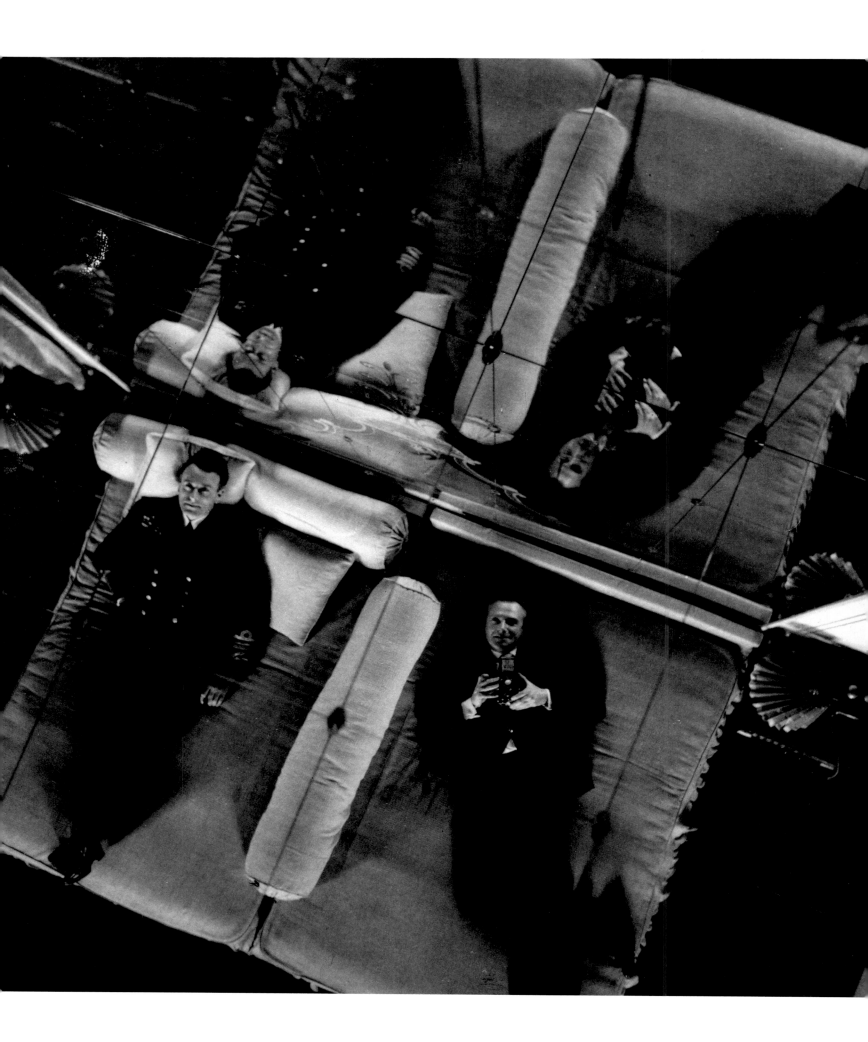

would be 'all very modern'.[23] He was to repeat and develop this theme well into the sixties and seventies, when he revised his double portraits of sisters and twins from the twenties (for example, that of Zita and Theresa Jungman[24] or Baba and Nancy Beaton). But it is significant that in the sixties he extended this device to male sitters, like the Myers twins. They appear in a pastoral location – arcadian even – under trees at Reddish, Beaton's country house from 1947, a propped-up mirror redoubling their duality as twins. At about the same time Beaton photographed a male nude model, Gervase, in the same landscape, but posed to parody the iconography of John the Baptist, with one finger pointing towards the sky. Beaton also posed him indoors in the conservatory, gazing at his own reflection in the fishpool, alluding once more – but forty years later – to Narcissus, to a text laid down at the centre of Beaton's imaginary universe.[25]

With the use of mirrors,[26] Beaton insinuated himself literally into the picture and the set, reflected alongside his ostensible sitter, whether this was Picasso in 1930 or Andy Warhol in the late sixties. Mirrors were symptomatically associated with him. Evelyn Waugh's fictional version of Beaton, David Lennox, in the novel *Decline and Fall* (1928), is represented as arriving at the house of the High Bohemian Lady Beste-Chetwynde, where he 'made straight for the nearest looking glass'.[27] According to the prevailing notions of 'conservative-modern' decoration, as theorized by his friend, the society hostess Elsie de Wolfe, mirrors were key elements which 'rejuvenated' house interiors.[28] In 1942 Beaton's mirror was set up like an altar on the table in his army tent, called 'The Ritz', in the Western Desert. He was the hero of his reflection pictures: for he found himself and seduced himself in every mirror and in every place – whether in

Emerald Cunard's apartment at the Dorchester, or at the Jain Temple at Jaipur, or in the plexiglass cockpit of an RAF bomber. He was, therefore, reflected in the scene as a willing victim and simultaneously as an omnipotent master of visual functions, everywhere drawn into an 'entrapment in...the (reflecting) surfaces of appearance'.[29]

In the summer of 1944 Beaton made just such a seductive self-portrait in a mirrored bedroom at an Indian palace in Delhi, Faridkot House. It is a double portrait which includes, reflected in the walls and mirrors of the bedroom, the Supreme Allied Commander for South-East Asia, the charismatic Lord Louis Mountbatten. Like Beaton, Mountbatten was a master of artifice, a dashing naval dandy impersonated by Noel Coward in the contemporary film, *In Which We Serve* (1942), for which Beaton had shot stills. In the photograph, Beaton and Lord Mountbatten lie on a bed in a bordello room – a room given over to visual phantasies (phantasies of auto-voyeurism) – from which vantage point Beaton takes the photograph, with his Rolleiflex reflected as a radiant point in the many mirrors. All this with Mountbatten's obvious connivance, like a late episode from the games and parties of the Bright Young People which Beaton had photographed in the 1920s. As Beaton recorded in his diary, Mountbatten 'was in a light mood and only wished to make jokes. No intention of listening to China's troubles which Mrs C(asey) had asked me to expound upon but thoroughly frivolous about our photographing in the glass bed at Faridkot House.'[30] In the photograph a bolster lies between them, a diagonal spar in the reflected geometries; bedded but without contact, paired but barred off from one another. The double portrait was a supreme joke narrative and, moreover, a specular allegory on Beaton's aspiration to be embedded in 'the set I must get in with'.

23. Cecil Beaton, *The Wandering Years*, p.81.
24. See *Tatler*, 19 January 1927, cover.
25. My argument here, as elsewhere, is greatly indebted to Jean Sagne's introduction to *Cecil Beaton*, Paris, 1984. For Sagne, Beaton's doubling is *'thème centrale de sa production'*.
26. For a discussion of the significance of mirror representation, adapted from the writings of Jacques Lacan, see Christian Metz, *The Imaginary Signifier*, 1982, p.82.
27. Evelyn Waugh, *Decline and Fall*, 1974 edition, p.128.
28. Elsie de Wolfe, *After All*, 1935, pp.84-5.
29. Louise Burchill, 'Either/or', *Seduced and Abandoned*, ed. A. Frankovitz, 1984, pp.28-44.
30. Hugo Vickers, *Cecil Beaton*, London, 1985, p.290. For an important examination of Mountbatten which raises the central issues of publicity, theatricality, Empire and representations of authority within British culture, see David Cannadine, 'Masterpiece Theatre', *New York Review of Books*, 9 May 1985, pp.6-9.

Cecil Beaton and Admiral Lord Louis Mountbatten, Delhi, 1944

Such a photograph photographs the photographer. It is an auto-representation, and Beaton's official war photographs contain many of these recurrent moments when, either through mirrors or delayed exposure, Beaton represents himself. There is in all of this an aspiration to masterful spectatorship, to a condition of becoming all-seeing within the picture itself through self-inclusion. In 1944 Beaton photographed himself before the mirrors at the Jain Temple in Jaipur, and the following year the picture was reproduced in the magazine *The Sketch*, with the punning caption 'Four Shows – Four Books'.[31] commenting on his perennial exhibitionism. Beaton is credited with exhibiting himself not only in four published books and four theatrical productions ('Four Shows') but also in the punning sense that the autoportrait is 'for shows', literally 'for show'. *The Sketch*, a society magazine which had published Beaton's work since the mid-twenties, used his exhibitionist, self-referential and self-reflexive portraits, ones that would have been read, presumably, as lapses by Beaton's superiors at the Ministry of Information. 'In some of these five pictures,' ran a wartime *Sketch* caption, 'he makes a game of his own game and of himself – quite a change from the splendid photographs of the three services which he has taken...under the aegis of MoI.'[32] *The Sketch* presented such self-portraits as if they had issued from some counter-world, like that inhabited by the momentary frivolity of Mountbatten, which subverted briefly the high seriousness of war, and the rectitudes of authority.

III / The Fictional Self

In the twenties Beaton was caught up in the development of new modes of biography, and the dramatization of public or fictive personalities. Just as Lytton Strachey's project at this time was to ironize traditional biography, so Beaton seems to have undertaken to revise portraiture into a kind of comedy of egoism, narcissism and shifting identity. The historian Miles F. Shore has traced this moment when nineteenth-century biographic forms began to fissure in Anglo-American culture: 'In its Victorian version the official tone of deadly propriety was replaced by the irreverent "new biography", which by the late 1920s and early 1930s made biography a major literary form at least in terms of sales.'[33]

No sooner had irony been freed and the notion of an authoritative biography 'debunked', than the genre parodied itself. One monument to this, and a probable major influence on Beaton himself, was Virginia Woolf's novel *Orlando* (1928). It is, as Professor Quentin Bell has reminded us, 'a parody of that then fashionable literary form, the fictionalized biography; it leaps away from fact tracing its hero's career from the late 16th century to the early 20th century.'[34] Although he was to write parodic historic biographies which celebrated an ironized aristocracy (such as *My Royal Past*, 1939, and *Quail in Aspic*, 1962), the significance of *Orlando* as a model for Beaton lay in other formal and thematic areas. Half-way through *Orlando* the hero becomes a woman: gender is displaced, like historical time in the novel. This theme of transvestism is well grounded in the culture of the twenties, and loss of fixed gender (another blow against the epoch of the Victorian patriarch),[35] as well as the figure of the androgyne, are distributed throughout Beaton's work with some regularity. At Cambridge he played several transvestite roles on stage, and again in 1934, in travesty, he photographed himself impersonating Elsie de Wolfe at Elsa Maxwell's ball in New York. In 1946 he portrayed Garbo as a

'Sunday Morning', self-portrait with the *New York Times*, 1937

31. *The Sketch*, 13 June 1945, p.329. The photograph is no. IB.2355 in the Imperial War Museum collection of photographs, London.
32. 'Beaton Plays with Effects', *The Sketch*, 22 February 1943.

33. Miles F. Shore, 'Biography in the Eighties: A Psychoanalytic Perspective', *The New History*, ed. T.K. Rabb and R.I. Rothberg, New Jersey, 1982, pp.89-113.
34. Quentin Bell, *Bloomsbury*, 1968, p.96.
35. See the arguments of Martin Green on generational revolt and conflict among the young dandies (including Beaton) of the 1920s in *Children of the Sun*, 1978.

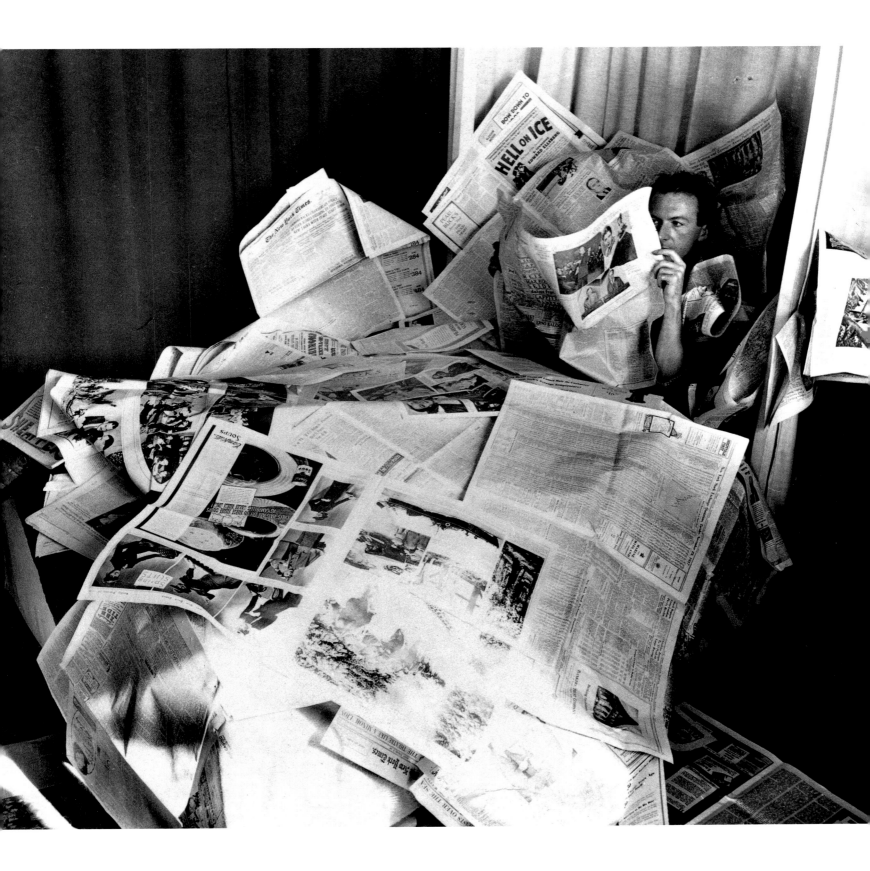

> 'If I'd known there were to be no
> photographs in the press I wouldn't have
> acted. It's all I care about – well no – but
> still it's one of the things I like best.
> Everyone sees them.'

Hugo Vickers, *Cecil Beaton*, p.45

36. Cecil Beaton, *The Parting Years*, p.45.
37. Virginia Woolf, *Orlando*, 1928, p.312.

sexless Pierrot, and even as late as 1968 rendered Mick Jagger as an androgyne[36] – another commonplace, but this time of late-sixties pop culture.

If gender is unstable in *Orlando* and in Beaton's productions, so too is identity: or rather identity is multiplied like Beaton's mirror reflections. *Orlando* has several historical identities, and in the twentieth century becomes the object of modern publicity and fame, a photocrat like a number of Beaton's debutante sitters from good patrician families of long lineage. 'I understand crops,' Orlando says. 'But (here another self came skipping over the top of her mind like a beam from a lighthouse) Fame! Seven Editions. A prize. Photographs in the evening papers.'[37] In his diaries of 1924, Beaton had anguished over his appearances in Luigi Pirandello's play, *Henry IV*, which was performed for the first time in Britain by the Cambridge Amateur Dramatic Company. What provoked his anxiety was not so much his stage appearance as

its lack of media coverage: he was in danger of losing his other, duplicated, fictional self as an image in the newspapers. 'If I'd known there were to be no photographs in the press I wouldn't have acted,' he wrote in his diary. 'It's all I care about – well no – but still it's one of the things I like best. Everyone sees them.'[38] But with his first debut in magazines and gossip columns in 1926 as one of his photocracy, 'Cecil Beaton' was born in the networks of publicity. Later, his absence from the newspapers was equally to become a cause for comment, as happened during the 1931 London society 'Season', when *The Bystander* noticed his non-appearance with astonishment: 'Cecil Beaton and his sister have done little or nothing to attract publicity.'[39]

At the centre of *Orlando*, and at the centre of a story which Beaton began to outline in the year of *Orlando*'s publication, 1928, was a 'fabulous woman', a representation framed and magnified like the actress Lily Elsie in that primal postcard, a fancy-

38. Hugo Vickers, *Cecil Beaton*, London, 1985, p.45.
39. *The Bystander*, 15 July 1931.

dress woman wearing alternating costumes in historical settings and scenery. In the forties, fifties and sixties, that same woman would be multiplied as Anna Karenina and Eliza Doolittle. Beaton wished to write 'a story with times and periods jumbled together so that some fabulous woman would be sitting to have her portrait painted by Greco and Gainsborough simultaneously – enter celebrities of every period.'[40] That same year saw the publication of another narrative of a time-travelling female, *The Harlequinade: An Excursion*, by Dion Clayton Calthorp and Granville Baker, about a figure who progresses through a sequence of historical tableaux to the present. Works like this and *Orlando* were strictly analogous to Beaton's strategy of historical costume revival in those comic, over-abundant tableaux vivants that sustained his framed women. The recurrence of similar, related motifs in Beaton's work is manifest as late as 1969, when he worked on Vincente Minnelli's film, *On a Clear Day You Can See Forever*, which starred Barbara Streisand as Daisy, a twentieth-century woman haunted by a centuries-old English lady, Melinda; haunted, that is by a set of picturesque and touristic historical environments and backdrops.

Narratives like this, and Beaton's revivalist costume photography, were mirrored in Virginia Woolf's *Orlando*, not only by the agency of the plot itself but by the novel's illustrations. These consisted of portrait paintings that were appropriated, photographed and re-captioned, together with a number of photographs of Vita Sackville-West posed in various portrait styles ranging from Italian Baroque,[41] to parodied versions of the portrait style of Julia Margaret Cameron, or Hill and Adamson.[42] Woolf's book had a final illustration, *Orlando at the Present Time*,[43] which had close similarities to some of Beaton's idyllic, mock-Gainsborough, conversation-piece-pastiche portrait photographs of

the late twenties and early thirties. Photography, under Woolf's and Beaton's authorship, appears to devolve into a game of allusion and citation of historical signs and styles, and also records private 'fancy dress' jokes. Signs of the past and present are collapsed into 'costume', and meta-fictions proliferate.

Beaton's earlier, overwhelming lesson in this kind of Modernist meta-fictionality was learned during his participation as designer and actor in Luigi Pirandello's *Henry IV*. In this work 'the time of the play is today',[44] yet the dress is medieval, since the actors are engaged in a therapeutic charade to cure a traumatized player. The play became a kind of touchstone for Beaton, signifying scrambled levels of reality, and in later life, in difficult social situations, he would refer to the anti-naturalistic drama of Pirandello as a paradigm for dislocation. *Henry IV* is a piece of theatre which plays with theatrical fictions. Its plot requires the impersonation of historical characters to be acted out, along with the mimicking of portrait paintings. To the contemporary twenties spectator, like Beaton for instance, it would have seemed most immediately comprehensible in terms of London's 'Society' pageants, tableaux and charades, which were held for charity and attracted considerable news coverage. During these charity tableaux, such as 'The Pageant of Great Lovers' in 1927, titled ladies masqueraded as living personifications of Reynolds or Gainsborough or Watteau paintings; and Beaton himself designed and acted in pageants such as these at the close of the twenties.

Pirandello's play, concerned with 'a life of fiction',[45] contains a number of Beatonesque themes. For example, Henry refers continually to his portrait mirroring himself on the wall, confirming his double status. And as the doctor says of Henry, 'In his own eyes he must inevitably be an Image...a

40. Hugo Vickers, *op. cit.*, p.350.
41. Virginia Woolf, *op. cit.*, 'Orlando on her return to England', facing p.158.
42. Virginia Woolf, *op. cit.*, 'Orlando about the year 1840', facing p.246.
43. Virginia Woolf, *op. cit.*, 'Orlando at the present time', facing p.318.

44. *The Graphic*, 14 June 1924, p.113.
45. Luigi Pirandello, *Henry IV*, ed. E. Martin Brown, 1962, p.246.

picture in his own imagination.'[46] Beaton acted the role of Donna Matilda, a matriarch impersonating a medieval aristocrat, and as Pirandello instructed, heavily made-up.[47] In this shifting meta-theatrical universe, Beaton's stage design for the drama added another important motif of authority, the iconography of the throne. In *Henry IV* it was an imperial seat with baldachin, based on the twelfth-century court of Goslar. This throne motif generated an iconography which he was to elaborate through his career, and it posed a crucial question in Beaton's system of substitutions and representations: what kind of authority can occupy the throne? The answer, boy kings, viceroys and sanctified queens, as in 1942 in Baghdad with the boy King Faisal, in 1944 in Bombay with the Governor-General, and in Westminster Abbey and Buckingham Palace with Her Majesty Queen Elizabeth II in 1953. These are depictions of power theatricalized as an image of himself. In Beaton's imagination, *Henry IV* was possibly the crucial point of departure which led him towards a distinctly Modernist reading of the pageant genre – Beaton's genre – of the costumed and staged self. By being the arbiter of those detached signs of story-book history used in this genre, Beaton acquired, in phantasy, an exalted position, a throne; an authority of a kind, perhaps.

A year after acting as one of the plural selves of *Henry IV*, Beaton impersonated another self to stand as signatory or author of his photographs. The name he took to sign his pictures was that of a Venetian Renaissance painter, Carlo Crivelli, a rarefied artist. For Beaton was undoubtedly anxious over his name and over his family's social status: it was his father's name which provoked his anxiety. Did he come from a 'good' family or, as it seemed, a family 'in trade'? To compensate for this, Beaton claimed that his sisters were descendants of Mary Beaton, Lady-in-Waiting to Mary, Queen of Scots, and went as far as costuming them in this part for a charity ball. But Beaton's anxiety over his genealogy and lineage played upon his name and was focused upon his signature, his trademark. For Beaton felt that he lacked authority, hence the persona of Carlo Crivelli and the phantasy of courtly ancestry. He was fascinated by those contemporary, ennobled senior photographers who possessed apparently honorific and well-established identities, particularly Baron de Meyer, who was ennobled by Edward VII, and Baron Hoyningen-Huene, together with Colonel Steichen, of military caste. Not until 1972, at the end of his life, would Beaton also be a titled photographer, when he was knighted as Sir Cecil Beaton. In the 1920s, his signature and his authorizing mark took on some significance. He copied the hieratic, quasi-oriental signature of de Meyer, associating himself with the latter's prestige. In the decayed universe of Pictorialist art photography in the twenties, autographs were still valued; but in the magazine world, in which Beaton was increasingly enmeshed at the end of the decade, the flourish of authorship was downgraded to a typeset name credit.

By 1926 he had dropped the fictive identity 'Carlo Crivelli', and in order to compensate, Beaton's signature swelled and enlarged. He contrived, as always, to place himself and his signature inside the frame. Thus Beaton acts as scriptor as well as pictor. There he embeds himself (as at Faridkot House), signified solely by his christian name, written large across the painted background and always adjacent to the portrait's sitter. On the other hand his father's name, florid and red, was written larger still, so inflated as if to disperse it, on the card frame of a portrait he entered for the London Salon of Photography in 1930. It was so large that the reviewer wrote that Beaton was 'thus reducing the

46. *Ibid.*, p.207.
47. *Ibid.*, p.176.

photograph to background'.[48] Precisely. For the exhibiting, multiple, self must always occupy the foreground.

IV / An Exception

Beaton fashioned himself as a prodigy, a figure who was seemingly untainted by the 'trade' connotations of the studio system, and he aspired to the status of the courtly artist. This epic self-construction commenced with the publicity surrounding his first exhibition at the Cooling Galleries, London, in November 1927. Fifteen years later he contributed a short biographical essay to a book entitled *Photography as a Career*, along with other essays by professionals, all of whom commended specialist training. But in this context, Beaton refused to recommend photography as a career, instead perceiving his experiences to be, in the words of the essay's title, 'The Story of an Exception'.[49] This phrase is symptomatic of that myth of Beaton's sheer exceptionality which was first written into the story by Osbert Sitwell, when he outlined Beaton's merit in his introduction to the Cooling Galleries exhibition catalogue. Sitwell's tactic was to list contemporary photographers, but with a grudging allowance: Maurice Beck, E.O. Hoppé and Curtis Moffat are admitted by Sitwell to be 'famous' and 'excellent photographers in their own way'.[50] But Beaton represented himself as wholly exceptional, a *Wunderkind*, and one who could not be judged alongside or be ranked with them, since he 'does not belong to any school, but is absolutely individual'.[51] The biographic tropes in which Sitwell set Beaton were those of the over-reaching and the epic.

During the twenties, the work of London studio photographers was slowly becoming known, if only marginally so, through those major West End galleries and institutions which went beyond the club-like circles of Pictorialism. Of Beaton's listed rivals, E. O. Hoppé had held a one-man show at the Goupil Gallery in January 1922, and Maurice Beck and his partner Helen McGregor (the latter a major influence on Beaton) had held a major exhibition at the Piccadilly Hotel in November 1923. These events formed a horizon of possibility for Beaton's West End display of photographs. Nevertheless, such shows were secondary to regular appearances of portrait work in the glossy society press, that is in *The Sphere*, *Tatler*, *The Sketch*, *The Bystander*, *The Graphic* and *Vogue*. 'Society' and theatrical portrait photography was consolidating its place in competitive journalism,[52] or so it seemed. For by the early thirties, with the onset of the Depression, the studio photographers entered a period of absolute economic decline, a decline from which Beaton was saved because of his idiosyncratic operating procedures: 'I have a studio of my own and send a great deal of my photographic work to a firm of excellent technicians. I have no qualms about studio staff languishing.'[53]

Like the dandy that he was, Beaton passed on the laborious portion of photography – developing and printing – to others, to 'trade' in fact. In addition, he avoided the necessity of having a studio for portrait sessions by initially using his mother's drawing room and later his own residences or the private houses or apartments of his sitters. And, of course, there was always the *Vogue* studio itself.

With this particular division of labour, he reasserted the aesthetic claim of the photographer-as-artist, and excluded routine commercial work. He wrote, 'All artists speak the same language, so photographers should be considered in terms of artists...no great technician can make a photographer.'[54] Beaton stood at the terminus of the old studio portrait system which, as an industrial and commercial form, had run from the 1850s to the 1930s.

48. *Truth*, 7 September, 1930.
49. Cecil Beaton, 'The Story of an Exception', *Photography as a Career*, ed. A. Kraszna-Krausz, London 1944, pp.28-32.
50. Osbert Sitwell, 'Appreciation', Cooling Galleries exhibition catalogue, November 1927.
51. *Ibid.*

52. Hugh Cecil, 'Society Portraiture New Style', *The Graphic*, 14 June 1922.
53. Ed. A. Kraszna-Krausz, *op. cit.*, p.30.
54. *Ibid.*, p.31.

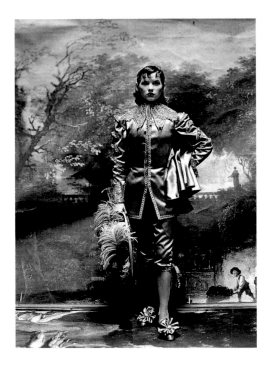

Boy in costume, 'The Gainsborough Girls', 1951

His ability to pass from the phantasy of the romantic photographer-as-artist, to being a corporate agent of *Vogue* and the Ministry of Information, without ever touching the uneasy base of the portrait studio at all, was perhaps one of his more important achievements; an eccentric case, certainly, within the economic and social history of British photography.

Yet Beaton stood in a nostalgic relationship to that very same studio system which he hoped to supersede and which, paradoxically, he celebrated in his own writing of the history of photography, *British Photographers* (1944). In his photographs he created comic and parodic homages to studio portrait practice, ironically incorporating it and affirming it as part of a wonderland of artifice in *My Royal Past* (1939), for which Beaton used actual props from the studio of Thomas Downey, the Edwardian portraitist. With immense reflexiveness he quoted and alluded to photographs by Hugh Cecil, Bertram Park and E.O. Hoppé, the kings of the big London portrait studios, while still remaining outside their pattern of organizing manufacture, and therefore outside 'trade'. The history of the form was conserved by Beaton even as he comically recounted it (and discounted it). He stood groomed as 'The Exception', and Beaton's career, in post-Second World War culture, was to act as a kind of conservator, a last custodian of the *rôle* of the artist-gentleman-photographer. This was a part that beckoned to him from the nineteenth century, and was exemplified by the Baron de Meyer, friend and courtier of Edward VII, and a figure who fascinated Beaton. It was in the guise of the *grand seigneur*-photographer that Beaton made a farewell gesture at the close of 1971, when he appeared dressed as Nadar, the French photographer of a whole century before, at the Proust Ball held by the Rothschilds. He was impersonating the lost functions of photography in a fancy-dress role of exceptionality,[55] that of the artist-photographer.

55. Cecil Beaton, 'A Remembrance of Things Proust', British *Vogue*, February 1972, pp.78-83.

Others, senior to Beaton, had aspired to this paradoxical role of artist-photographer in the market-place of society and theatrical portraiture in the twenties. Curtis Moffat and Helen McGregor, both American High Bohemians, were regarded by Beaton as possible models to emulate. When he re-wrote his diaries in the early sixties, Beaton recounted his leap, in the spring of 1926, into a new kind of photography of narcissistic reflected doubles and disembodied heads under glass domes. He presented this development as being preceded by a critical visit to Helen McGregor. As Beaton plots it in his diary, the meeting with her resembled an encounter with 'one's Fairy Godmother'.[56] Just as his mother had presided over his first discovery of the 'unbearably beautiful' photograph from her paradisiacal bed, so Helen McGregor introduced Beaton to another photographic universe – the shimmering, dazzling and reflecting world of Orientalism. Beaton describes the visit as an inspiring, influential point of departure within his own photography; Helen McGregor sanctioned his efforts. 'She favours Chinese things I suppose...I looked around the studio at a large screen, which was prepared with silver foil, the lacquer chest and other oriental props I'd seen photographed by her in *Vogue*.'[57] This Aladdin's Cave afforded a second glimpse of that world of glittering props, reinforcing what Osbert Sitwell described as his fixation with 'theatrical glamour'.[58] It was the self-same glamour that began, in phantasy, with his mother's postcard: everything shines and reflects, like the pages of glossy magazines, the surfaces of photographic prints, or the sheen of postcards themselves – a filmy mirrored world. But with McGregor there was a strong supplementary meaning which augmented the theatrical imagination, and that was the spectacle and mentality of Orientalism, which was to become Beaton's

paramount discourse when he pictured the British Empire at war in the Near and Far East in 1942, and again in 1944.[59]

The press reception for Beaton's November 1927 exhibition took up and further circulated Sitwell's characterization of Beaton's exceptionalism: 'Mr Cecil Beaton is uncommonly clever, so clever that he is afraid to let himself go'[60] commented the art critic of *The Morning Post*, who mistrusted the connotations of artifice and reflexiveness which multiplied themselves across Beaton's pictures. *The Sketch* carried four pages of reproductions at the end of the week in which the exhibition opened, while *Eve* and *Tatler* gave only one page each.

Often it was the many-sidedness and virtuosity of Beaton that provided the press with their headings: Beaton the draughtsman (he had included a room of drawings and paintings to enhance his credibility as an 'artist'): Beaton the stage-manager of tableaux vivants and impersonation. Like the media event it was, the exhibition was composed of sensational novelty items, 'Weird and Novel Photographs of Celebrities',[61] to quote *The Star's* headlines. There were items suited to all the diverse segments of the press. One of the surviving middle-class family journals of the late Victorian era, *Pearson's Magazine*, with its pre-existing categories of 'eccentric pictures' and trick photography (which had long been a component of the Edwardian period), chose to reproduce Beaton's *Miss Olga Lynn as Seen by the Angels*, a compressed and distorted high-angle view taken from a step-ladder. Also selected was a portrait from the opposite, low-angle, foot-of-the-stairs view, entitled *Miss Nelson as Seen by a Dog*. If Beaton revived this kind of late-nineteenth-century grotesque photography (albeit in the age of Renger-Patzsch and Rodchenko), he also made allusions to Victorian spirit photography in his multi-exposure

56. Cecil Beaton, *The Wandering Years*, p.81.
57. *Ibid.*
58. Osbert Sitwell, *op. cit.*

59. See the author's 'Picturing the End of Empire', *Creative Camera*, January 1982, pp.359-63.
60. *The Morning Post*, 23 November 1927.
61. *The Star*, 22 November 1927.

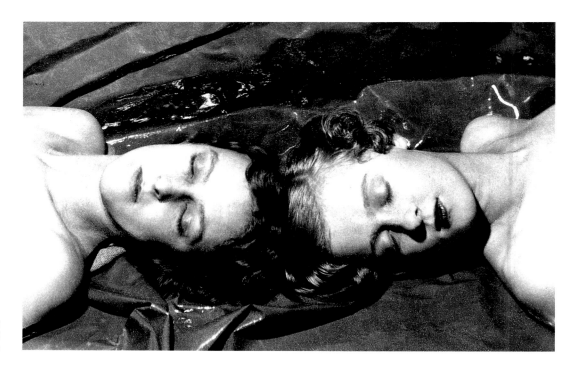

The Jungman sisters, Zita and Theresa, 1926

62 'Review', *The British Journal of Photography*, 21 November, 1927.
63. See 'Les Morts', *Photographies*, Avril 1984, no.4, pp.74-8. *The Portrait* by Valentine Hugo (1931) is reproduced on p.77.
64. *Tatler*, 14 December 1927, p.493.
65. *The Standard*, 22 November 1927.

portraits of 'heads floating about in a non-descript medium'.[62] He made a pastiche of the deathbed portrait, another Victorian genre, with his soon to become notorious photographs of Edith Sitwell and her brothers, looking dream-like and lying in state. These were Beatonesque citations of the visual fiction of spiritualism, and of the nineteenth-century cult of death, which bordered upon the concerns of Valentine Hugo's 1931 Surrealist photographs of the seemingly dead André Breton and Paul Eluard 'passing over to the other side'.[63]

However, the role in which Beaton was most often portrayed by the press, and in spectacular fashion, was as 'the latest addition to the ranks of Society Photographers'.[64] *The Standard* and *The Sunday Herald* presented the exhibition as simply one more mutation of codes in 'the latest phase of Society portraiture'.[65] Beaton's special commodity, his novelty product, was the doubling up of twins or sisters, or of debutantes reflected in

lacquered piano tops (a pictorial donation from his 'Fairy Godmother', Helen McGregor). *The Standard* headlined this as 'A Double Face Business \ Young Artist Supplies Society With New Fad'.[66] In that cross-over sector between publicity and art, the habitat of High Bohemia, which Beaton was at pains to join, portraiture was one of the key genres of the twenties. In sculpture, Frank Dobson was working on the heads of Osbert Sitwell, Tallulah Bankhead, Iris Tree and Sidney Bernstein, denizens of High Bohemian photocracy. Dobson's sculptures were invariably photographed during their production for the front covers of *The Graphic*, or for *The Standard*, alongside sitters and Dobson himself, for he was a master of publicity; ranged in echelon, heads and signs were tripled within the frame. In early November 1929, Beaton was pictured in the London newspapers together with his own sculptured head and with Dobson, all profiled in a line, with the caption 'The Cecil Beaton Effect'.[67]

66. *Ibid.*
67. Cecil Beaton, *Cuttings Books*, vol. I.

'All artists speak the same language,
so photographers should be considered
in terms of artists … no great technician
can make a photographer.'

'The Story of an Exception', *Photography as a Career*, pp.28-32

This caption knowingly acknowledged the currency of Beaton's profiled double portraits, and opened up an abyss of reflexive reference to media fame and the fictional self, as well as pointing back to that named exception, Beaton.

V / The Amateur as Photographer as Dandy

After the spectacular and newsworthy aspects of the first exhibition had been circulated in the London press – the society ladies who attended the opening; the presence of the Sitwells; the cocktails served – there was one single attempt to place Beaton within the context of current styles in photography. This was published in *Vogue* magazine, which headlined Beaton as a representative of the 'New Photography', in opposition to Pictorialism and soft-focus gentility. With Beaton's photographs, they announced, 'The

death knell of the foggy school of Impressionist photography is sounded.'[68] As a judgement, this followed in the steps of Osbert Sitwell's 'Appreciation', in which he polemically established Beaton's difference from all the other practitioners in the field – his exceptionality. Following a Modernist line of argument, Sitwell commended Beaton's formalism and his specificity: 'The peculiar excellence of Mr Beaton's photographs is that they are so photographic...and there is no haze, no scotch mist through which the familiar features can lose themselves.'[69] Yet there was a Pictorialist residue in Beaton. The 'haze', we might say, re-appeared, transferred to the interplay of translucencies in Beaton's props of tinsel and cellophane, and in the sitter's costumes: the shimmer and glitter which produced that dazzlement of illumination in his portraits of the late twenties. Paradoxically, Beaton entered photographs for the Pictorialist Salon exhibitions throughout this period. These were usually double-reflection portraits, and they

68. 'The New Photography', British *Vogue*, 14 December 1927.
69. Osbert Sitwell, 'Appreciation', Cooling Galleries exhibition catalogue, November 1927.

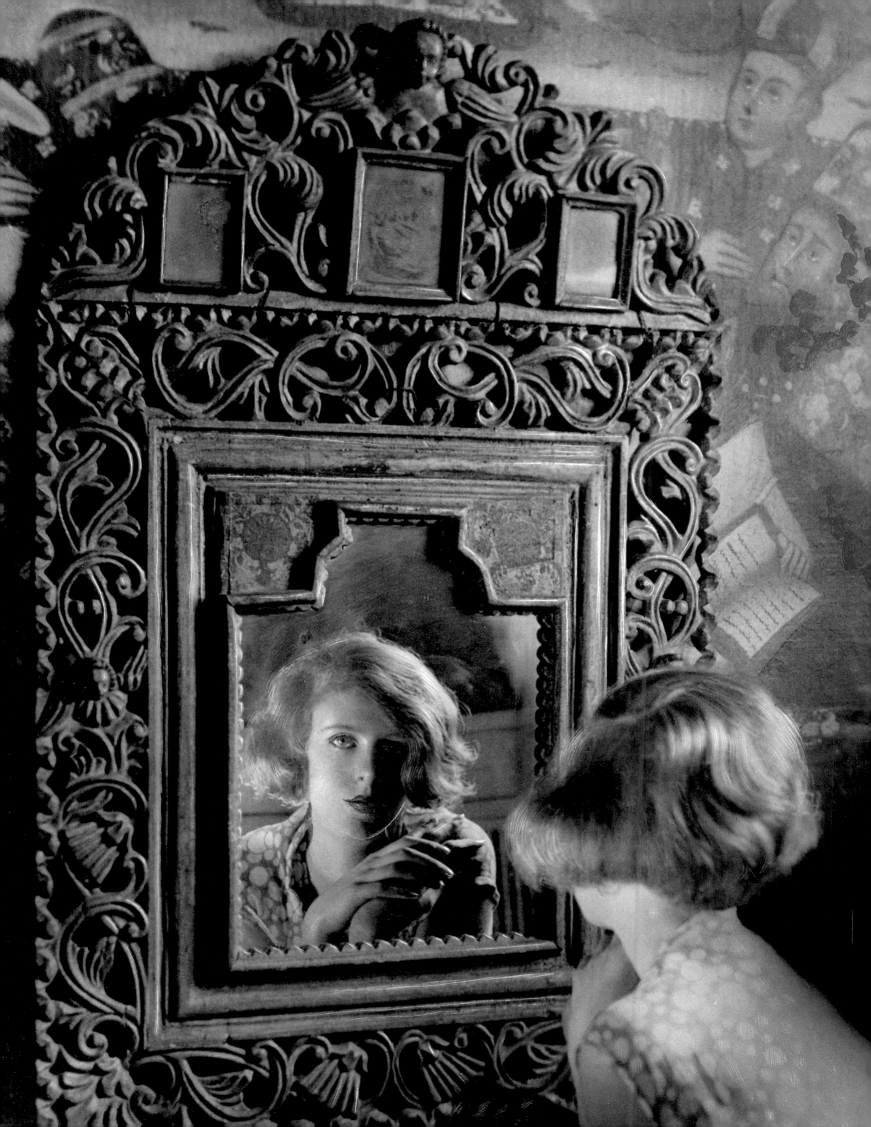

finally drew a moralizing rebuke from the Pictorialist critic, 'Mentor', who argued that 'in all artistic work...it is essential that the motive be sincere and truthfully expressed ...the aim of this print (a double portrait of Edith Sitwell) on the contrary seems to be the acquirement of notoriety'. There was 'nothing in the work except a manifestation of the author's willful eccentricity'.[70] 'Mentor' correctly suspected that Beaton's playing with signs, and his Modernist sensibility, were wholly at odds with such naturalistic, nineteenth-century criteria as 'sincerity' and 'truthfulness'.

Beaton's involvement with Modernist photography was contradictory. For example, probably taking his cue from Curtis Moffat, he made a series of photograms in 1926 which he called 'Dada-like designs by placing various objects on sensitized paper'.[71] Yet instead of the lexicon of objects which Man Ray and Moffat had used in their Parisian experiments in the early twenties – Bohemian signs like wine glasses, masks and musical instruments – Beaton, like Fox Talbot in the 1840s, had gathered far more domestic elements: net curtains, lace doileys, flowers, glass animals and vases, all from his mother's drawing room. Similarly, his use of multiple-exposure techniques, as in *Tallulah Bankhead as the Divine Sarah*, were not grounded in continental vanguardist experimentation, but were rather an appropriation of the style of multiple-exposure 'spirit' photography combined with memories of Edwardian theatrical illusions and comic impersonations.

This naturalized joke-domestication of Modernist elements (the fragmented identity found comically in the drawing-room, reflected decoratively in the piano lid) pointed to Beaton's distant and spasmodic contact with some of the issues concerning European photography. Modernity seemed a fashionable

style, and not only a figurative style but a social one too, as a correspondent from *The British Journal of Photography* reported when he recounted a remark overheard at the Cooling Galleries exhibition: 'Everyone is modern now.'[72] From Germany, the centre of 'New Photography' in Europe, Beaton had contact with a young journalist, Paul Cohen-Portheim, who managed to sell Beaton's pictures to the leading photo-magazines in Munich, Frankfurt and Berlin.[73] At the important *Film und Foto* exhibition in Stuttgart in 1929, which surveyed a panorama of Modernist photography, Beaton was the only British photographer whose work was included.[74] His exhibits were all portraits, and in one of them, of his sister Nancy, Beaton responded to his new German context. While resorting to his customary image of the mirror-gazing sitter, he also jammed as many stereotyped signifiers of 'Germanness' into the frame as possible. Nancy was modelled on German film actresses seen in pin-up postcards, with drooping cigarette and blonde bobbed hair. She was posed by Beaton looking at a heavily-carved, late-Gothic, wooden-framed mirror, with medieval murals in the background – a film-world-cum-Gothic version of Germany. In 1929 and 1930, Beaton's photographs were on the covers of several German magazines, such as the *Münchner Illustrierte Presse*, as 'Ein Neuer Weg der Porträt-Photographie'[75] – 'a new way for portrait photography'. Here, and in the *Frankfurter Zeitung's* supplement, *Für die Frau*,[76] Cohen-Portheim laboured to present Beaton as belonging to a mythical English aristocracy that was every bit as stereotyped as Beaton's view of Germany. According to Cohen-Portheim, Beaton was truly the fashionable gentleman-society-photographer that he phantasized himself to be, pictured in the German press attending a Royal Academy opening in top hat and tails, 'als Amateur' – 'as an amateur'.

Nancy Beaton, 1929

70. Cecil Beaton, *Cuttings Books*, vol. I.
71. Cf. Cecil Beaton, *The Wandering Years*, p.147.

72. 'Review', *The British Journal of Photography*, 21 November 1927.
73. Cf. Cecil Beaton, *The Wandering Years*, p.94, and also Cecil Beaton, *Cuttings Books*, vols. II and III.
74. See catalogue of the *Internationale Ausstellung des Deutschen Werkbunds 1929*, Stuttgart entries 104-11.
75. *Münchner Illustrierte Presse 1929*, no. 41.
76. See Cecil Beaton, *Cutting Books*, vols. II and III.

Beaton 'als Amateur' indeed. But perhaps there is greater relevance in the Latin derivation of amateur as *amator*, lover of that good object, photography, and its accoutrements – its postcards, props, paraphernalia, cameras and its past. He also posed as an amateur in another sense: 'I don't understand speeds or apertures...I take an assistant who looks after the details.'[77] And for the thirties circle of bohemian Mayfair photographers, which included Beaton, Peter Rose Pulham and Francis Goodman, it was 'considered *mauvais goût* to be professional', as Goodman recently recalled. But the issue of professionalism was not to do with any lack of technical competence, so much as a wish to restore an earlier golden age of photography, as was seen in the nineteenth century, before the arrival of rationalized industrial processes. In Beaton's remembrance and re-enactment of the supposed nineteenth-century 'amateurs' of photography, he hoped to bypass, or at least re-negotiate, the prevailing commercial structure. This anachronistic stance was noticed immediately, and the *British Journal of Photography* criticized his pictures for resembling closely the products of 'amateurs of two generations ago'.[78] Throughout his first crop of interviews in December 1927 and January 1928, Beaton recurrently stated an aversion towards the routinizing that had resulted from the development of professional commercial practices in the twentieth century, in contrast to 'the best Victorian photographer (who) has us hopelessly beaten'.[79] Writing again in 1927, and again in 1957, in his essay 'The Devil's Instrument',[80] Beaton represented modern photography as hopelessly rushed and without the redeeming factor of inspiration, having become merely 'a brutal and relentless medium'.[81] Throughout his career Beaton revealed a persistent horror of an imagined threat: the threat of de-personalized photography. His phobia was directed

towards 'zombie' sitters and models, and the practitioners themselves in their satanic studios where 'they have one sitter following another, with the result that they become so deadened with routine work that there is no energy left for inspiration'.[82] Beaton's horror was, in essence, a dread of industrial mass society, of a world simply made up of 'trade': a world contained in that paradigm of the twenties imagination, the film *Metropolis* (1927). Nevertheless, resistance was possible: 'The tendency to uniformity that is so marked a characteristic of these years', Osbert Sitwell had written in support of Beaton, 'has not been able to swamp individual loveliness'.[83] Thus Beaton romantically perceived 'inspiration', 'individuality' and amateur status as the keys to a beautified and leisured existence: 'I am an amateur in the sense that I work by inspiration.'[84]

When he wrote his first extended history of photography, *British Photographers* (1944), those he most approved of were presented as quasi-amateurs. In Beaton's history, de Meyer 'begins' as an amateur and is then recognized by royalty; Beck and McGregor 'set about their work with a deep and unspoilt relish more generally found in the amateur'; Curtis Moffat and Olivia Wyndham have 'only a half-hearted professionalism'.[85] For Beaton, the 'Professional' was a caricature creature who belonged to the standardized, routine, mechanized, diabolic world – the *Metropolis* world. 'Perhaps', he wrote in 'The Devil's Instrument', 'it is all part of modern life. The camera is after all only a machine; and with the machine efficiency is too often valued above performance.'[86] Beaton's wish was to cleave to a rudimentary innocence, propped up and aided by the devices of his Edwardian and Georgian childhood, primarily his beloved Kodak 3A camera, with which he continued to take professional photographs for *Vogue* and

77. Baron, *Baron by Baron*, London, 1957, p.204.
78. 'The Review', *The British Journal of Photography*, 21 November 1927.
79. 'Fantasy in Photography', *World's Press News*, 5 June 1930, p.18.
80. Cecil Beaton, *The Face of the World*, pp.114-16
81. *World's Press News*, op. cit.

Cecil Beaton,
photographed
by Bill Brandt,
c.1945

82. Cecil Beaton, *The Face of the World*, pp.114-16.
83. Osbert Sitwell, op. cit.
84. World's Press News, op. cit.
85. *Ibid.*, p.38.
86. Cecil Beaton, *The Face of the World*, pp.114-16.

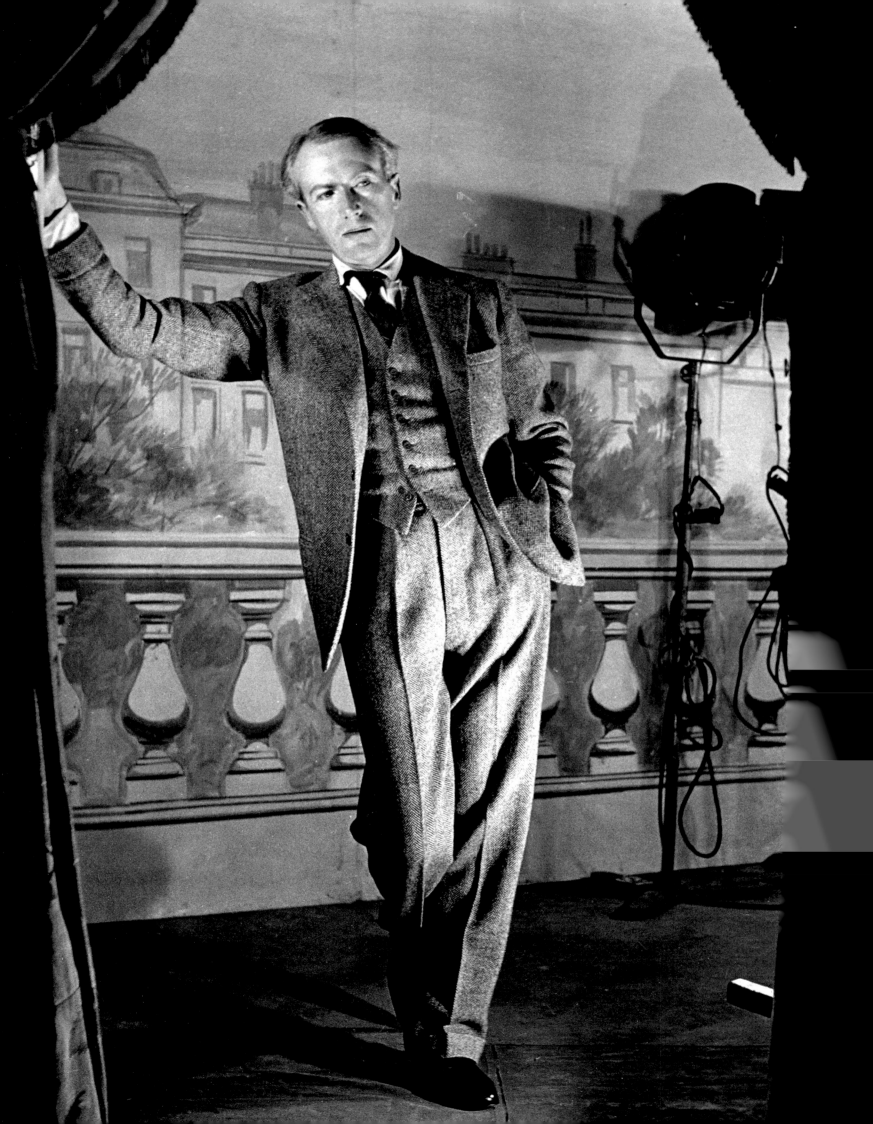

private sitters until 1929. We might see him as an *amator* of his Kodak, that beloved tool of his childhood before the Modern age. 'I love my Kodak; I've had it for years...I refuse to hamper myself with expensive and complicated cameras,'[87] he wrote. His 'toy camera', moreover, became a publicity gimmick which marked him as a newsworthy *faux-naïf* in the gossip columns of London and New York. Until, that is, Condé Nast, the patriarch of *Vogue*, decided to deprive him of his Kodak in December 1929, when he demanded a far higher level of technical proficiency from Beaton, and the adoption of a professional 10 x 8 inch plate camera, a change of equipment which Beaton registered as a personal loss, indeed, as a symbolic castration.[88]

The year before, during his .second visit to America, Beaton had made much in interviews of his disdain for routine portrait commissions, insisting that he was, in fact, a portrait painter and that he photographed for $500 a time only if 'I can think of something amusing with a client.'[89] Otherwise, he claimed, he refused the commission. This motif of detachment, and of apparent abstinence from business unless 'amused', is perhaps the key which might unlock Beaton's dandyism. An attendant at that first Cooling Galleries exhibition was reported as regularly warning visitors as they left the gallery that 'we must not regard it as a commercial enterprise (since) under no conditions whatsoever did Mr Beaton accept commissions to take portraits.'[90] Like a dandy attempting to ward off boredom, Beaton told an *Evening News* reporter in November 1927 that he photographed 'just to pass the time'.[91] Instead of the production of goods, Beaton, like Oscar Wilde and an earlier generation of dandies, put forward performance and the exhibition of the charismatic self. But this was judged by the journalistic criteria of 'personality profiles' and the new gossip columns that had

arisen in the early twenties. 'Gossip as we now have it', remarks a character in Wyndham Lewis's novel *The Apes of God* (1930) 'was invented about 1924',[92] and it was in the mental space of this new institution that Beaton emerged.

Luxury goods, and the mass circulation of images, were compressed and confounded in Beaton's *The Book of Beauty* (1930). Besides attempting to return systematically to Victorian formats with vignetted portraits, the preparation of the book's illustrations was made by the process of colotypy, which added the appearance of scarcity value and supplemented mass production processes. Dandyism in the production and consumption of luxury goods was always a part of Beaton's existence, and one salient aspect of this trait was the design of his own, his sisters' and his mother's clothing. Beaton's desired exclusion from mass society, demonstrated by posing as the dandified exception, was noticed as part of his construction as a celebrity by the press in the late twenties. The columnist William Gerhardie wrote in *The Graphic* in June 1928 that Beaton's shirt collars were a sign of his 'originality', 'a deliberate act of stamping one's personality on the herd mind, a conscious addition of inches...imaginatively and with grace'.[93] At this point, Proust, whose new volume in the series *A la recherche du temps perdu* had just been published, was cited by Gerhardie. Beaton's dandified collar, Gerhardie indicated, was exactly what Proust called a 'sentimental acquisition'.[94]

The association of nostalgic, aristocratic dandyism with a French subculture was significant. Once Beaton's friendship with Peter Watson was formed, he had a direct link to the great dandy taste-maker of Paris, Comte Etienne de Beaumont, one of Cocteau's great patrons, and in addition a role model for an élite of cultured cosmopolitan homosexuals.[95] De Beaumont was the leading

87. 'Portraiture With a Simple Kodak', *The Kodak Magazine*, 1 January 1928, p.39.
88. Hugo Vickers, *Cecil Beaton*, London, 1985, pp.126-7.
89. 'Far Above Beauty', *New York City Journal*, 18 November 1929.
90. *The British Journal of Photography*, 2 December 1927.
91. Cecil Beaton, *Cuttings Books*, vol. I.

92. P. Wyndham Lewis, *The Apes of God*, London, 1930, p.387.
93. *The Graphic*, 23 June 1928, p.466. The article also reproduces a photograph of the last pre-First World War Ascot, one of Beaton's favourite *topoi*.
94. *Ibid.*
95. Francis Steegmuller, *Cocteau*, London, 1970.

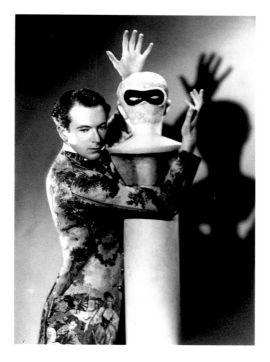

Cecil Beaton,
photographed by
Paul Tanqueray,
1936

96. David
Bailey in con-
versation with
David Mellor,
May 1982.

European organizer of tableaux and costume balls, which were reported in *Vogue* and which Beaton attended. His immersion in Swinging London in the mid and late sixties was certainly derived from his perceived role as a kind of senior custodian of dandyism, and as a seasoned media celebrity of self-exhibiting 'style'. 'We all owe a great debt to Cecil', said David Bailey, 'for keeping the idea of style alive'.[96] Beaton's self-incorporation as a dandy was taken a step further in America in 1946, when, as well as designing Wilde's comedy, *Lady Windermere's Fan*, Beaton also acted in the play, taking the part of Cecil Graham. In the stage version, as he appears in publicity photographs, Cecil's Cecil Graham became a vengeful dandy persecuting bulky patriarchs. In Hollywood Beaton was photographed opposite the stout and stalwart Rex Evans, who played the role of the noble buffoon. Beaton, thin, painted, immaculate and with an insinuating leer, faced Evans, who appeared to be stunned and shocked by the Wildean revenge of the dandy wit on the patriarch, amongst the matriarchal culture of Lady Windermere's milieu. At various moments in his career, Beaton represented himself as the dandy he was now impersonating. It was Beaton who had instructed Cyril Connolly in that prerequisite 'sensibility' while at school, and in 1937 Connolly devoted an entire chapter of his book, *Enemies of Promise*, to 'An Anatomy of Dandyism' in recent British culture. There he directed his reader to the critical edge of dandyism that was manifest in a novelist like Ronald Firbank (one of Beaton's chief influences, especially through his novel, *The Artificial Princess*). Connolly argued that Firbank, 'like most dandies disliked the bourgeoisie, idealized the aristocracy (and)...recognized frivolity as the most insolent refinement of satire'.[97] It is to that darker, satirical Beaton that we should now turn.

97. Cyril
Connolly,
*Enemies of
Promise*,
London, 1938,
p.45.

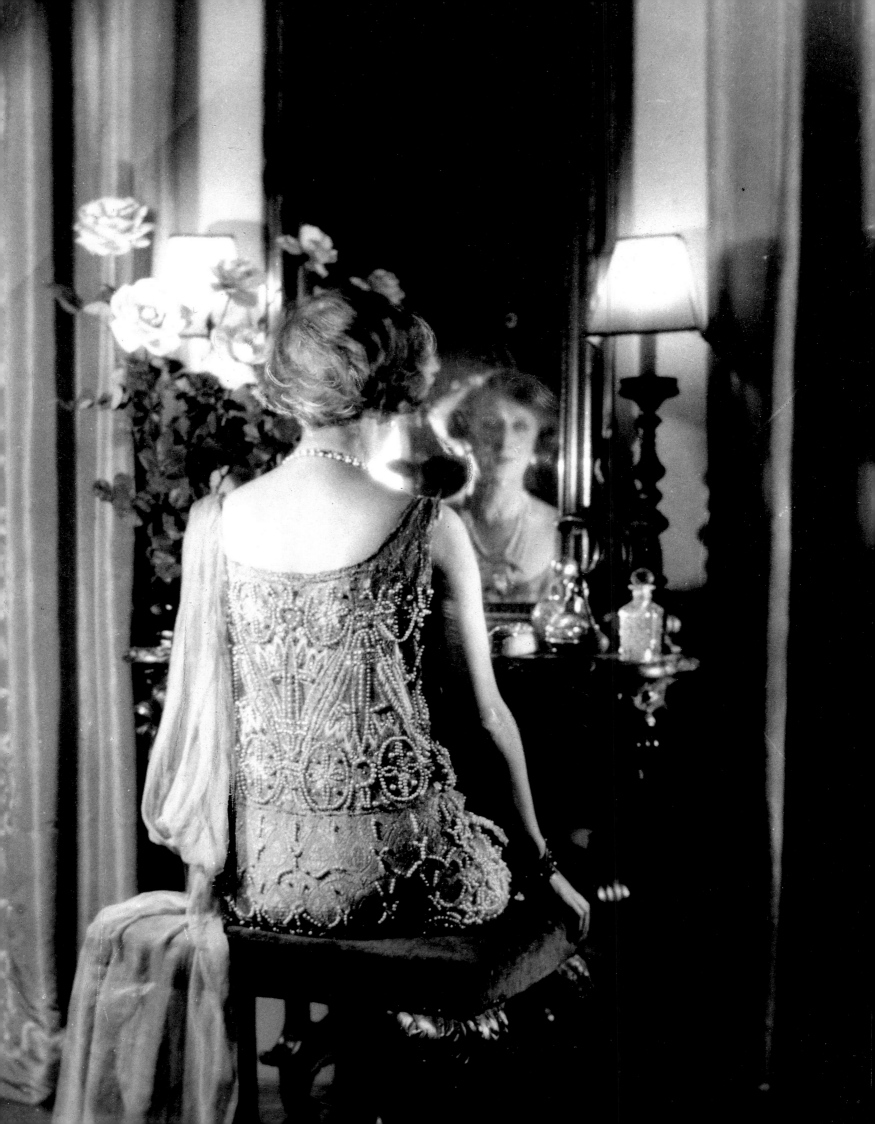

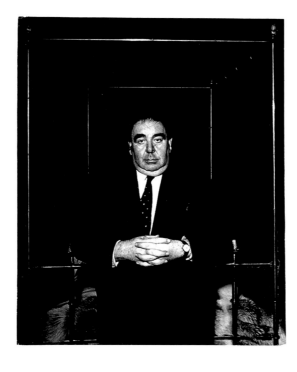

Mrs Beaton,
c.1925

Lord Goodman,
1968

VI / The Comedian

Very often – more often than we might wish
to believe – Beaton arranged his representa-
tions of the great, the good, the noble and the
beautiful as satirical grotesques, encased in a
fictional theatre of display. His line of carica-
tured celebrities perhaps ended with that of
Lord Goodman, 1968, in which the sitter is
seen head-on and boxed-in within the space
frame formed by the end of Beaton's bed at
his home in Pelham Place. The frame betrays
Beaton's fascination with Francis Bacon's
painting in the fifties, and his staging of
grotesques in well-furnished, luxuriously-
coloured surroundings. As a vengeful dandy
(and as a photographer), he schooled himself
in a kind of caricatural Modernism that had
become a major tendency in the last hundred
years of British art, from Max Beerbohm,
Aubrey Beardsley and Walter Sickert,
through to Francis Bacon. As a system of
representation in Beaton's work, this

grotesque mode was identified in his first
exhibition. There it perturbed critics who,
through Beaton's strategies, were offered
insecure positions from which to view (and
review) *Miss Nelson as Seen by a Dog* or *The
Madonna Enthroned*. The latter, reported in
the *Morning Post*, 'is on the comic side and so
is in questionable taste', while Mother and
Daughter was 'cruel'.[98] This last picture could
well have been linked to an interview with
Beaton the following month, when he set up
his usual pose of the wilful and fastidious
dandy who turned away commissions, saying,
'I refuse to "take" any dull fat mother with
her schoolgirl of sixteen.'[99]

This was the other, angrier, face to
Beaton's pursuit of fictions of the celebrated.
It was the side which was only acknowledged
occasionally or else was subsumed in the act
of consigning Beaton's productions to the
status of visual gossip. *Time*, in 1931, dis-
cussed the 'Beaton Method', which seemed
to amount to another set of two-faced

98. Cecil
Beaton, *Cuttings
Books*, vols. I
and II.
99. *The Evening
News*, 7 Decem-
ber 1927.

representations of adoration and loathing for the 'Beauties' that Beaton had to 'take'. '(He) make(s) a highly flattering photograph of a lovely lady in an exotic attitude...To this is added a not nearly so flattering drawing and a slightly malicious essay,'[100] commented *Time*. Beverley Nichols, the author, was one of Beaton's cult heroes of youthful success in that celebrity universe of journalism which Beaton had set out to conquer, and which Nichols had charted in his early autobiography, *25* (1925), a handbook to the possibilities of fame which Beaton read avidly. Later, in the fifties, Nichols was to analyse Beaton as a satirist, describing his 'curious spidery sketches of Society beauties glimpsed through razor-sharp eyes',[101] a picture which confirmed *Time*'s earlier account of Beaton's masked aggression, and his misogynism.

On the other hand, Beaton was part of a larger graphic discourse which surrounded caricature. In late-twenties London there was a definite fashion in 'Society' for caricature as a 'fad', which was being reported as 'The Craze For Caricature'[102] in women's magazines intended for lower-middle-class readership, and was even suggested as a desirable social accomplishment. There was also a major Daumier exhibition in 1927, at which Beaton was interviewed with Osbert Sitwell for the evening papers.[103] But Beaton had been preparing a specifically satiric persona since leaving Cambridge University, where he had portrayed himself reading a highly visible copy of the tenth volume of Juvenal's *Satires*. He adopted comedy as a mode for his diaries and journalistic writing from his earliest years: irony, pastiche, satire and caricature became his great narrative devices.[104] Beaton's diaries move towards a comic resolution of reported setbacks, social embarrassments and family tensions, which are paraded with a ceaseless egoism. This egoism is their great theme: it is 'Beaton's Progress', an epic which

is constantly and comically traced over the terrain of Society and High Bohemia, which he pitted himself against in mock-heroic fashion. Hayden White has described this kind of narrative as a comic dream: 'the triumph of the protagonist over the society which blocks his progression to this goal... (this) kind of comic employment may be called the Comedy of Desire.'[105] In such a comedy narrative, 'my greatest triumph' is his successful courtship of Greta Garbo, the photocrat star, the enigma, and the beautiful woman in the picture.[106]

By the forties and fifties, Beaton's gestures of comic caricature were being made in an ageing universe of once Bright Young People – stars, photocrats and artists. Death is surely coming for Walter Sickert and for Augustus John in the pictures he took of them in the early 1940s: these are portraits of the final ruination of the lionized painter-photocrats. In his portrait of John in 1940, house curtains became baroque drapery, and with John's help, candelabrum in hand, a romantic bohemia in decline was staged, pre-figuring the mad, piratical portrait which Beaton was to make of John at the end of the fifties. Osbert Sitwell detected Beaton's adept use of the grotesque in 1930, when he wrote of Beaton's photograph of the ageing comedienne Nelly Wallace, shown at the second Cooling Galleries exhibition: 'The grotesque style which she affects is portrayed with such consummate mastery: each of these photographs is as beautiful and as strange as an etching by Callot of Della Bella.'[107] The citation of these seventeenth-century Baroque artists by Sitwell, acting as a connoisseur of the grotesque, is crucial in re-assembling two paradoxical structures of feeling in 'Beaton's Progress' – the 'beautiful' and the 'grotesque', or as Sitwell described it, the 'strange'. In his portraits of Nelly Wallace and Lady Alexander, there is one of Beaton's motifs, the figure of an elderly, tattered, painted and overstaged monster, read paradoxically

100. 'Too, Too, Vomitous', *Time*, 2 February 1931.
101. Beverly Nichols, *The Sweet and Twenties*, London, 1958, p.212.
102. *Woman's Life*, 31 March 1928, p.4.
103. Cecil Beaton, *Cuttings Books*, vol. I.
104. 'The Book of Beauty', *Library Review*, Summer, 1931.

105. Hayden White, *Metahistory*, London, 1973, p.90.
106. Hugo Vickers, *Cecil Beaton*, London, 1985, p.312.
107. Osbert Sitwell, 'Appreciation', Cooling Galleries exhibition catalogue, New York, 1931.

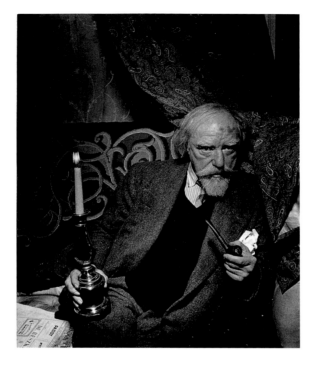

Augustus John,
c.1940

108. Ella
Hepworth Dixon.
*The Westminster
Gazette*, 30
November 1927.

as astonishing, or 'beautiful'. Another motif, less caricatural but still related to this satiric mode, is the sinister 'fatal' woman, like that found in his 1935 portrait series of Marlene Dietrich. Melodramatic, enigmatic, independent, dressed in the 1904 clothes of *The Merry Widow* musical comedy, Dietrich appears threatening, or rather mock-threatening, for Beaton is playing with the clothes and signs of the *femme fatale*. These signs are used ironically, scavenged from his childhood archives of musical comedy theatre productions, and then gathered together in his albums.

Dietrich in 1935 resembled Beaton's drawing eight years earlier of the 'sinister "Rose Queen"...a Victorian lady...with a menacing air'[108] based on Queen Alexandra. An immense phantasy of Beaton's revolved primarily around the figure of his beloved matriarchs of the Edwardian period. Yet, in his sarcastic portraits of Lady Oxford and Lady Lavery in the twenties and thirties, and in his later portraits of Mae Murray and Elsa

Maxwell in the fifties, this phantasy was visibly decomposing as Beaton's sadistic aggression caricatured his previous love objects.[109] Mae Murray was placed behind a lace barrier, resembling the apparition of Diane Arbus's *Woman with a Veil, Fifth Avenue, New York* (1968); other ageing stars of stage and screen were defaced, just as Robert Aldrich was to do in *Whatever Happened to Baby Jane?* (1962). Lady Oxford, as early as 1930, was described by Beaton as having 'powdered hair, brittle arrogance and witch-like delicacy' in his *Book of Beauty*. Ten years later, he photographed her like a Daumier caricature, *profil perdu*, but her head like a dead turkey's – literally an 'old-bird', in Beaton's conflicted misogyny.[110]

These women were portrayed by Beaton as spectacular and elderly female wrecks. Among his grotesques, he was most fascinated by the millionaire's widow, Mrs Mosscockle, whose appearance gave him the occasion to write extensive baroque passages

109. See J.
Lacan, 'Desire
and the
Interpretation of
Desire', *Psycho-
analysis and
Literature*, ed.
S. Felman,
Baltimore, USA,
1982, pp.11-52.
110. Cecil Beaton, *The Book of
Beauty*, p.8.

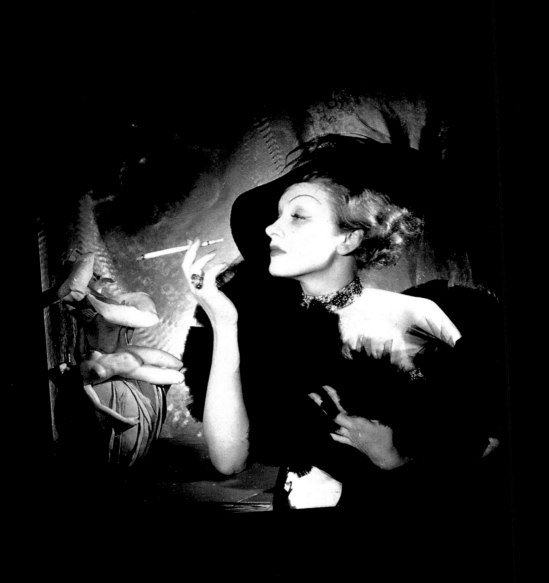

Marlene Dietrich, New York, 1935

Lady Oxford, 1937

111. Cecil Beaton, *The Wandering Years,* p.106.
112. *Ibid.*

about her that were published in his revised 1926 diary. She is presented by him as a failed copy of Queen Alexandra, a shambling version of the Edwardian hostess, but nevertheless, to the connoisseur of the grotesque, a collectable counterfeit to be pursued as a derelict, an abysmal sign of a sign. She was multiplied over and over again in his photographs and photomontages. 'A travesty to end all travesties,'[111] as Beaton wrote in his diary. Beaton narrated his visit to her as a dramatized comedy in a series of acts, complete with stage directions, a pastiche of Wildean comedy. At the outset, he confessed the wish which had led to his surveillance of this battered effigy of Edwardianism: 'it was my penchant for the grotesque that made Mrs Mosscockle fascinating to me.'[112] It was the inauthenticity of Mrs Mosscockle which fascinated him, since she passed as an ironic icon of 'nobility', compared to the authentic appearance of Queen Alexandra. Beaton's phantasies of vision, photography, and frame

were mapped onto the royal figure herself, but were qualified by the massive sentiment of romantic royalism. 'I even peered (at Sandringham) through one of the ground floor windows, and caught a glimpse of the Old Queen pottering about the sitting room. Stopping at a crowded table she picked up a silver framed photograph of the Duke and Duchess of York taken by Bertram Park, in soft focus.'[113] From his gaze upon her glance, the latter portrait became for him a Proustian 'sentimental acquisition', a beloved Royal object, collected in the allegorical act of collecting precious photographs.

The framing of the noble face in the frame of a mirror also reminded Beaton of those childhood memories of his mother at her toilette, seated in front of her dressing-table, her face (and perhaps his too) reflected in the mirror in which he photographed her in the mid-twenties. The play of mirrors, and the spectacle of the woman 'making-up', became for him a mightily invested and

113. *Ibid.,* p.48.

Self portrait with Peter Watson, the Circus Bedroom. Ashcombe. 1930s

114. *The Sketch*, 3 April 1946, p.185.

recurrent topic; as late as the sixties, Margot Fonteyn was shown reflected in large room-sized mirrors, and also in the mirror of her powder-compact. Using the same motif, Beaton photographed the actress Marita Hunt on the set of David Lean's *Great Expectations* (1946),[114] portraying her as the elderly, disintegrating, Miss Havisham, gazing at her cobwebbed dressing-table, and catching there a glimpse of her young ward, Estella. This *Grand Guignol* portrait brought together Beaton's powerful mythology of the superior matriarch, a sadistic voyeurism, and the theme of the mirrored subject's narcissistic gaze.

This motif of the mirrored matriarch had formed the extraordinary introduction to the novel by painter and writer Percy Wyndham Lewis, *The Apes of God* (1930), a long fictional critique of high bohemian mentality in the London of the twenties and the tastes and habits of the Sitwell family in particular. Lewis opened with a prologue which had the Beatonesque title, 'The Toilette of a Veteran

Gossip Star', and went on to anatomize the elderly Lady Fredigonde Follet (who was, like Lady Asquith, a 'Gossip Column Star'), as she was being made-up, 'her formidable image framed by a cheval glass'.[115] But more than this, Lewis used the notion of decay to allegorize a far larger topic – the British cultural climate, where the decadence of the high bohemian micro-culture indicated a wider, encroaching decadence for the nation, the state and the Empire. *The Apes of God* was set in 1926 against the background of the General Strike, a premonition of Britain's decline and fall; Beaton's first exhibition in 1927 was taken by some as a similar portent of political collapse. The reviewer in *Apollo* magazine, January 1928, re-told Osbert Sitwell's comic description of Beaton toppling onto the Sitwell's bodies from the top of a ladder from which he was taking high-angle pictures, seeing in it a political metaphor: 'there you have a description of a modern *Götterdämmerung* ...and as it not only

115. P. Wyndham Lewis, *The Apes of God*, London, 1930, p.11.

happened once, but perhaps is not unlikely to happen again on a far bigger stage. There was a kind of *après nous le déluge* about this innocent and pleasing show – a portent that the deluge is not far off, and that when it comes it will be a rather risible anti-climax.'[116] The Empire and Beaton would tumble – one day, but it would be of no consequence, for comedy was the master of Beatonesque history.

British culture was thus perceived as entering into a decline, a fallen, ironic 'iron age' where only caricature and satire could adequately signify. This was also to be the opinion of Peter Quennell, when he began his commentary to Beaton's scrap-album compendium of photographs, *Time Exposure* (1941). Set opposite the sentiment and trauma of Beaton's portrait of Eileen Dunne (a blitz victim, framed head-on in her hospital bed, just as Lord Goodman was to be thirty years later), Quennell's introduction makes an apocalyptic reading of Beaton's photographs as belonging to 'a period...as catastrophic as the epoch that preceded the fall of the Roman Empire'.[117] His mode of address resembled Lincoln Kirstein's ironic commentary to Walker Evans's *American Photographs* (1938), which he saw as being records of an age before 'imminent collapse'. Certainly, some consciousness of living in an iron age – living on after the high point of Western civilization, haunts and inflects Beaton's thoughts. For him, the high point was, of course, the Edwardian era before the Great War, which was followed by the great fall and an immeasurable alteration. To restore a plenitude to existence, Beaton could appeal only to some historically lost authority, one based in his mother's time and in the epoch of his own childhood: a matriarchal authority, perhaps, of the *ancien régime*. This was constructed for Beaton out of that group of society hostesses which he adored (and hated) – Sybil Colefax, Emerald Cunard, Elsie de Wolfe, Elsa Maxwell

and Lady Oxford. It followed closely the example of Lytton Strachey's writing of the 1910s and 1920s where he described a Utopian eighteenth-century world, presided over by a matriarchy of Salon hostesses – Madame de Sévigné, Madame de Lieven, Madame de Deffand and Mademoiselle de Lespinasse.[118]

Behind the Edwardian *ancien régime*, there stood also in Beaton's imagination the reference point of the eighteenth-century *ancien régime*. A sculpted head of Marie Antoinette surmounted the overmantel at Reddish, signifier of the eighteenth century, its pictorial iconography composed of bowers, gardens, ruins and *fête champêtre* groups. This was an intimate imaginary world of correspondents, hunters of erotic souvenirs, diarists and guitar players, which Beaton had transferred to his private photographs of Ashcombe in the thirties, and to his fashion and portrait photographs well into the seventies. He organized period-revival sets for his portrait photography by arranging complex scenographies, sometimes based on porcelain figures or collected objects, whether Rococo chairs or Edwardian props. Borrowing pictorial paradigms direct from Watteau, Fragonard, Gainsborough and Piranesi, he enlarged them as photo-'blow-ups', scenery backdrops that acted, in that iron age of the thirties, as sentimental fragments of another, lost civilization, one which could be phantasized as being noble, aristocratic, and matriarchal. Thus, in July 1939, he could write: 'Pictures were taken of the Queen (HM Queen Elizabeth) against my old Piranesi and Fragonard backgrounds.'[119]

In Beaton's first published diaries, with their evocative eighteenth-century title *The Wandering Years* (1961), a title associated with the historical rhetoric of youth's sentimental progress, he gave the subheading 'The Last Summer', to his account of the summer of 1939; another year, like 1914, of

116. 'Review', *Apollo*, January, 1928.
117. Cecil Beaton and Peter Quennell, *Time Exposure*, p.3.

118. See Lytton Strachey, *Biographical Essays*, London, 1960.
119. Cecil Beaton, *The Wandering Years*, p.375.

120. Cecil Beat-
on, *The Book of
Beauty*, p.2.
121. See James
Danziger,
Beaton, London,
1980, pp.39-43,
and Gail Buck-
land, *Cecil
Beaton War
Photographs
1939-1945*,
London, 1981.

closure, of threatened loss, and interruption to the 'beautiful' stream of phantasmic portraits of Society ladies. He had already described his experience of such a loss when he remembered his childhood from the vantage point of 1930 in *The Book of Beauty*. There he described his toy theatre stage, full of pictures of actresses and nobility which he had cut from the weekly glossy magazines: 'then – oh horror! the war came and *The Sketch* and *Tatler* stopped for a week, after which a very thin ghost of these magazines appeared filled with photographs of – soldiers. But I prayed very hard, and soon the photographs I wanted reappeared.'[120] This was the infantilist language of J.M. Barrie's *Peter Pan*, but it was also an obsessively egoistic version of history as comedy, where pleasure could be renewed through the consoling apparition of the 'beautiful' photograph.

VII / Penitence, War and Orientalism

Beaton organized, and was organized by, the spectacle of the Second World War. He re-wrote his own story, which was likewise re-written by others, until the outlines of another Beaton emerge, one who renounced frivolity and was engaged in ascetically recording martial activity. The war is figured by Beaton, and by those who wrote about him, as some kind of transfiguring purgation, a rhetoric which continued to structure accounts of Beaton for nearly forty years.[121] There was a redemptive programme to the representation of Beaton during these war years, and a kind of puritan and purgatorial narrative was utilized by Raymond Mortimer and Peter Quennell in their wartime writings about him. A confessant, repentant Beaton was ventriloquized by Quennell in *Time*

Exposure (1941), a Beaton who once, in the thirties, 'had a passion – a perverse passion he now considers – for the romantic quality of the artificial and the charm of the second rate'.[122] Thus, recalling the previous decade, the dead walk before Quennell as they walked before Beaton when he wrote his diary in the Western Desert in 1942. There, relics of vanity were remembered, together with a ritual loathing for the inter-war period – 'a period when, trusting in Baldwin, we went to fancy dress parties, did imitations, danced the Lindy Hop and carted heavy luggage over the face of the globe',[123] – a protracted *mea culpa* for his involvement in the culture of appeasement and his casual anti-semitism.

But redemption, of a kind, was accomplished; and a film still by Beaton, reproduced on the cover of *The Sketch* in 1941, is metaphoric for this moment in Beaton's career. It shows an actress, Valerie Hobson, standing fashionably dressed in the ruins of a bombed building, playing the main role in *Unpublished Story* (1942), 'a fashion journalist turned war reporter',[124] casting modishness aside and austere of countenance, in short, transfigured by her new wartime identity. This sort of transformation was being ascribed to Beaton as well, and his career was brought into alignment with the changed political circumstances, which had shifted from appeasement in the thirties to the heroic wartime collectivity of the forties. In 1943 the book reviewer Henry Saville, writing in *The News Review*, said that 'As far as any one man typifies any one thing, Cecil Beaton can be considered today to symbolize the revolution the war has brought to Britain.'[125] In the thirties, observed Saville, he was 'amusing, mostly clever', but in the last three years had been transformed by serious 'reporting'. Saville concluded that 'It needed a war to make Beaton write and illustrate so good a book as *Near East*.'[126] Thus, Beaton

122. Cecil Beaton
and Peter
Quennell, *Time
Exposure*, p.4.
123. Cecil Beaton,
Near East, p.43.
124. *The Sketch*,
3 December 1941.
125. Henry
Saville, 'Books
of the Week',
News Review,
12 August 1942.
126. *Ibid.*

was represented as fulfilling the imperatives of war, a renascent Briton discovering new and sober skills that were suited to the recently prioritized style of documentary realism, which could depict Britain at war. In 1940–41, Beaton's work appeared in that exemplary magazine of photo-stories and documentary realist style, *Picture Post*. Soon, however, the functional demands of his tasks as an official Ministry of Information photographer began to put a strain on his dandy-photographer persona, exempt from 'trade'. As he wrote to Francis Rose in 1941, 'I am really very overworked... I've done such a lot of photography that it isn't really funny any more. It's just like being a press photographer.'[127]

Yet, although Beaton tried to accommodate himself to the new photographic language of heroic documentary propaganda, his repertory of devices – irony, theatrical framing, the grotesque, the use of mirrors and an open display of fiction – were still operative, and working against the grain of the dominant codes of documentary style. Sometimes they coincided, as in his long assignment to record the RAF in 1941, where Beaton adapted and re-adapted the mythic pathos of the 'Few' from Fighter and Bomber Command. Even here Beaton lapsed into his brilliant juggling act with 'star' fictions. In his portrait on the cover of *The Sketch* in October 1941, an anonymous fighter pilot, DFC and Bar, is shown standing backlit in fine de Meyer-style profile, before banks of studio arc lights with their barn doors open, like a relaxing film star in uniform.[128] This was a recollection by Beaton of his cunning and reflexive Hollywood photographs of the early thirties, when he portrayed stars such as Gary Cooper, Buster Keaton and William Powell on film sets, among the fictions of the backdrops, with the cameras and the arc lights of the film studio openly visible. This was a development of the Hollywood 'star' photography of Anton

Bruehl and James Abbé, and Beaton's display of the means and fictions of the studio had been hailed in American film-fan magazines as 'Hollywood Debunked',[129] but the fighter pilot, in 1941, was represented as an entirely mythical, heroic being.

If Hollywood's fictions were still active in his wartime photographic language, Beaton was also involved in manufacturing British fictions to be sent to America. His portrait of Churchill in the Cabinet Room was first used in major British daily newspapers on 23 December 1940, with captions reminding the reader that Churchill would speak to Britain and the Empire that night on the radio. The photograph then appeared full page in *Life* magazine, with a text commenting on Churchill's 'great Bulldog jaw and penetrating stare...He inspires an Empire in its hour of need'.[130] Beaton's iconography of Churchill for the American market had already been established in his photo essay published in *Life* in October 1940, called 'Churchill, England'.[131] This essay was centred not upon the Premier's physiognomy and his symbolic, bulky power, but instead upon the village of Churchill in Dorset – a pastoral personification of Churchill the man, now redoubled as chief symbol of Britain. Beaton portrayed a cross-section of members of this village in documentary style. But his choice did not reflect any heroic documentary typology of Britain at all. The group that he picked for *Life* was a bizarre and caricatural collection of eccentrics – exceptions all of them: a local millionaire; an odd-job man recruited from the local workhouse; and an aristocratic lady in reduced circumstances – a comedy of pecuniary status. This was a village England that had been collected from the extreme margins, a kind of musical-comedy Tory England, just as Churchill, in his role as British Premier, came from the same political margins of nostalgic Toryism.

127. Hugo Vickers, *Cecil Beaton*, London, 1985, p.249.
128. *The Sketch*, 22 October, cover.

129. Cecil Beaton, *Cuttings Books*, vol. X.
130. *Life*, January 1941, p.59.
131. 'Churchill, England', *Life*, October 1940.

At this point, *Life* began to take up and publish Beaton's reportage work, after carrying his portrait of the bomb victim, Eileen Dunne, in her hospital bed on its cover in September 1940. It, too, signalled the implied transition in Beaton's career from frivolity to implications of heroism: '*Life* received from Cecil Beaton, England's crack Society photographer, the pictures of a North England bombing.'[132] Eileen Dunne was twice framed, once by the edge of the picture and again by the bed-frame itself, just as the towers of St Paul's are framed in his Blitz photographs by a bombed arch, like a rusticated screen. To photograph the war, Beaton turned it into a framed spectacle, with similar ornamental screens and sub-frames to seal in the picturesque ruins. He did this most conspicuously, perhaps, with his abyss of empty frames made from wrecked tank turrets, upended as circular metal forms at Halfaya Pass in the Western Desert in 1942. *Vogue* printed this picture as 'Desert Design' in November of that year with a caption that once more mobilized Beaton's aesthetic of the grotesque, stating that 'he found these macabre and beautiful forms.'[133] It was a fundamentally decorative and ornamental landscape of war that he represented in his commissions, a war continually supplemented by found theatrical, scenographic and *parergonal* devices,[134] a photographic strategy already clearly under way in the 1930s in his portrait and fashion photography, which relied heavily upon the use of screens and frames.

Beaton's war was a staged war, a static war behind doorways, windows and screens. An example of this can be found in the Chinese police department which he photographed at Chengtu in head-on stasis, as if they were presenting themselves for applause to an imaginary theatre audience, with a cut-out circle for a proscenium arch, and flats behind and around them. Everywhere in Beaton's war photographs, officers, soldiers and civilians are spread horizontally to make informal chorus lines in these theatres of war. Beaton's choice of code was well made, for he knew that he could not possibly compete with the kind of visceral combat photography which had been developed in the late thirties by Robert Capa, whose pictures of the bombing in Hankow, published in *Life*, had been collected by Beaton for inclusion in his own *Miscellaneous Scrapbook* of 1938. Beaton's framed, distanced and ornamented world removed itself from the Capaesque, photo-journalistic ethic of involvement and immediacy. In the introduction to *Near East*, in 1943, he announced that 'this book has no news value',[135] demonstrating his aversion to the dreaded, routinized, workaday role of the 'news-photographer'. By his calligraphy and autobiography, writ large on the cover and binding, Beaton managed to customize his production of *Near East* into a kind of wartime travel book and album that seemed unique in an age of austerity regulations and standards: a luxury item of exotica.

All Beaton's visual metaphors of the theatre, his collections of grotesque detail, his doubling and mirroring served, in the context of India, Egypt and Palestine in the early and mid-forties, to secretly declare the essentially comic organization of the Empire in decline. In New Delhi in 1944, Beaton photographed William Henderson, a British Officer in ceremonial uniform, his helmet removed, indolently posed with one foot leaning on a plinth, gazing up at the back of an enormous, over-life-size statue of Queen Alexandra, which he captioned 'Imperial Delhi'.[136] This gesture, which appears near the beginning of the book *Far East* (1945), was one of ironic nostalgia, a nostalgia which Beaton felt keenly, but nevertheless he admitted to himself and to his readers in *Far East*, that it was an absurdity, a comic gesture of hopeless affirmation of

132. *Life*, 23 September 1940, cover and pp. 26-7.
133. British *Vogue*, November 1942, p.42.
134. See Jacques Derrida, 'The Parergon', *October*, 1979, no.9, p.26.
135. Cecil Beaton, *Near East*, p. vii.
136. Cecil Beaton, *Far East*, facing p.8.

British power. New Delhi, Beaton wrote, was 'a city built for an exhibition'.[137] a symptom of Imperial rule which had 'no roots to develop a future'.[138] Beaton was left instead with a melancholic vista of the Orient as pure display, of a Beatonesque exhibition from the Imperial centre: for he had arrived, as he knew, too late. (But also too early, at a different moment and with a different role to, say, Henri Cartier-Bresson, who only a few years later was to record the close of colonial rule in the East.) In the stasis of history, Beaton could only ironize. He continually juxtaposed the signs and debris of Western technology, advertising and entertainment with their oriental setting, showing the Orient to be contaminated with the West and with the display of British styles and signs, rather than being an immaculate oriental spectacle. In the Western Desert of Egypt, he found Western writing everywhere: calligraphy abutted Western signs; he photographed an elderly musical comedy star, Alice Delysia, against Islamic decoration in Cairo, while in other examples a British soldier drinks tea in front of a wall covered with Islamic script, and Egyptians in jellabas pass before a film poster of MGM stars Hedy Lamarr, Lana Turner and Judy Garland in the film *Ziegfeld Girls* (1941).[139] These ironic cultural superimpositions are still ornamental and decorative, but also bizarre and deconstructive.

Beaton's Orient was comically unstable. But then it could never be unified or intact because it could never reproduce the Orientalist fiction of the East that he had first seen in the London theatre of his childhood. It could never correspond, as he wished, to those stage panoramas of *The Garden of Allah* in Drury Lane (1920), or to Lovat Fraser's designs for Lord Dunsany's play *If* (1921), or to the great musical comedy fictions about the East that were performed at Daly's Theatre in Leicester Square, such as

The Geisha, San Toy and *The Cingalee*. The Orientalist mentality, which has been systematically examined by Edward Said in literary forms,[140] was also well sedimented iconographically in that part of the British theatrical imagination in which Beaton was well schooled. With his first Orientalist photographs taken in a brothel in Morocco as far back as 1933, Beaton had returned to that model of the Orient that he had first identified on stage in *The Garden of Allah*, and also in those Royal Academy paintings that he was so versed in from the early twenties, like Glyn Philpot's *L'Après-midi tunisien* (1921): exotic and erotic spectacles of staged oriental 'otherness'. Besides being theatre-based, this Orient – Beaton's Orient – was also a patterned, decorated, imaginary place, like the mirrored temple walls at Jaipur and Calcutta which Beaton was to photograph.

In China Beaton pushed his constructions of photographic space into a flatter, more planified world. With increasing frequency, he presented portraits in front of façades or walls, with enormous ideograms of Chinese decorative motifs painted or worked upon them. These were rococo, Sitwellian representations, where the faces were just one more emblem that could be floated off, leaving a purely decorative sign, just as he did with the cover for *Chinese Album*, which Beaton derived from his portraits of Chinese gatekeepers. In Chengtu, Szechuan Province, he photographed the façades of shops – frames within frames, and apertures within apertures once more.[141] He paid special attention to the flagmaker of Chengtu, with his festoons of American and Chinese Nationalist flags: a celebratory ornament in the visual economy of cornucopian excess which held sway over Beaton's decorated text, where all stuffs and materials elaborated themselves in agitated display.

The 'feminine' superfluity of tulle,

137. *Ibid.*, p.8.
138. *Ibid.*, p.9.
139. See Cecil Beaton, *Near East*, facing p.27 ('Cairo Patterns').

Prince Mohammed Ali of Egypt, 1942

140. Edward Said, *Orientalism*, London, 1980.
141. For an example of Beaton's *mise-en-âbîme* visual strategy see Cecil Beaton, 'Hat Check Girl', *Cecil Beaton's New York*, facing p.208.

> ‘I am really very overworked …
> I've done such a lot of photography that
> it isn't really funny any more. It's just
> like being a press photographer.’
>
> Hugo Vickers, *Cecil Beaton*, p.249

142. Noël Coward, *Play Parade*, London, 1939, vol. II. p.118.

which so fascinated Beaton in the twenties and thirties, was to him a quintessentially Edwardian material, one with which he protectively wrapped his Kodak. His love of transparency reappeared with the use of other translucent materials, particularly cottons, and with the camouflage netting, blinds and screens that he found in the props of the East at war. To Beaton, Egypt and India were netted and curtained places, sites shaded against the sun for soldiers, natives, and grand colonial and enthroned Imperial rulers. In his visual imagination, these were places which entertained an intertextual relationship with Noël Coward's words from his song for the review, *Words and Music* (1932), *Mad Dogs and Englishmen:* 'In the Philippines, there are lovely screens to protect you from the sun.'[142] If New Delhi was to Beaton an 'exhibition' city, then the entire Empire was similarly a scenographic, and emphatically nostalgic, spectacle, which was lit by dappled, shuttered and screened light just like that at Daly's

Theatre. Beaton attempted to match the pictorial and theatrical schemata of orientalism with the great, half-Westernized, shambling and recalcitrant sites which constantly betrayed his phantasies. He was dispatched to Teheran in 1940, to photograph the Shah of Persia and his wife, hoping 'to photograph the Queen looking like the Persian miniatures that were made during the golden age of Shah Abbas'.[143] His ploy failed; Beaton related that Queen Fawzieh was wearing 'vulgar' Shaftesbury Avenue clothes and that the Palace was 'as new as any Hollywood Picture Palace'.[144] Ironically, he regretted that he could not find a pristine Orient, and that the division between East and West was closing. He admitted that his romantic nostalgic project was ruined: 'It was my mistake. How unwise to try to link the past with the present.'[145] Beaton painfully discovered that the East was not in another primitive age: it was modernized, ruled, co-ordinated and organized by British administrators and their

143. Cecil Beaton, *Near East*, p.100.
144. *Ibid.*, p.101.
145. *Ibid.*

nominees. At least, this is the evidence of his portraits, where maps dominate offices and officers, and an 'Englishman of the East', Glubb Pasha, 'an expert-adventurer-eccentric'[146] modestly shoulders his task as an Imperial agent, altogether dominated by the instrumental telephone shown in abrupt close-up on his desk.

VIII / The Romantic Royalist

For Beaton, the dream of the past – his conserving mission – acquired such priority that it effectively structured one of his most significant achievements, the renovation of Royal portraiture in the late thirties to the fifties. The determining factors of the style and the iconography with which he chose to represent the Royal family can be discovered back in the twenties, in his insistence on a romantic femininity and a return to an Edwardian, or even Victorian, imagination of 'feminine' ornamentation, to tulle and to gauze. That it was a definite image of a woman, aristocratic and radiant, that was at stake, can be seen in his childhood and adolescent cult for Queen Alexandra. Beaton placed her, as the only coloured reproduction and the frontispiece to his *Book of Beauty*, with a crown floating above the picture frame, around which he drew exclamatory rays. The long continuity of British monarchy, signified by the intricately decorated pastiche painting of Queen Alexandra, worked to safeguard the notion of modern 'Beauty' around which Beaton had written his book. 'Beauty' was theorized as virtually a sacred remnant from the recent (Edwardian and Victorian) past in Beaton's introduction, a remnant connected with aristocracy, nobility and the stage, which was under siege from modernizing elements in the world. Earlier, he had contrasted two versions of *The Merry Widow*, his favourite, talismanic

childhood musical comedy, in a 1924 caricature for *Granta*, the Cambridge University magazine. One version titled 'As she was', with a huge hat, Edwardian ballgown, jewels, pearls and gloves, signified a past era; the other, 'As she is, Alas', was an anonymous, thin, 'Flapper-Girl', boyish in a tube dress.[147] Thus was established a remembered Utopia of gender, where a Firbankian 'Artificial Princess' stood over against the emancipated, post-Great War woman.

Faced with an interview on the topic of 'Woman of the Future' in 1928, the year of the extension of female suffrage, Beaton readily predicted a reaction against 'the rather harsh "sex equality" business. This "woman doing all the work" nonsense, this driving the car... "running a job", is wearying. So there is now a tendency among women to lavender picking in old-world gardens.'[148] Like a figure from an Augustus John painting of before the Great War, Beaton held his phantasy of 'old-world' femininity as a counterbalance to another, but equally fantastic, threat from the sexual metaphors of what he called 'a race of Robot women, uncaring and unreal'.[149] Beaton had already prescribed a kind of ban on contemporary dress in his portraits of women, thereby following in the steps of a tradition among portrait painters which had been especially prevalent in the eighteenth and nineteenth centuries – 'As far as possible I avoid allowing modern clothes to appear in a photograph...I try to get my sitters to wear some kind of costume that has withstood the criticism of time'[150] – that was located amidst a decor of 'rosebuds, chiffons and turtle-doves'.[151] A genre of whimsical revivalism was clearly at work, just as it was in the paintings of his friend Rex Whistler, or in Beaton's favourite novels by David Garnett. Through whimsy it seemed possible to neutralize the present by fancy dress, supplemented with an ornamentalism

146. Edward Said, *op. cit.*, p.246.

147. *Granta*, 24 October 1924, p.37.
148. *Evening News*, 22 February 1928.
149. *Ibid.*
150. *The Daily Chronicle*, 8 January 1926.
151. *Evening News*, op. cit.

Cecil Beaton

that might even attempt, in Beaton's words, to 'decorate a machine with dog roses'.[152] The threat of mechanized Modernism was also related to the shadow of Bolshevism, and by association, in Beaton's imagination, to that traumatic break in his images of 'Beauty' that had been occasioned by the beginning of the Great War. In his early scrap-books, he had collected a press cutting of 'The Murder of the Czar's Daughters',[153] where, appallingly, female nobility was doomed and beautiful royalty were under threat. Bolshevism was undoubtedly a great cultural terror for the British middle classes during Beaton's formative years, and it also looms as an apocalypse on the horizon of high bohemia and society in Wyndham Lewis's *The Apes of God*. Beaton feared that it would entail an end to 'Beauty', and this knowledge was confirmed and reinforced through his friendships with those White Russian *émigrés* whom he knew in the thirties – Pavel Tchelitchew and Baron Hoyningen-Huene – and also in the brilliant evidence of the exiled Ballets Russes from Soviet Russia.

There was a major change in British consciousness of the Royal Family in the twenties. While George V was the secure father of the nation, Europe was left bereft of its royalty by the revolutions of 1917–19. (Beaton's *My Royal Past*, 1939, was a comic essay about the nostalgia for those lost European institutions and pageantry, a nostalgia which had arisen in the inter-war period.) The historian David Cannadine has identified the innovative way in which British royalty was represented in the twenties, particularly with the advent of outside radio broadcasts for state ceremonials and weddings. These began with the wedding of the Duke of York in 1923, and soon developed, under the Director-General of the BBC, Lord Reith, into 'audible pageants' which addressed the bulk of the British public through a new mass

medium, drawing them into 'a sense of participation in ceremonial'.[154]

It was of great importance that Beaton came to maturity in this new mass-media, royalist era. He was eventually to take his first pictures of HM Queen Elizabeth (now the Queen Mother) in July 1939, signifying a further change in the diffusion of the British monarchy's image in an era of mass communication. Like Lord Reith, Beaton also effected 'The Invention of Tradition'.[155] This was not so much in terms of technical form as in style and connotation, through a strongly romantic representation of a 'fairy book' queen,[156] which was circulated to an extent which few royal portraits had been before. This effectively transformed the symbolic meaning of the monarchy after the trauma of Edward VIII, inflecting it strongly towards a sweet nostalgia for the Edwardian and Georgian periods. The official caption, typed and stuck on the back of one of the July 1939 portraits, underwrote this new, post-abdication rhetoric of maternal continuity and 'Beauty' rather than that fatal Modernity which had surrounded the iconography of Edward VIII: 'The serenity of this beautiful photograph well portrays the sweetness and dignity of HM The Queen.'[157]

Beaton's own recital of that July 1939 sitting at Buckingham Palace was narrated as an adoring piece of rococo fiction, a staging for his diary of an eighteenth-century *fête champêtre* in the present day, populated solely, blissfully, by himself and his fairy queen monarch, and visually coded by the nebulosities of Watteau and Pater, with the omnipresent, magical material, tulle, and the atmospherics of the regally sacred. It was a brief, idyllic episode at the still Imperial centre of the metropolis, framed by 'my old Piranesi and Fragonard backgrounds',[158] as well as the mighty doorways, urns and pillars of the Palace. His portrait of Her Majesty in

HRH Queen Elizabeth, Buckingham Palace, 1939

152. Cecil Beaton, *The Book of Beauty*, p.9.
153. See Cecil Beaton, *Miscellaneous Scrapbook 1908-20*; source *Tatler*, 1 September 1920.

154. David Cannadine, 'The Context, Performance and Meaning of Ritual: The British Monarchy' and the 'Invention of Tradition c. 1820-1977', *The Invention of Tradition*, ed. E. Hobsbawm and T. Ranger, London, 1984, pp.101-65.
155. *Ibid.*
156. *Illustrated*, 4 November 1950, p.39.
157. I am indebted to Eileen Hose for this detail.
158. Cecil Beaton, *The Wandering Years*, p.375.

profile, by a sofa with sunlight from windows behind her, had its prototype in the Baron de Meyer's photographs[159] from the circle of Edward VII, with Lady de Grey and that last, lost world of grand quarters and deliquescent light, displaying a courtly elegance. Another group of portraits, taken in the grounds with parasol and white ball dress, referred directly to the paintings of de Meyer's friend, the artist Charles Conder, who depicted loose, light-filled fantasias populated by white-clad leisured ladies. These were all Edwardian schemata, which Beaton the romantic-conservative now invoked for this occasion. But the central signifier in them all was light, iridescent and nebulous. A repeated Beatonesque association of light and monarchy, which he had first indicated by the rays emitted from Queen Alexandra's crown, characterizes these photographs; they are royal auras. Beaton was later to write: 'It has caught her radiance...that elusive quality of light and fairybook charm surrounding her.'[160]

Reproductions of his photographs of the Queen and her daughters as heroines of a transfigured neo-Romantic monarchy, were ubiquitous in the forties and fifties and were applied, emblematically, to book and magazine covers, and addressed all sections of the British and Imperial public from *The Girls' Own Paper* in April 1943, to *The Queen's Book of The Red Cross* (1939), and *The Times of India* in 1944. Because of their cultural currency, they were used for a multitude of other functions, and a version of his portrait of HM Queen Elizabeth was given as a Christmas postcard to all the men and women serving in the British armed forces in December 1949. They entered countless scrapbooks as royal souvenirs. The great wave of monarchist sentiment in Britain for the first half of the forties was part of the mental re-structuring of the 'Churchillian renaissance', a culture in which Beaton

flourished. In 1943, Nigel Dennis drew together the different strands of the emergent cultural configuration of romantic Toryism, including the wartime novels of Evelyn Waugh, and even the quixotic, exceptionalist statements of Salvador Dali. 'In exchange for puritanism,' Nigel Dennis wondered, 'are we to have, as Dali suggests, "an individualist tradition... aristocratic and probably monarchic"?'[161] Although temporarily deprived of its political base through Churchill's loss of power at the 1945 election, this cultural drift continued and intensified as a reaction to the egalitarian politics of the post-war Labour government and its austere stance. As a political conservative as well as a cultural one, Beaton resisted Socialist restrictiveness, writing bitterly in his scrapbook for 1947, beneath a cutting of Sir Stafford Cripps, the Labour Chancellor, who had been photographed puritanically refusing champagne at dinner: 'What England came to after the Great Victory'. A few pages away, Beaton had included a photograph from the *Illustrated London News* of the Union Jack being hauled down at Lucknow after Lord Louis Mountbatten's negotiation of Indian independence.[162] The end of the Empire had arrived, and the floating fictions of British ascendancy, which Beaton had depicted in 1944, were now utterly detached.

Beaton redoubled his gestures of nostalgia, and almost exiled himself to America where he toured in a revival of Wilde's comedy, *Lady Windermere's Fan*. His resistance to change was reflected in his performance in, and designs for, a group of flamboyant theatre and film productions, which re-staged the *fin de siècle* and the Edwardian era. They should be seen, at least initially, as anti-austerity compensations, beginning with *Lady Windermere's Fan* (1945-46), then continuing with Korda's production of *An Ideal Husband* (1947). As a genre, these designs reached forward into the fifties and sixties with sets and costumes for

159. See *Portrait of a Man* reproduced in *Pictorial Photography in Britain 1900-20*, Arts Council of Great Britain, 1978, illustration no.38.
160. *Illustrated*, op. cit.

161. Nigel Dennis, 'Evelyn Waugh, The Pillar of Anchorage House', *Partisan Review*, July/August 1943, p.350.
162. *The Blue Scrap Book*, 1947; source *Illustrated London News*, 23 August 1947.

> 'It has caught her radiance ...
> that elusive quality of light and fairybook
> charm surrounding her.'
>
> *Illustrated*, 4 November 1950, p.39

163. H.W. Yoxall. 'Fashion Photography'. *Penrose Annual 1949*, pp.68-70.

Gigi (1957) and *My Fair Lady* (1955 and 1963). His works of the late forties were the scenic counterparts to the arrival and success of Christian Dior's 'New Look', in a shared cultural field of revivalism and nostalgia for that world before the Modern era, before 1914.

Colour was, perhaps, the chief element in this late forties strategy, whether in his fashion photography, interior decoration or theatre design. During the war and immediately afterwards, Beaton had constructed his photography as a kind of *grisaille*, producing a grey, even-toned world of melancholy that was in such a marked contrast to Bill Brandt's chiaroscuro, and which provided Irving Penn with his decisive point of departure; 'the deliberate cultivation of soft grey colours',[163] as one of Beaton's English *Vogue* superiors described it. But in 1946, at the moment of his extended visit to America, Beaton began to experiment with colour, not only in an anti-naturalistic register, but also

in a code rooted in his remembrance of colours from late childhood and adolescence. He returned, among other things, to the high, artificial, colouring of the costumes from *The Beggar's Opera* (1920), especially the 'ice-cream pink' that Lovat Fraser had employed in his designs. For Lady Windermere's costume, Beaton designed a gown in apricot, 'a romantic colour which has been neglected for nearly three decades'.[164] Colour was for him a proof of artifice, and the difference (and identity) between woman and photograph: all those things that he described as having been first imprinted on his memory by the glimpse of the pink tinting on Lily Elsie's postcard. Colour was bound to infancy, to childhood and to adolescence and its world, elements that were all reconstituted in his plays and photographs. Beaton probably put colour most fully at the service of this spectacle (before *Gigi* that is) in his sets for Korda's film production of *An Ideal Husband* (1947). Korda, an intimate of Churchill and, like

164. 'Beaton's Color Palette' US *House and Garden*, February 1947, p.75.

55

**Cecil Beaton and
Audrey Hepburn
on the set of
'My Fair Lady',**
Hollywood, 1963

Self-portrait,
1951

165. *Daily
Express*, 4
November 1947.
For the signifi-
cance of the
colour pink with-
in a scheme of
sexual poetics,
see Jane Gallop,
'Annie Leclerc
Writing a Letter,
with Vermeer',
October, Summer
1985, no.33,
p.103-118: 'Pink
then becomes *the*
colour of sexual
difference ...sexu-
al difference itself
becomes femi-
nine', p.104.
166. *The New
York Post*, 15
January 1948.
167. *Ibid.*
168. US *House
and Garden*,
op. cit.
169. *Ibid.*

Beaton, a flamboyant conservative and romantic royalist, was driven to manufacture florid productions which, he hoped, would colonize the American market with British pictures, a project not unlike Beaton's aim on first going to America in 1928. Beaton's colour was the most remarked upon aspect of the film: 'puce, purple and pink walls',[165] and 'pastelled technicolour',[166] to the extent that American critics complained of its artificiality and its loss of storyline, since it appeared to move towards 'a series of living, moving tableaux'.[167]

Kordaesque lavishness and hot colour-ing were then displaced into Beaton's royal portraits at the end of the forties. 'He intro-duces a touch of crimson into every room.'[168] wrote an American critic of Beaton's interior decorations in 1947, attributing Beaton's debt specifically to the taste of Lady de Grey, 'a friend of Queen Alexandra and Diaghilev'.[169] That luxurious red – an heraldic, not Socialist, red – that was in

evidence in several parts of his portrait of HM Queen Elizabeth in 1949, lay encased in the extraordinary set constructed partly of real drapery, and partly of painted curtains, that was built by his assistant Martin Battersby, and then erected by Beaton in the Music Room of Buckingham Palace. There, in painted fiction, was an idyllic garden, 'not a real garden'.[170]

Beaton was back, refusing austerity and embedded in the painted backcloth world of those Edwardian portraitists (and before them, of the Victorian, Camille Silvy) whose work he had craved, admired and wished to emulate and collect. As the headline in the Socialist *Daily Herald* read, 'I wanted to make it look like a painting by Winterhal-ter.'[171] and clearly his project was to write himself into that tradition of royal portrai-ture, just as he had some years before, when, for *Vogue* magazine,[172] he had photographed one of his own photographs of HM Queen Elizabeth, from 1939, onto the set of

170. Cecil Beaton,
Cuttings Book,
vol. XXX.
171. *Ibid.*
172. *Ibid.*

'As far as possible I avoid allowing modern clothes to appear in a photograph … I try to get my sitters to wear some kind of costume that has withstood the criticism of time.'

The Daily Chronicle, 8 January, 1926

reproductions of previous oil paintings of British royalty. All had heavily opulent frames drawn by Beaton, and included Van Dyck's *Queen Henrietta Maria*, Edmund Brooks's *Duchess of York and the Princess*, Zoffany's *George III and His Family*, and finally Winterhalter's *The First of May* – a predominantly female collection of gendered royal signs. Placing himself amongst them, he entered the lineage of Royal portraitists and there, in the presence of such maternal authority, began again his restless, endless, allusions, his nostalgias and revivals, his re-stagings and re-framings far from mother's bed and all along the radiant, eccentric lines of British culture in this century.

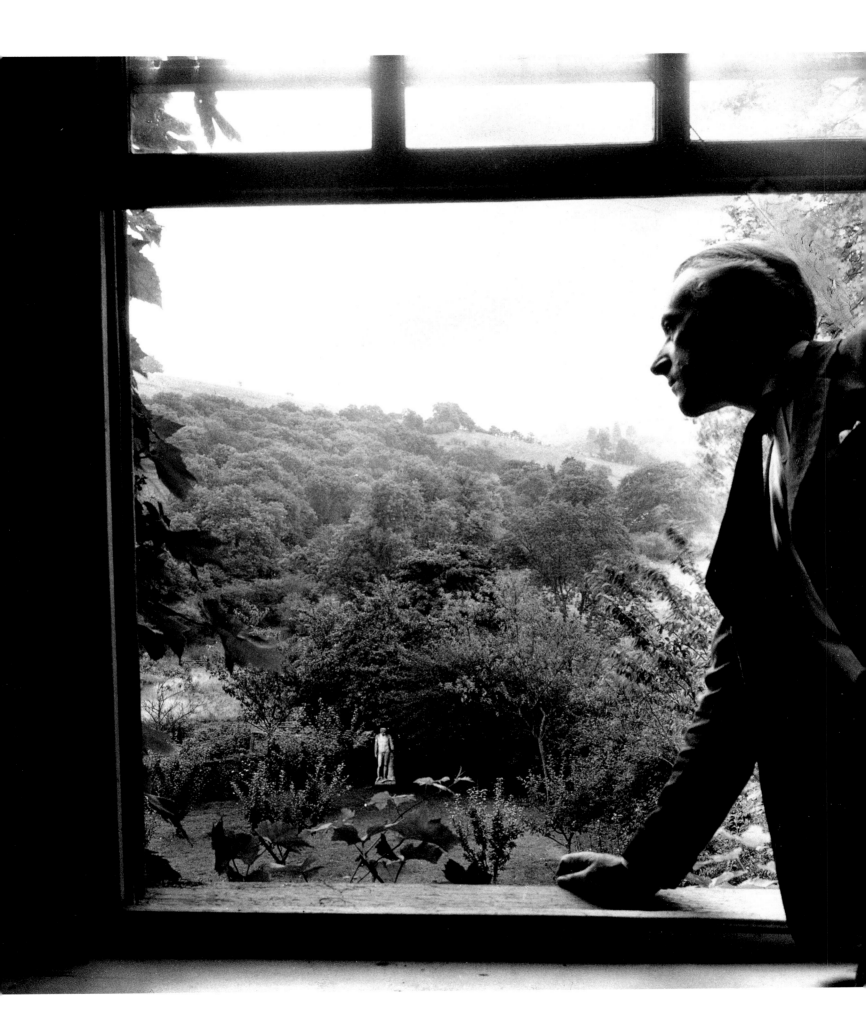

'The fashion
photographer's job is to
stage an apotheosis.'

Photobiography, p.74

An Instinct for Style

Philippe Garner

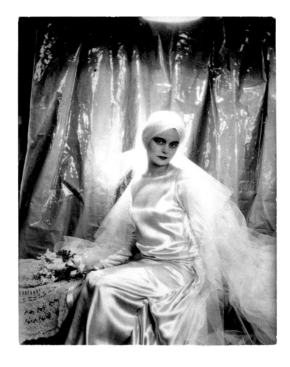

Top right: **Lily
Elsie as Sonia
in 'The Merry
Widow',** pho-
tographed by
Foulsham &
Banfield, a post-
card published
by the Rotary
Photographic
Co., 1907

Bottom right:
Modes Drécoll,
photographed
by Reutlinger,
Paris, c.1903

I / Impressions Received

Cecil Beaton's infancy coincided with the
earliest phases of a new discipline within the
commercial applications of photography.
Fashion photography, a complex weave of
idealized beauty, artifice, artistry, technical
dexterity and commercial diktats, had its ori-
gins in the Edwardian era, into which Beaton
was born on 14 January 1904. Crucial to this
evolution were the developments in printing
which enabled fashion journals to reproduce
photographs as easily as line drawing illus-
trations. The refinement of half-tone printing
and the possibility of reproducing photo-
graphic images in full colour gave a new
dimension to fashion magazines and marked
the beginning of a boom in this area of pub-
lishing. The pioneering French magazines,
Les Modes, *Femina* and *Le Figaro Modes*,
were soon to be eclipsed by a revitalized
Vogue, published by the American, Condé
Nast (the British edition of which was first

published in 1916), and by its great rival,
Harper's Bazar.

The earliest professional fashion stu-
dios were the Paris establishments of Reut-
linger, Félix and Talbot where, in the tradi-
tion of nineteenth-century portrait studios,
conventionalized poses before painted back-
drops were the norm. The profession of fash-
ion model did not then exist, and models were
often drawn from the world of the theatre. In
Britain the stars of the Edwardian musical
comedy were the popular idols of their day,
and their exaggerated dress was perhaps the
strongest influence in fashion. The young
Beaton's fascination with these glamorous
stage stars, foremost amongst them Lily Elsie,
and their elegant, elaborately stylized cos-
tumes, led to a lasting passion for the worlds
of fashion and theatre. The interplay of these
two influences became an essential ingredient
of Beaton's aesthetic. Characteristically, when
designing his *My Fair Lady* costumes he
drew extensively on the illustrations in the

'On one of her yearly visits to England … Mrs Chase,
the American editor-in-chief of *Vogue* magazine, had seen
some of my drawings … When she was told that I also took
photographs, I was summoned to her office to submit my
work … the pictures … were obviously amateur work …
But Mrs Chase was not entirely put off. "If you come to
New York you must do some things for us".'

Photobiography, p.45

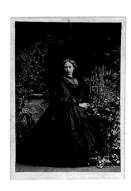

Edwardian theatrical journal *The Play Picto-rial*, and frequently throughout his career as a fashion photographer his work made allusion to the world of the stage.

Amongst the photographers whose work defined beauty in the eyes of the young Beaton were the West End portraitists such as Lallie Charles and Rita Martin, who enjoyed success as flatterers of Edwardian society and stage subjects. These were the heirs of Camille Silvy, the pre-eminent carte de visite portrait photographer of the 1860s. Silvy's rich chiaroscuro full-length portraits emphasized the texture and detail of dress and used painted backdrops and props to establish the status of his subjects. He created an aristocratic iconography which evidently appealed to Beaton, who preserved examples of Silvy's work in his own scrap-albums.

The first fashion photographer whose work impressed and influenced Beaton was Baron de Meyer, whose shimmering light effects and stylish poses Beaton has described in rapturous prose using musical metaphors.[1] Beaton acknowledged another, perhaps less obvious but equally fascinating influence in the work of Francis Bruguière, a photographer who, 'By using lights on strips of metal and paper... created an abstract world... The results were a marriage of the camera and the essence of light.'[2] Beaton's artistry as a fashion photographer developed from the lessons of early practitioners whose task was to idealize their subjects. He enriched this function with a painterly eye for the effects of light, space and imagery.

Beaton's scope and sensibility as a fashion photographer can only have benefited from his unique additional roles as a chronicler of twentieth-century fashion and as a photographic historian whose distinguished written contributions to these subjects include most notably *The Glass of Fashion*, published in 1954, and *The Magic Image*, published in 1975.

1. For example: Cecil Beaton, *Photobiography*, pp.26-8; Cecil Beaton and Gail Buckland, *The Magic Image*, 1975, p.106.
2. Cecil Beaton, *Photobiography*, p.38.

Top left:
Princess Alice, carte de visite photograph by Camille Silvy, 4 July 1861

Bottom left:
Abstraction, by Francis Bruguière, 1920s

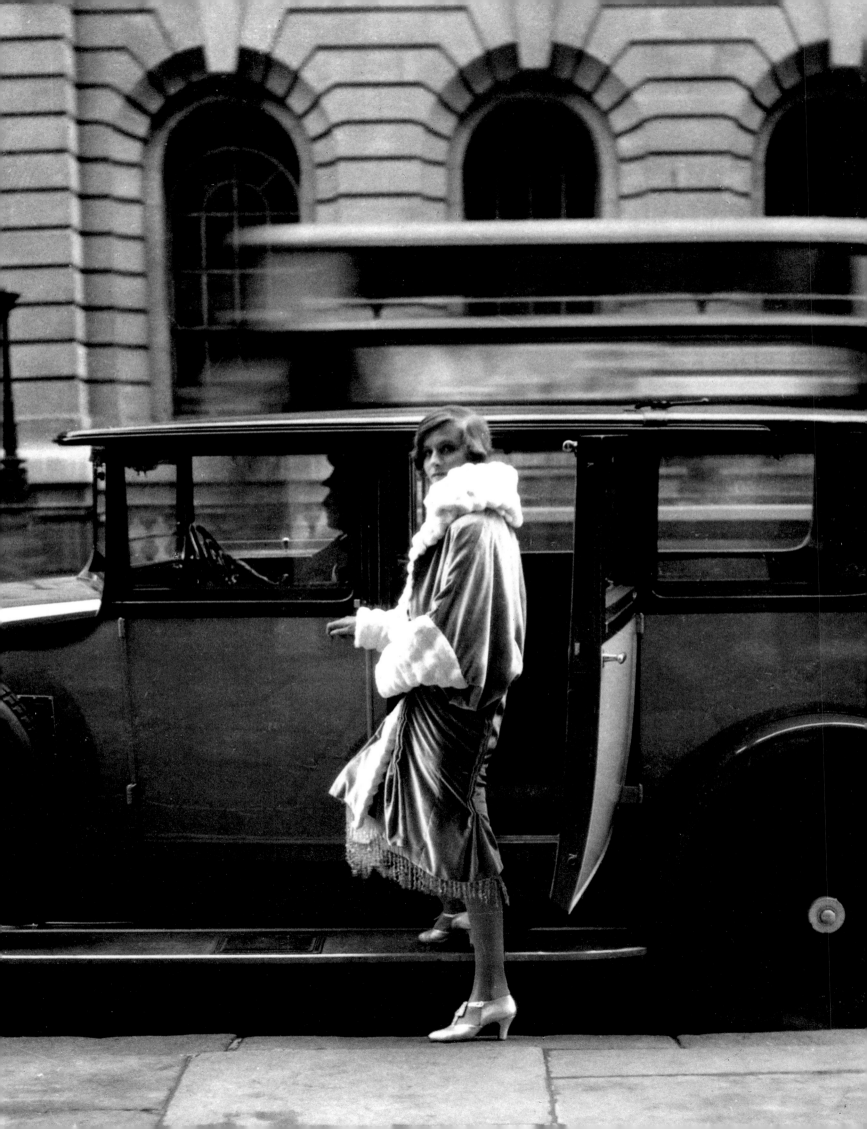

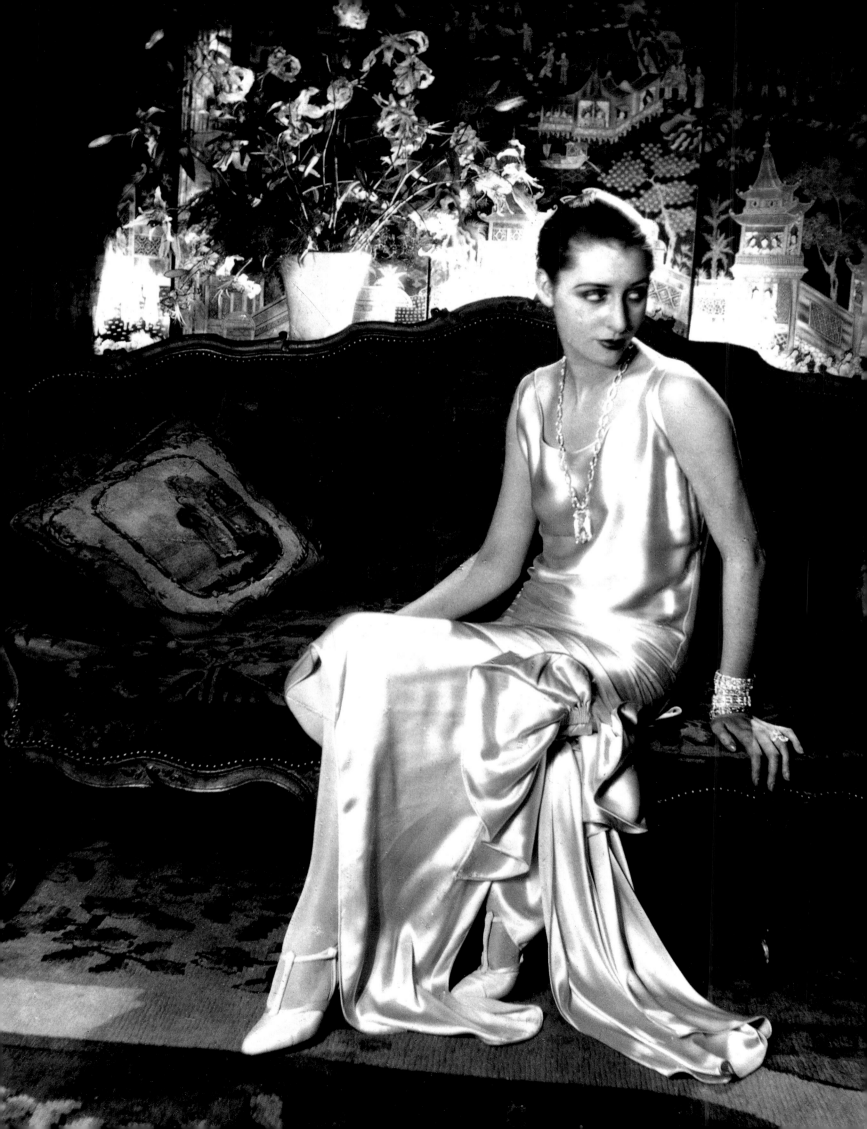

II / Introductions Made

Beaton's career as a fashion photographer grew naturally out of his work as a society portraitist and flourished under the patronage of *Vogue*, first in London and then in New York and Paris. H.W. Yoxall, managing director of *Vogue* in London, recalled, 'One of my chief claims to fame [is] that, in 1927, I signed [*Vogue's*] first contract with Cecil Beaton, just down from Cambridge – though I can't bespeak the credit of discovering him. That was done by our then editor Alison Settle. Cecil was first engaged as a social cartoonist, but his photographic talent soon emerged.'[3]

Beaton recalled his introduction to American *Vogue*:

'On one of her yearly visits to England in search of talent, Mrs Chase, the American editor-in-chief of *Vogue* magazine, had seen some of my drawings. Mrs Chase considers she showed considerable perception in feeling that they showed promise and that they would one day be useful to her magazine. When she was told that I also took photographs, I was summoned to her office to submit my work… the pictures…were obviously amateur work… But Mrs Chase was not entirely put off. "If you come to New York you must do some things for us".'[4]

Mrs Chase wrote of this first meeting, 'I remember the day Cecil first came into my London office – tall, slender, swaying like a reed, blond, and very young. The aura emanating from him was an odd combination of airiness and assurance.'[5]

In 1928 Beaton made his first trip to New York. He recorded: 'I showed my latest photographs to Mrs Chase,[6] who considered that, although they might be poor technically, they had the merit of being unlike the pictures of any other photographer. I was soon taken into the *Vogue* fold and commissioned to photograph beautiful women up at the Condé Nast's fabulous apartment on Park Avenue.'[7] He returned from his New York trip with a 'contract with the Condé Nast Publications to take photographs exclusively for them for several thousands pounds a year for several years to come.'[8]

A return visit to New York during the winter of 1929–30 established what was to become a regular pattern of work on both sides of the Atlantic. It was on this trip that Condé Nast, who 'took an avuncular interest in [Beaton and his] photography',[9] encouraged a greater professionalism in his protégé. He insisted that 'It's all very well for you to take pictures with a snapshot camera; but you've got to grow up!'[10] and demanded that Beaton put aside his Kodak 3A in favour of a 10 x 8 inch plate camera. Beaton tried out the new camera in Hollywood, and from 1930 this large format gave added quality to his fashion photographs and other work.

Beaton's earliest published fashion studies are tentative essays, for the most part less self-assured than his contemporaneous portrait work; often somewhat stiff, they followed a stereotyped formula of a model in an interior setting, gaze to one side, with her hand resting on a table, chair back or mantel. He seemed more in his element with 'celebrity' models such as the Marquesa de Casa Maury, a favourite of Beaton's at this time,[11] and achieved polished results when collaborating with such sleek thoroughbreds as top New York model Marion Moorehouse.[12]

III / The Reckless Years

Beaton rapidly achieved a reputation as one of the foremost talents in international fashion photography. He was in great demand

Marion Moorehouse in Condé Nast's apartment, for *Vogue*, New York, 1929

3. H.W. Yoxall, *A Fashion of Life*, 1966, p.105.
4. Cecil Beaton, *op. cit.*, p.45.
5. Edna Woolman Chase and Ilka Chase, *Always in Vogue*, 1954, p.10.
6. On 10 November 1928.

7. Cecil Beaton, *op. cit.*, p.53.
8. *Ibid.*, p.56.
9. *Ibid.*, p.60.
10. *Ibid.*, p.60.
11. British *Vogue*, 22 February 1928, p.41.
12. See Cecil Beaton, *op. cit.*, p.176.

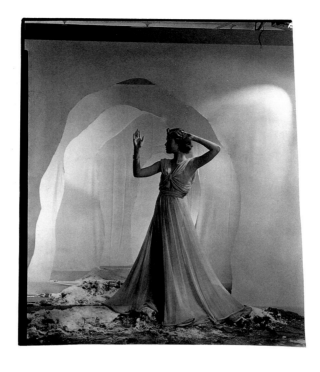

and was to fill countless pages of *Vogue* with his inimitable blend of wit, invention and high style. 'Until the arrival of Cecil Beaton and Norman Parkinson,' recalled H.W. Yoxall, 'our London studio was lamentably short of native aptitude; and even when they had arrived they were constantly being whisked off to Paris and New York.'[13]

Amongst his most able contemporaries were the American Edward Steichen and the Paris-based George Hoyningen-Huene. Beaton's comments on their work and his reaction to it reveal much as to his own aims and approach. Of Steichen he wrote:

'[He] was the Almighty Photographer at this time [c.1927]. His rich and meticulous studies... so full of light and shade, were now covering the pages of *Vanity Fair* and *Vogue*. But much as I admired Steichen's work... I knew that it would be hopeless for me ever to try to work in his vein. My work was the opposite end of the photographic pole...

Whereas Steichen's pictures were taken with an uncompromising frankness of viewpoint, against a plain background, perhaps half-black, half-white, my sitters were more likely to be somewhat hazily discovered in a bower or grotto of silvery blossom or in some Hades of polka dots.'[14]

Beaton's reaction to the style of his other distinguished contemporary, however, was quite different:

'Later I came under the influence of the work of Hoyningen-Huene, *Vogue*'s star photographer in Paris. Huene in turn had been under the spell of the great Steichen, but he brought more elaboration and extravagance to his photographs than the American master. Whereas Steichen seldom approached his subjects with humour, there was something almost frivolous in the way Huene brought a whole new collection of properties to his studios... Huene's violent activities in

13. H.W. Yoxall, *op. cit.*, p.103.
14. Cecil Beaton, *op. cit.*, p.53.

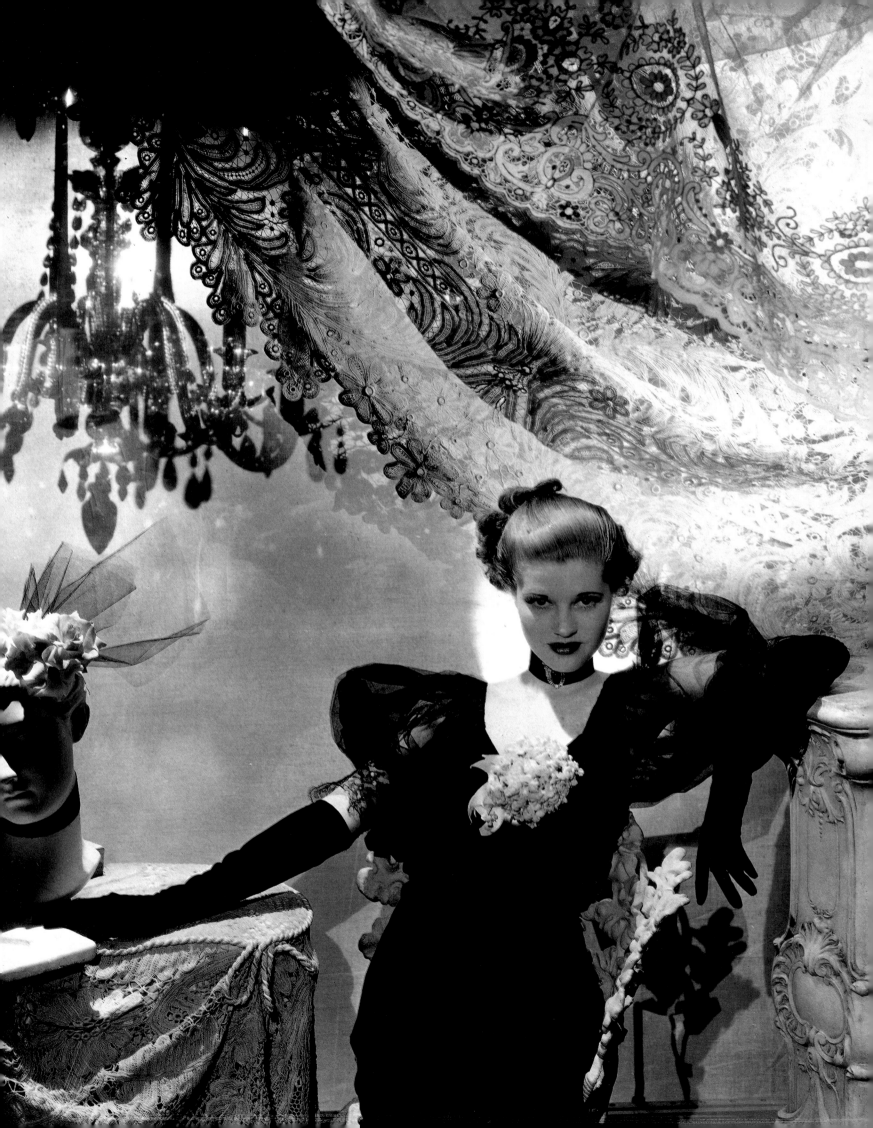

'In the thirties the fashion
photographers came into their own.
As one of them, I must confess to
having indulged myself in the generally
prevailing recklessness of style.'

The Glass of Fashion, p.191

**Model and
dresser,**
for *Vogue*,
1946

the pages of *Vogue* gave me my greatest
incentive to rival his eccentricities.'[15]

The thirties saw Beaton creating
with eclectic abandon a vernacular of novel
imagery which drew on a wide variety of
sources, not least the influence of the many
artists with whom he came into contact.
There were surrealistic settings and props
inspired by Dali and de Chirico, neo-romantic
flourishes with a debt to Christian Bérard or
Pavel Tchelitchew, baroque *mises-en-scène* in
the manner of the most whimsical interior
decorators of the day, and endless idyllic,
dramatic and witty variations on the
fashion theme.

Years later Beaton wrote:

'In the thirties the fashion photogra-
phers came into their own. As one of them, I
must confess to having indulged myself in the
generally prevailing recklessness of style. My
pictures became more and more rococo and

surrealist. Society women as well as man-
nequins were photographed in the most
flamboyant Greek-tragedy poses, in ecstatic
or highly mystical states, sometimes with the
melodramatic air of a Lady Macbeth caught
up in a cocoon of tulle... ladies of the upper
crust were to be seen in *Vogue* photographs
fighting their way out of a hat box or break-
ing through a huge sheet of white paper or
torn screen... Princesses were posed trying
frantically to be seen through a plate-glass
window that had been daubed with white-
wash... Backgrounds were equally exaggerat-
ed and often tasteless. Badly carved cupids
from junk shops on Third Avenue would be
wrapped in argentine cloth or cellophane.
Driftwood was supposed to bring an air of
neo-romanticism to a matter-of-fact subject.
Christmas paper chains were garlanded
around the model's shoulders, and wooden
doves, enormous paper flowers from Mexico,
Chinese lanterns, doilies or cutlet frills, fly
whisks, sporrans, egg beaters, or stars of all

15. *Ibid.*, p.38.

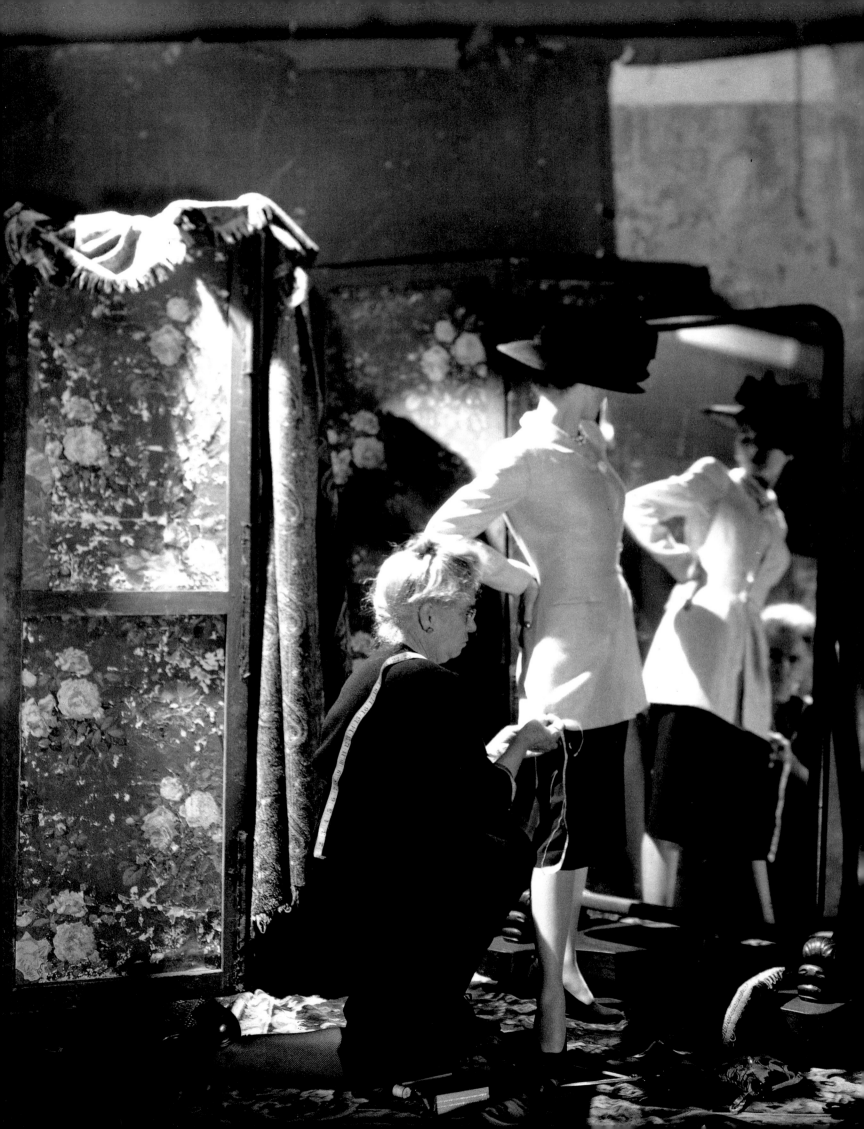

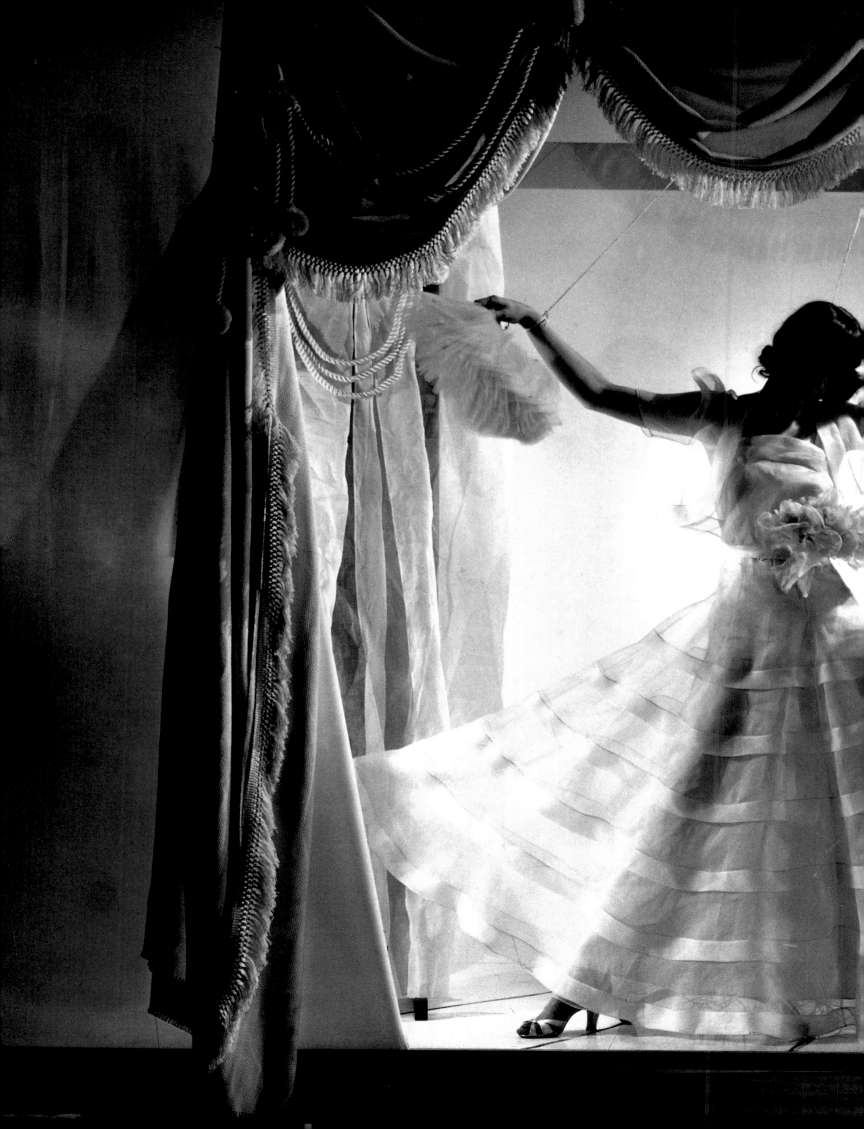

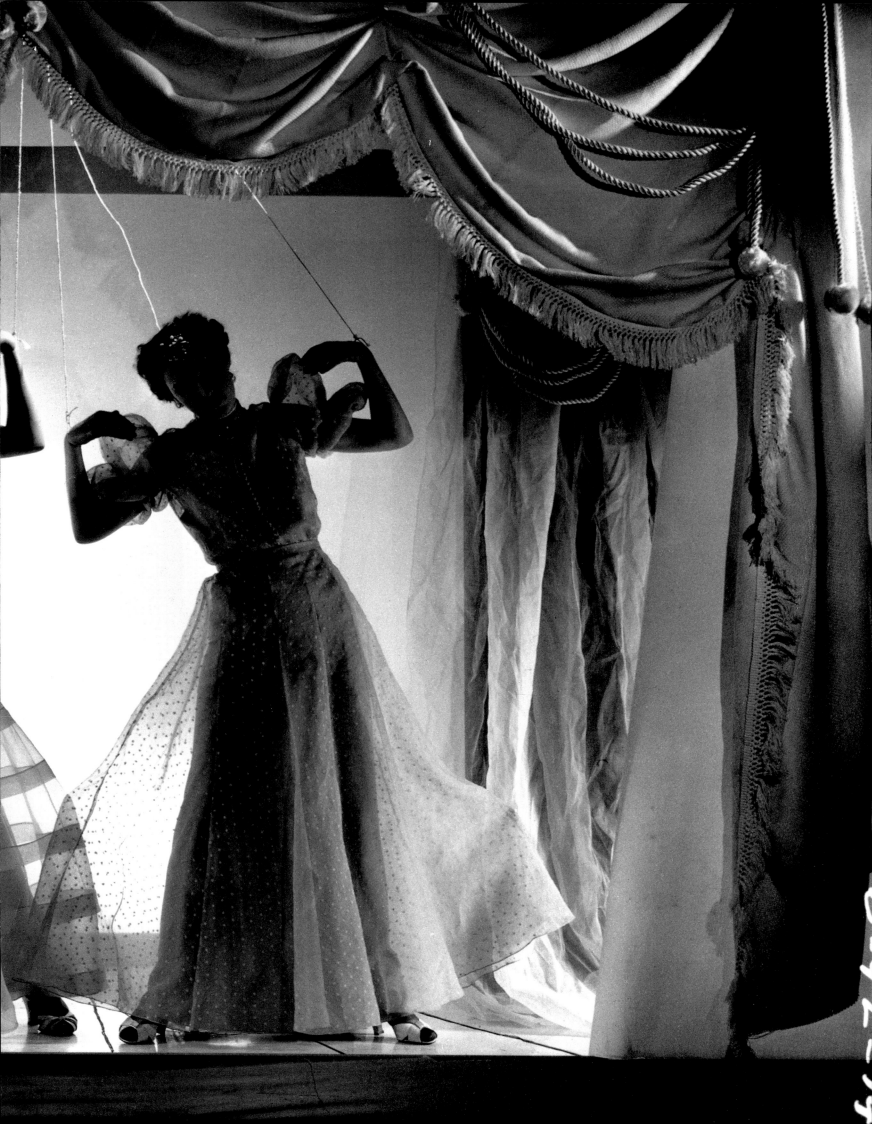

Previous pages:
Mock puppet theatre, for *Vogue*, 1936

Left: **Balmain clothes, with 'the lighting of a Corot'**, for *Vogue*, 1945

Fashion study amidst builders' debris, for *Vogue*, 1935

16. Cecil Beaton, *The Glass of Fashion*, p.191.
17. American *Vogue*, 15 June 1936, p.63.
18. For example: British *Vogue*, 14 October 1936, pp.92-3.
19. See Cecil Beaton, *Photobiography*, p.71.

shapes found their way into our hysterical and highly ridiculous pictures.'[16]

Beneath the fanciful trappings, other ideas were explored in a more purely photographic idiom – the play of projected shadows, silhouettes and patterns of light through cut-out paper, the latter especially calling to mind Beaton's reference to Bruguière. Beaton's passion for the theatre, meanwhile, provided specific inspiration for various fashion shots, including his 'puppet theatre'[17] series, and studies in the wings of unidentified productions[18] or amidst backstage clutter.

Beaton's favourite models of this era included Mary Taylor, whose distinctive beauty he might be said to have invented, Princess Natalie Paley and Helen Bennett, whom he posed on one occasion in a studio filled with giant ice-blocks for a feature entitled 'How to keep cool'.[19] Beaton found his form concocting elegant, inventive

images in which he cast his models as icons of status and style. His skill was in the constant reinvention of a formalized, remote ideal of female beauty, set in the present but assimilating many sources, from the work of court and society painters and photographers through to the imagery of the Edwardian stage.

IV / The New Realism

By 1936 a reaction had set in against the surfeit of romantic and extravagant indulgence which had marked Beaton's early work. This led him to explore new directions, and, once again, he became an innovator in his search for the ingredients of a new realism. One afternoon in 1936, he wrote:

'I was about to photograph a number of sports suits when suddenly I felt I could no longer portray them languishing in the usual attitudes of so-called elegance. I made them

put on dark glasses and stand in angular poses... I was called in for a special conference. What did I mean by making my models look so unladylike?... I retorted that, for me at any rate, the days of simpering were over... In my photographs the models had given up pretence. They were young and fresh, and to my mind, infinitely more alluring; they lent realism.'[20]

In the previous year Beaton had surprised Bettina Ballard, the fashion editor with whom he was working, with his change of style. She recorded: 'We were on our way to a sitting of street clothes in Paris one day when we passed by some offices that were being replastered. Beaton looked at the mess and said, 'How divine – exactly the background we need for these little costumes.'[21] And so the photographs were taken amidst the builders' debris.[22] Beaton was a pioneer in exploiting the seemingly incongruous realism of such locations as a setting for stylish clothes, a device he also employed in portraits made around the same date in Paris, in which he used a destroyed and derelict railway station as a backdrop. In these photographs Beaton had created, albeit unwittingly, a precursor for his celebrated war-time image of a model in a Digby Morton suit, seen against the rubble of a bomb-damaged London building.[23]

Beaton's growing disenchantment with the canons of elegance associated with *Vogue* led to conflict with the editorial staff and with American art director, Dr Agha. An unrelated dispute in February 1938[24] caused the termination of his American contract and a substantial reduction, until after the Second World War, in his fashion output. Beaton persisted in his endeavours to inject an element of realism into his work. Looking back on his career in 1968 he identified a distinct shift in mood demanding a fresh, less rarefied, though nonetheless stage-managed repertoire of poses, expressions and locations. He wrote:

'The posed, static hands with the pointed index finger and arched wrist acquired an overnight vulgarity; the celestial expression in the eyes suddenly became a joke shared by everyone except the sitter. The earlier pictures appeared over re-touched and altogether too artificial with ladies with forced rosebud simpers and impossibly golden curls.

Likewise, the locales for fashion photography changed from the boudoir, with its Louis Seize clichés, to places where the angelic Aunt Edna Woolman Chase would fear to tread. Instead of being caught nonchalantly arranging a vase of flowers with a satin shoe pointing to the full-blown rose on the Aubusson, sitters were seen in lowlier surroundings at humbler tasks: sewing, drinking from a cup, or feeling for rain. The results of my experiments in this genre of photography were considered to prove that I had at last grown up, and had acquired a new sense of reality. "Reality" was taken up by editors as the "new thing".'[25]

Beaton's 1945 study of a wistful young model in a plain jacket and trousers by Balmain is a masterpiece of this new realism. The antithesis of the high fashion mannequin, she is seen against a rough wall in a Paris courtyard with 'the lighting of a Corot'.[26]

V / Return to High Style

The dramatic revitalization of Paris couture after the war, heralded by Christian Dior's 'New Look' collection launched in February 1947, swept Beaton towards a new phase in his work. Ever sensitive to, and ever prescient of, shifts in the mood of fashion, he evolved a

20. *Ibid.*, p.72.
21. Bettina Ballard, *In My Fashion*, 1960, p.46.
22. American *Vogue*, 1 January 1936, pp.66-7; French *Vogue*, March 1936, pp.15, 28-9.
23. 'Fashion is indestructible', British *Vogue*, September 1941, p.32.
24. The 'all the damn kikes in town' dispute, detailed in Hugo Vickers, *Cecil Beaton*, 1985, p.207 ff.

Renée, Dior model, early 1950s

25. Cecil Beaton, *The Best of Beaton*, p.113.
26. American *Vogue*, 15 December 1945, p.59; British *Vogue*, November 1945, p.53.

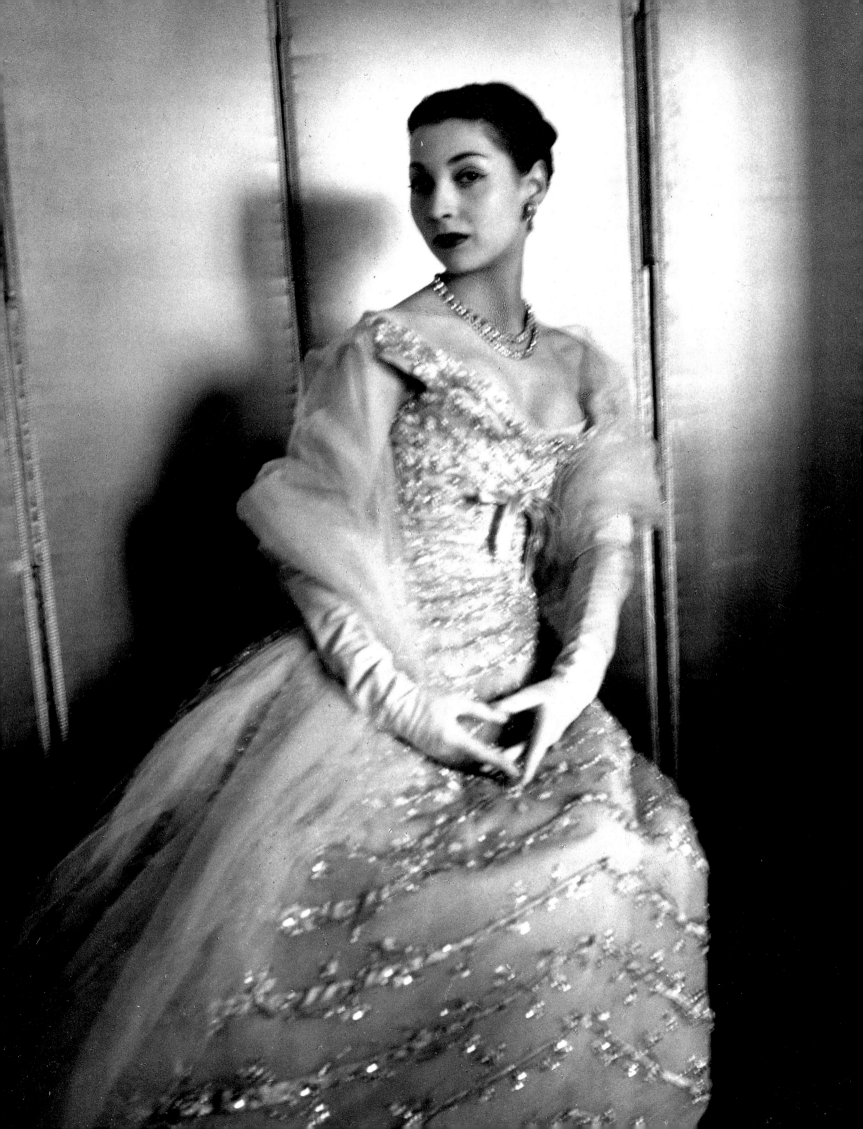

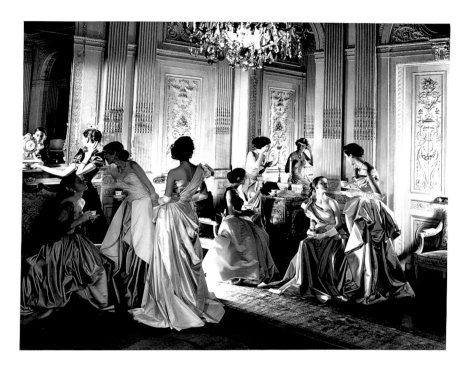

Charles James dresses, for American *Vogue*, 1948

27. American *Vogue*, June 1948, pp. 112-13.

high style appropriate to the new grandiose elegance of haute couture as exemplified by Dior, Balmain, Fath and Balenciaga in Paris or by Charles James, Beaton's contemporary at Harrow, now the star of New York couture.

Beaton's best work of this period was often seemingly straightforward, his models posed in grand interior settings or even against plain backdrops, without the contrivance of his work of the thirties. More fluid and altogether more seductive than his first attempts at interior shots in the late twenties, the epitome of this genre is the 1948 group of eight models in pastel silk satin evening gowns by Charles James, posed in a rich neo-classical salon.[27] Beaton captured the haughty elegance of a new generation of models including Jean Patchett, Dorian Leigh and Dovima. Accepted back into the fold of American *Vogue* at the end of the war he was again in regular demand in London, Paris and New York.

Exciting new talents, however, were bringing fresh ideas to fashion photography from around 1950. The mercurial young Richard Avedon was filling page after page of *Harper's Bazaar* with inspired location work, while at *Vogue*, Irving Penn breathed a noble serenity into studio work and his daylight studies against a neutral backdrop gave a new stature to the medium. By the mid to late fifties new photographers, including William Klein and Frank Horvat, were creating snappy, witty 'street-wise' images which blended fashion stylishness with documentary vitality. Beaton's formulae, however elegant, were starting to look somewhat predictable and in 1955 his contractual links with *Vogue* were terminated. Fashion and fashion photography were evolving new imperatives. Youth, energy, and vitality became central to the imagery of the sixties. Fashion photographers were free to explore new territories, including sexual and emotional scenarios which seemed more relevant to the era than the aristocratic hauteur which was Beaton's forte.

'Fashion photography is an insidious profession.
In art, it is what sex-appeal is to love. Artifice can be a
dangerous thing; when misapplied the results are vulgar and
tawdry. Its correct use depends on instinct. It is up to the
fashion photographer to create an illusion.'

The Magic Image, p.280

VI / Changing Times

Through the late fifties and the sixties, until his last sitting for British *Vogue* in 1973, Beaton made fashion photographs on a regular freelance basis for *Vogue*, often, in the latter years, as a 'star' guest, which left him free to work for other magazines. At *Vogue* he found favour with the eccentric and exuberant New York editor-in-chief, Diana Vreeland, though her dismissal in 1972 at a time of financial crisis marked the end of an era in which free rein was given to the whims of editors and photographers.

By 1970 Beaton was clearly the scion of a different era with different aesthetic criteria to those of the aggressive young photographers in the mould of the hero of Antonioni's 1966 film *Blow Up*. Fascinated though he may have been by the young heroes of the sixties, he found it difficult to relate to their tastes. 'I find', he wrote in his diary in February 1974, 'that, accepting the inevitable and "being my age"... the young seem so different, so beautiful, so energetic. They are like creatures from another planet and are as difficult to understand as young fowls or other animals.'[28]

In these later years Beaton was at his best when working in his established vein, in sophisticated interiors with models whose innate elegance conformed to his norms of high style. But he was arguably less successful in producing distinguished results when working with models such as Twiggy, whom he posed rather awkwardly in his Pelham Place home in 1967 for British *Vogue*.[29] One image, though, from this session underlines Beaton's intuitive attitude to his models, setting Twiggy literally on a pedestal. On another occasion, for the June 1964 issue of *Vogue*, he had transformed Jean Shrimpton into a Beaton woman by coiffing her in an eighteenth-century–style wig. He was perhaps more in his element with Baroness Fiona Thyssen as a model, photographing the Paris

28. Quoted: Hugo Vickers, *Cecil Beaton*, p.570.
29. British *Vogue*, October 1967, pp. 112-17.

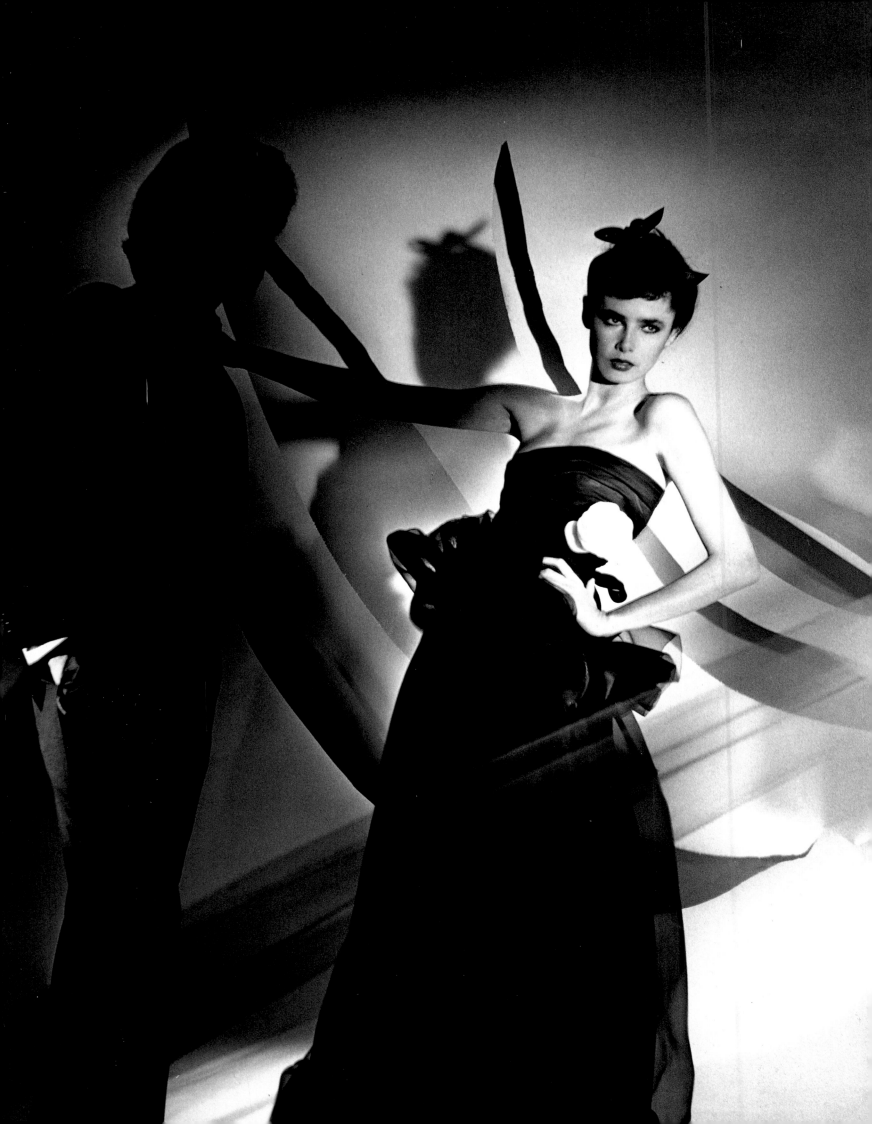

> '… forever improvising. It bored
> him to plan photographs and he was too confident
> of his ability to give them much thought.
> He was quite right, as something amusing always came
> out of his last-minute inspiration.'

Bettina Ballard, *In My Fashion*, p.46

Dayle Hadden,
for French
Vogue, March
1979

30. 'Beaton and
the Baroness',
*Weekend
Telegraph*, 2
September 1966,
pp.32-7, 39.
31. British
Vogue, December
1968, pp.90-97.
32. British
Vogue, 15 April
1973, pp.74-7.
33. French
Vogue, March
1979, pp.245-91.

couture autumn collections in 1966 for the
Weekend Telegraph.[30] Her aristocratic poise
and the splendid interiors in which she was
posed combined in Beaton's lens to produce
results worthy of him. A variety of stylish set-
tings, both traditional and avant-garde,
together with celebrity 'extras' provided the
context for some of his most interesting late
work – a series called 'The Great Indoors' for
British *Vogue* in 1968.[31]

His *Vogue* session with Tina Chow in
February 1973[32] was to be his last before his
incapacitating stroke. In 1979, however, he
was invited by French *Vogue* to photograph
the spring collections.[33] This was to be his
final fashion assignment, and it proved to be
a distinguished curtain call in his grand style
– celebrity models and haute couture exploit-
ed with flair and self-assurance in a series of
photographs which well demonstrate the
elements of Beaton's sensibilities as a
photographer of fashion.

VII / In Conclusion

Beaton's contribution to the history of fashion
photography, during a career which spanned
half a century, was a considerable one. His
was a unique talent. It has been said of
Beaton that he was not a photographer's
photographer, a suggestion which could be
explained by his professed technical ignor-
ance and seemingly dilettante approach to the
medium. He played the role of the gentleman
amateur but in fact 'was a remarkably hard-
working professional, sharply attentive to
the small detail of every image his camera
produced.'[34] It was integral to his working
methods, however, to be, in the words of
Bettina Ballard, 'forever improvising. It
bored him to plan photographs and he was
too confident of his ability to give them much
thought. He was quite right, as something
amusing always came out of his last-minute
inspiration.'[35]

Irving Penn acknowledged Beaton's

34. Gail Buck-
land, *Cecil
Beaton War
Photographs,
1939-45*, 1981,
p.7.
35. Bettina
Ballard, *In My
Fashion*, 1960,
p.46.

skill in creating with such apparent facility the image of beauty which he pursued. 'He could take a store girl from Texas or New York and transform her. Photography is projection. He projected them. Sometimes Cecil would come into the studio, give the impression that he'd had too much wine at lunch. He'd seem not to have thought about it all very much. He'd tear a bit of paper on one side, he'd talk to the model. He'd go behind the camera. Out would come the Cecil Beaton woman.'[36]

Beaton's fecundity was confirmed by Dr Agha, who, despite their numerous battles over the years, graciously conceded in a letter to him that 'practically all of the devices, trends and techniques that make today's photography (or at least fashion photography) what it is were originated or used by you.'[37]

Successful fashion images depend on a sure instinct to create a sense of mood, beauty and sometimes place which, at its best, defies analysis. Beaton defined fashion photography as 'an insidious profession. In art, it is what sex-appeal is to love. Artifice can be a dangerous thing: when misapplied the results are vulgar and tawdry. Its correct use depends on instinct. It is up to the fashion photographer to create an illusion. In doing so, he is not behaving with dishonesty, but when properly invoked, the result is not merely an illusion; rather, it makes the observer see what he should see.'[38] 'The fashion photographer's job', he wrote on another occasion, 'is to stage an apotheosis.'[39]

Truman Capote considered Beaton 'a recorder of fantasy'. He added that 'through the years [Beaton had] documented and illuminated the exact attitude of the moment.'[40] The juxtaposition of notions of fantasy and documentation is in some ways paradoxical, yet in Beaton's work invention and reality are indeed brought together. The world of high fashion which Beaton presents was for him a very real world. It was the world in which he chose to live, and to which his many-faceted professional activities were the ideal passport.

Beaton was an impresario who used fashion to colour the scenario of the play that he made of his life, and in which he himself starred as production photographer and principal player. He had written in 1929, 'I would like to live in scenery.'[41] In 1968 his feature series 'The Great Indoors' was introduced with the words 'Consider a house to be a theatre, every room a stage and every girl a player.'[42] Beaton's friend Stephen Tennant commented aptly, 'In Cecil Beaton's art it is always the birthday morning – the eve of the Ball, the rise of the curtain.'[43]

Large Trimmed Hat, fashion study, 1936

36. Hugo Vickers, *Cecil Beaton*, pp.347-48.
37. Cecil Beaton, *Photobiography*, p.163.
38. Cecil Beaton and Gail Buckland, *The Magic Image*, p.280.
39. Cecil Beaton, *op. cit.* p.74.

40. *Ibid.*, p.164.
41. Beaton's diary, 20 December 1929, quoted: Hugo Vickers, *Cecil Beaton*, p.251.
42. British *Vogue*, December 1968, p.91.
43. *Horizon*, September 1941, vol. IV, no. 21, pp.213-14.

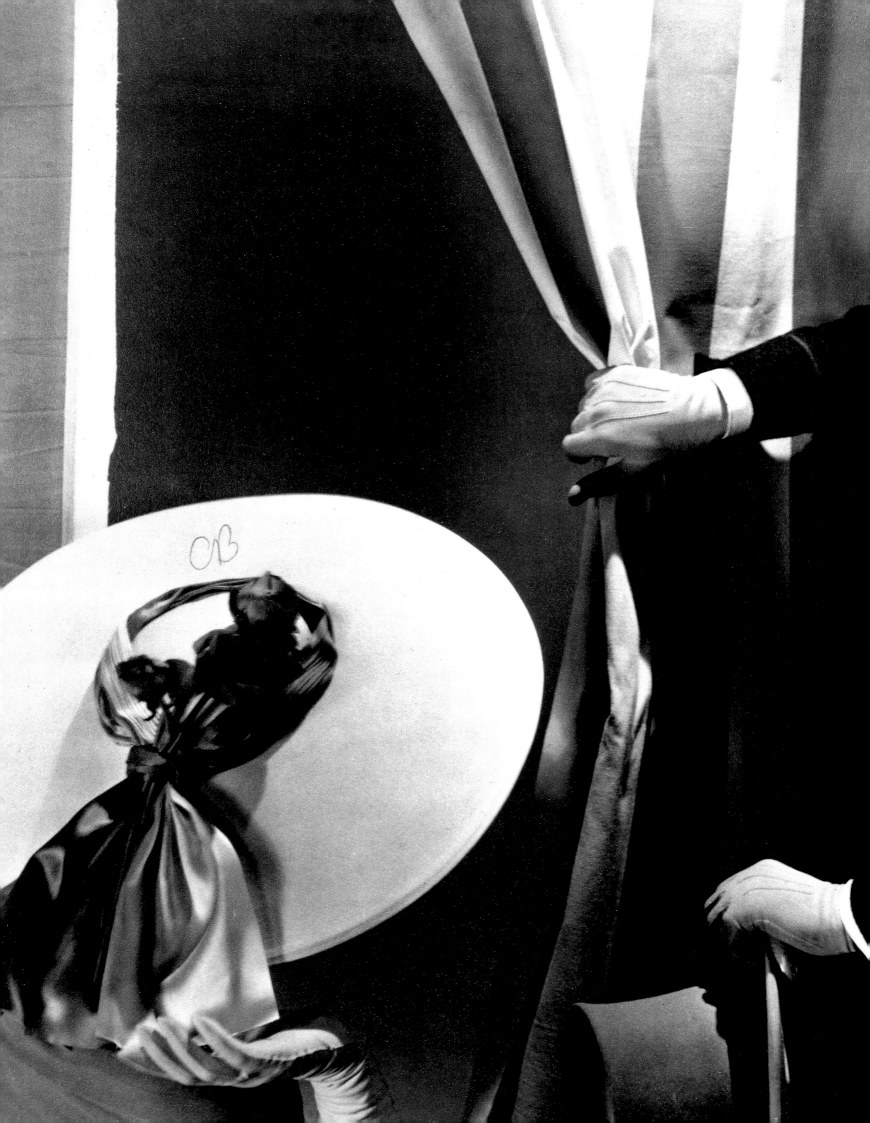

'Though I saw
few "actresses"...
in the flesh, their
photographs were
for me an
absorbing interest
and an almost
entirely satisfactory
substitute ...'

'The Story of an Exception', *Photography as a Career*, pp.28-32

'But how could I, with my Kodak and crude lighting equipment, ever hope to tread this dazzling but difficult path.'

Photobiography, p.26

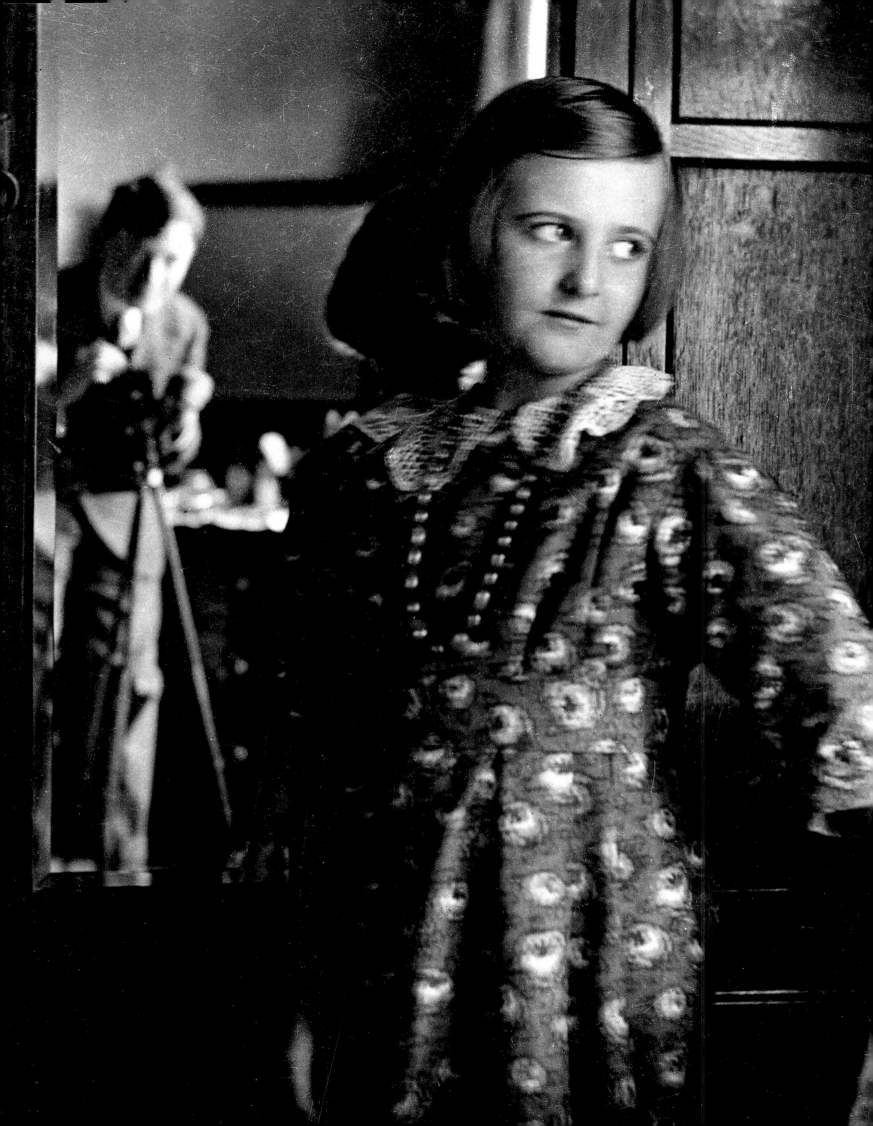

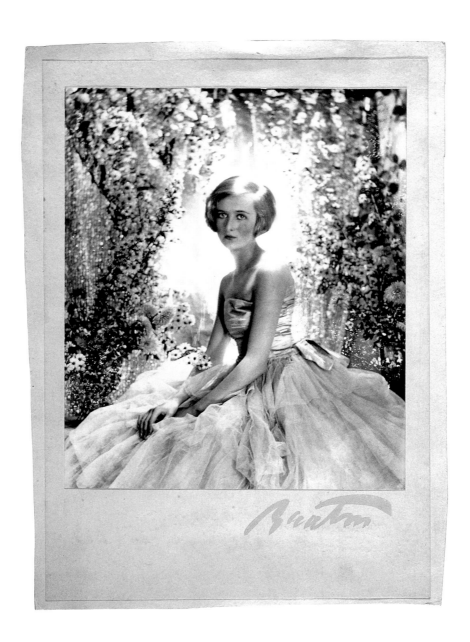

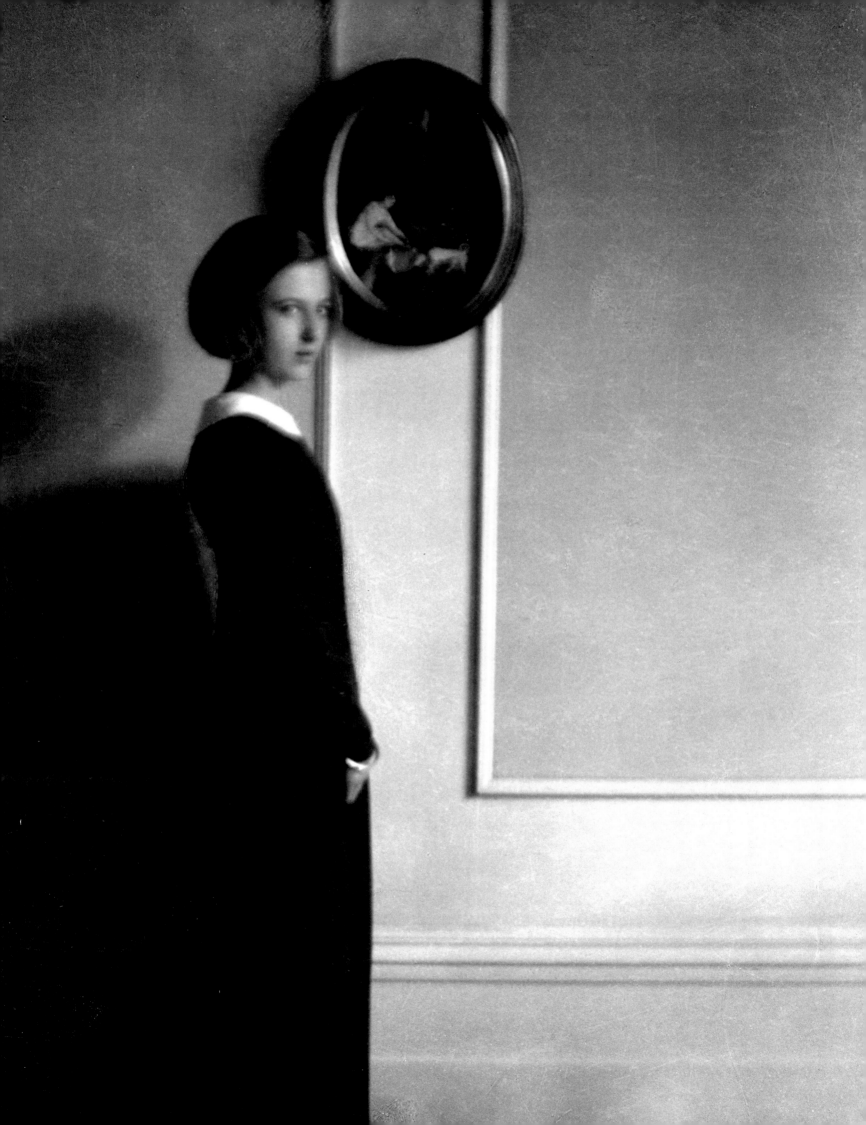

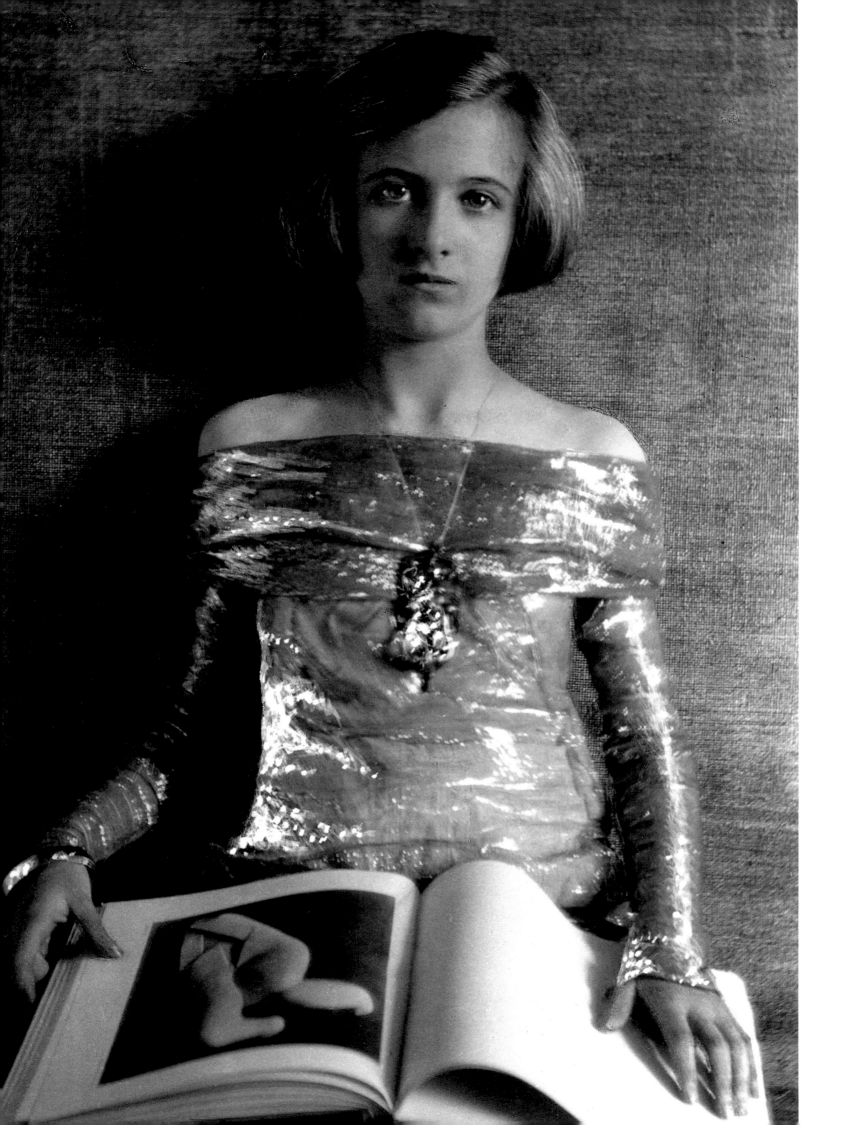

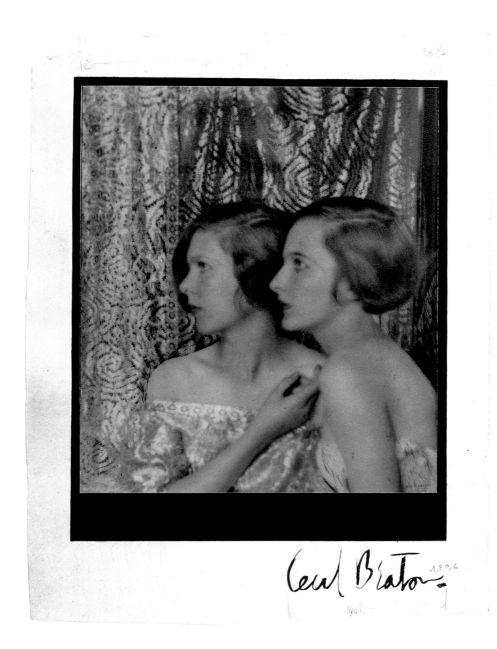

**Nancy Beaton
as a Shooting
Star for the
Galaxy Ball,**
1929

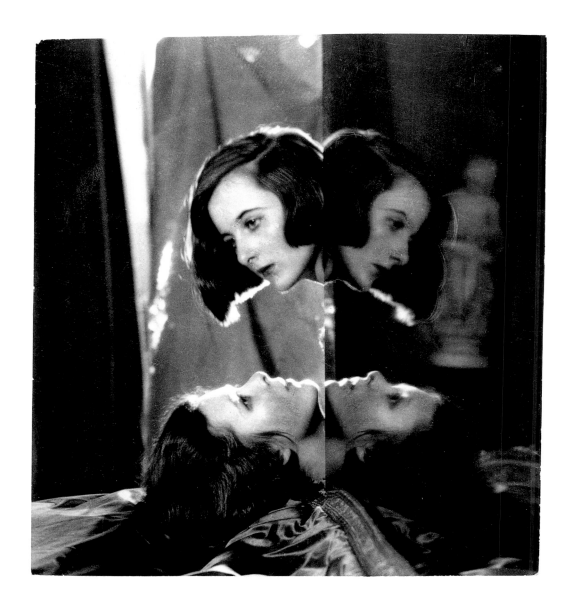

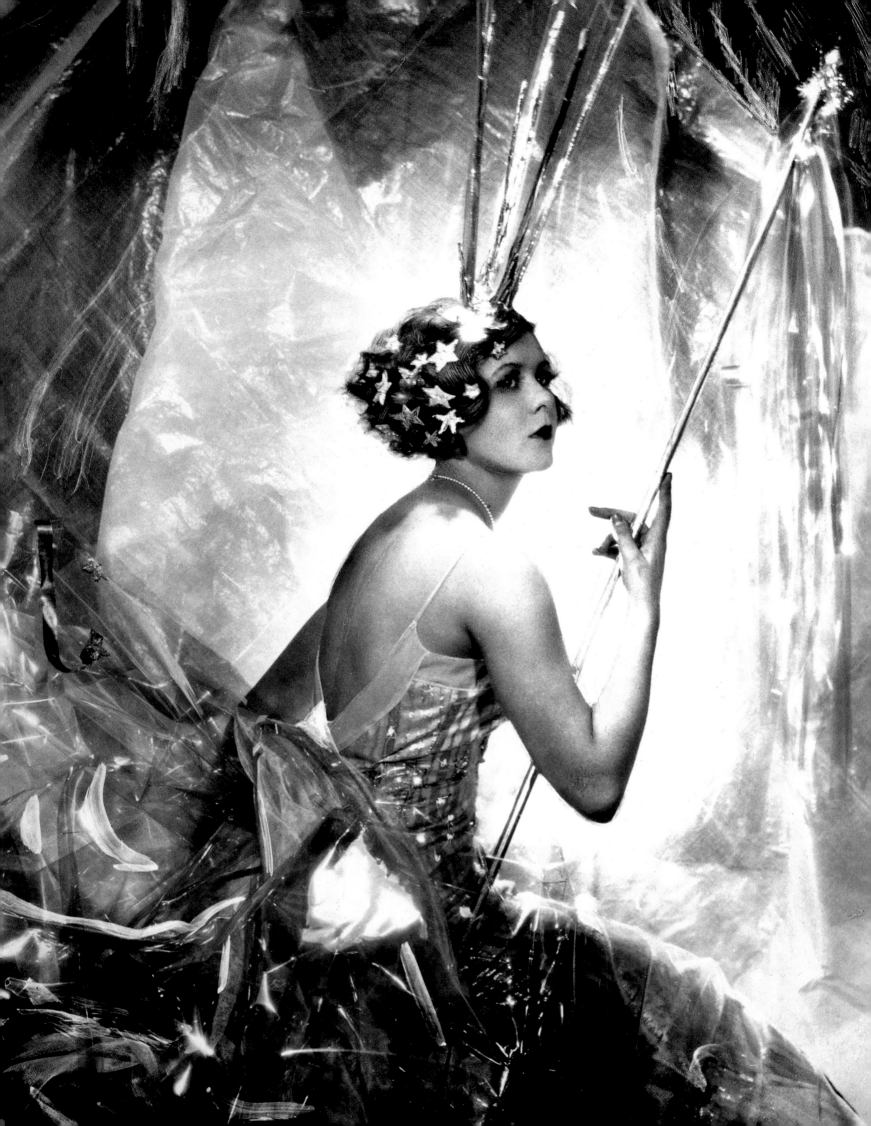

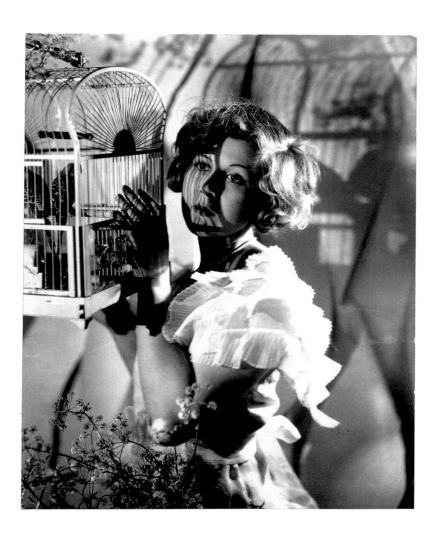

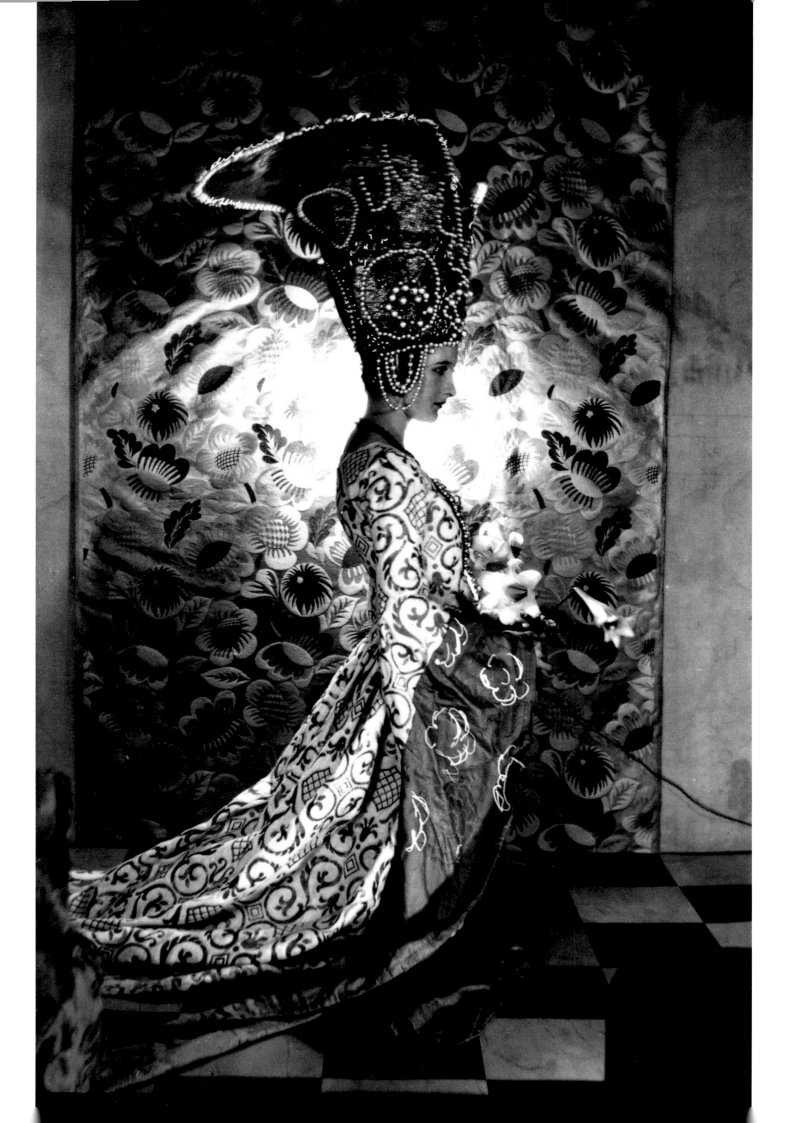

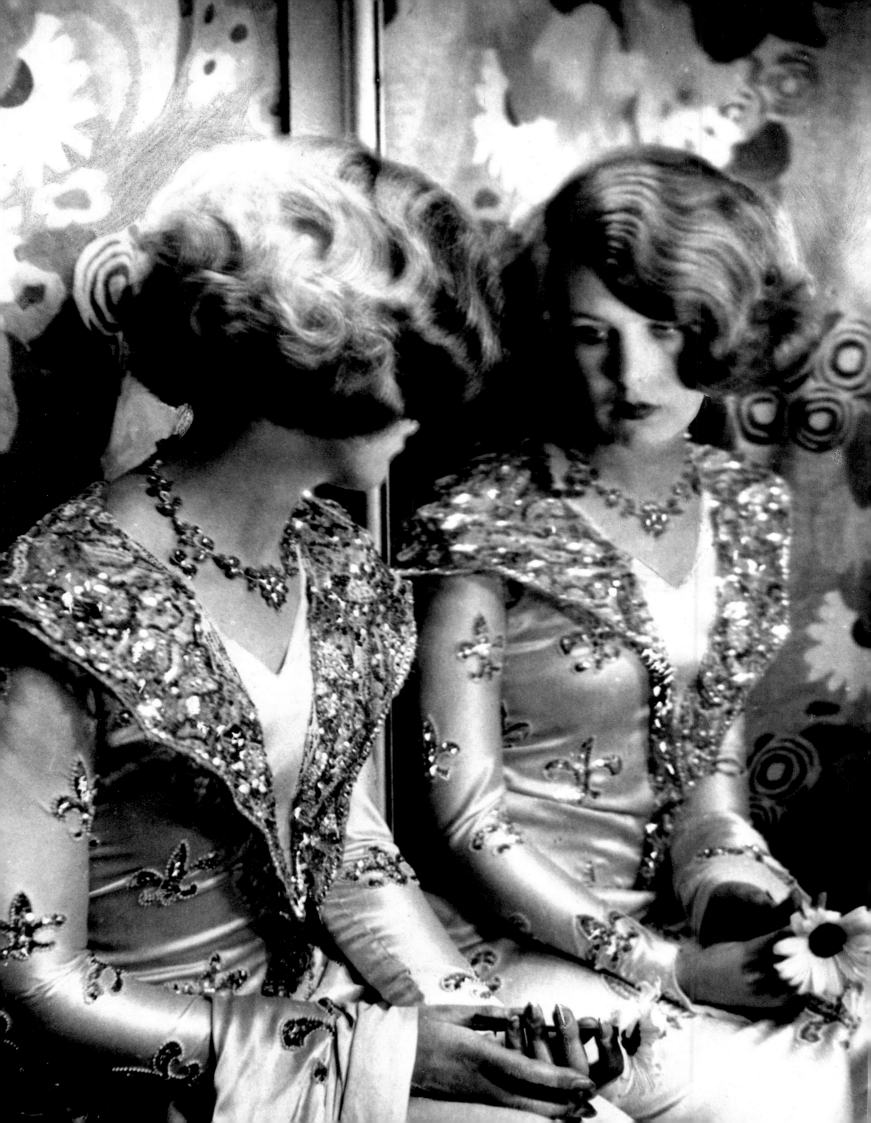

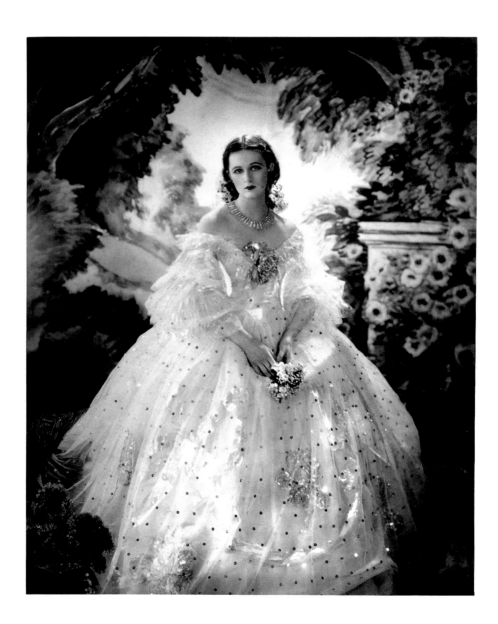

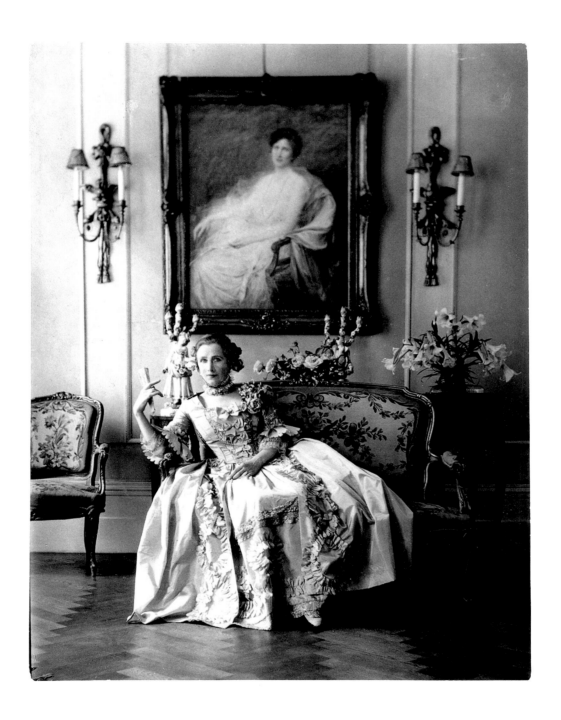

Cecil Beaton

'… I must photograph my subjects with such a welter of radiance enveloping them … their faces seen in … becoming reflections.'

Photobiography, p.27

'When in 1922
I arrived
at Cambridge
I set about
becoming
a rabid
aesthete …'

Photobiography, p.33

Boy Le Bas, Cambridge,
1924, illustrated in
Photograms of the Year,
1925, pl. 39 with the
title 'Mrs Vulpy'

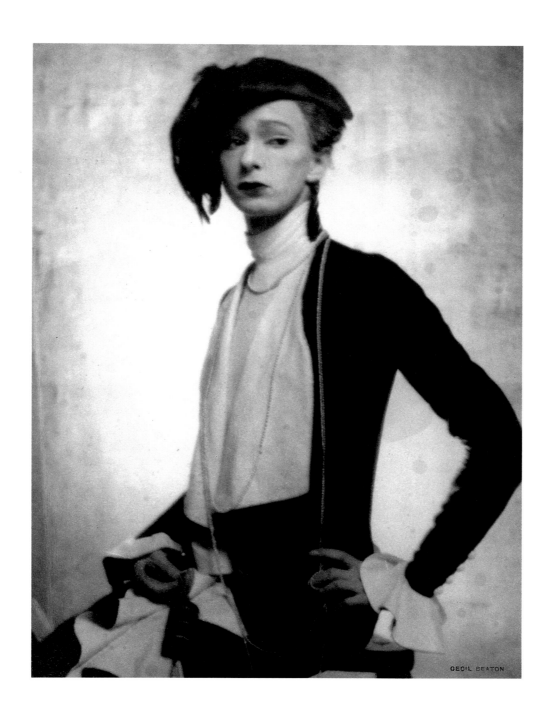

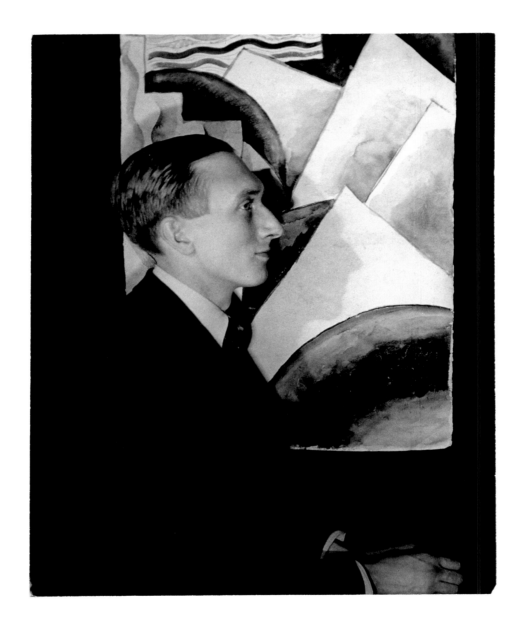

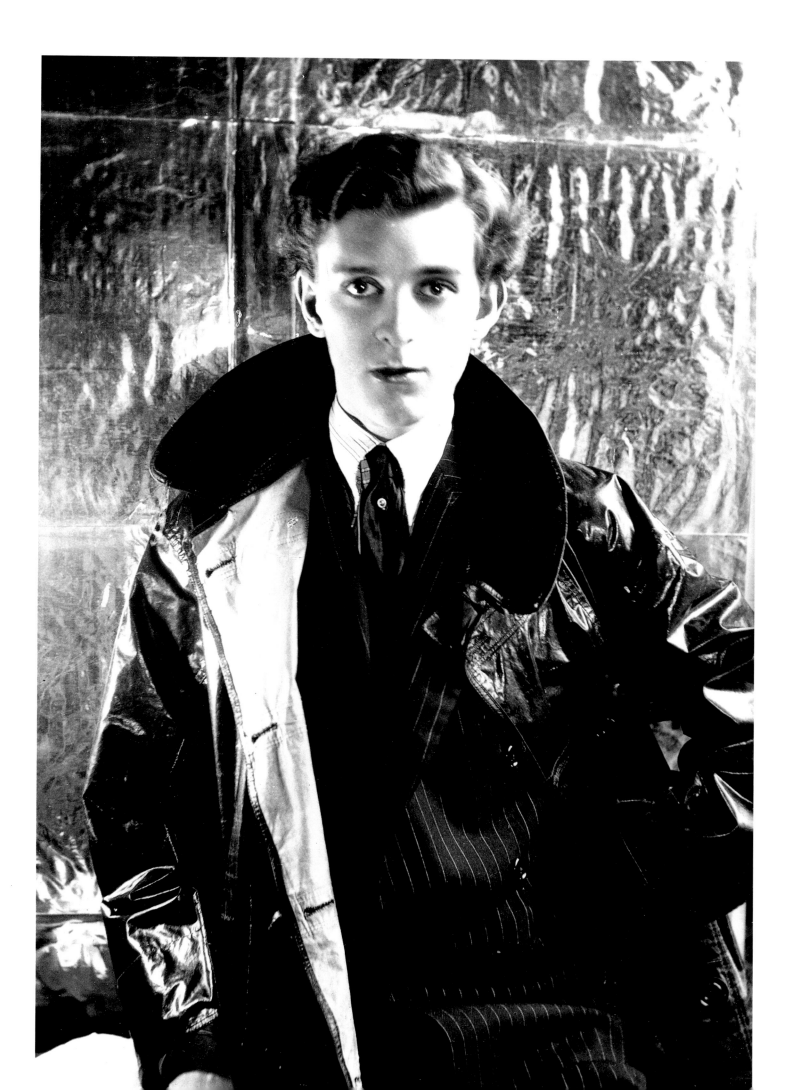

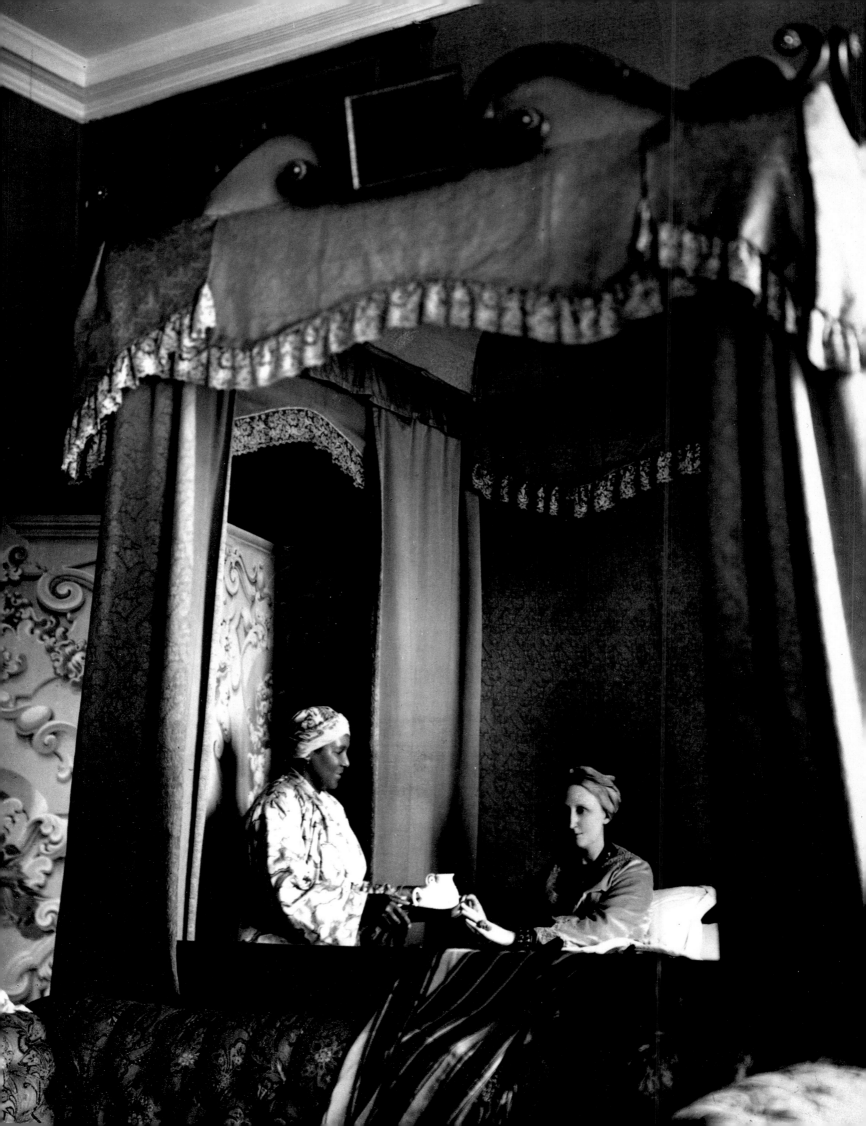

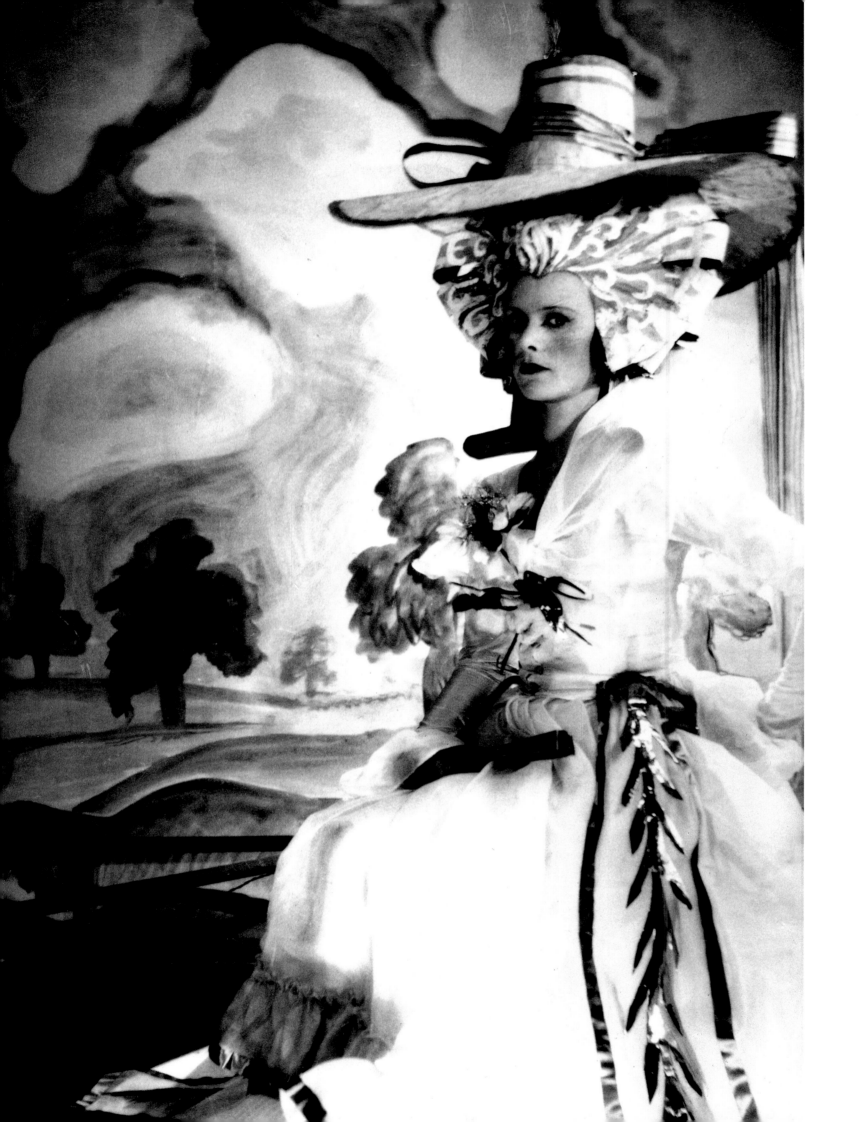

**Mrs Ronald
Armstrong-Jones
as Perdita
Robinson in the
Pageant of Hyde
Park,** 1928

Edith Sitwell,
1926

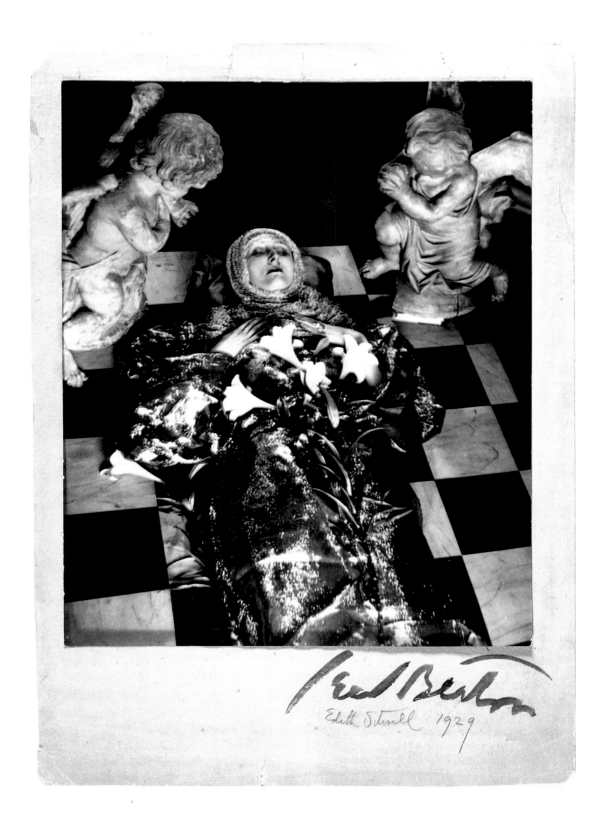

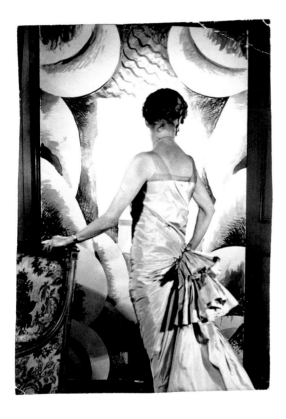

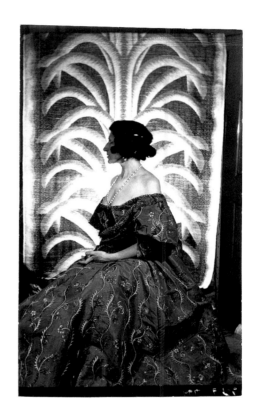

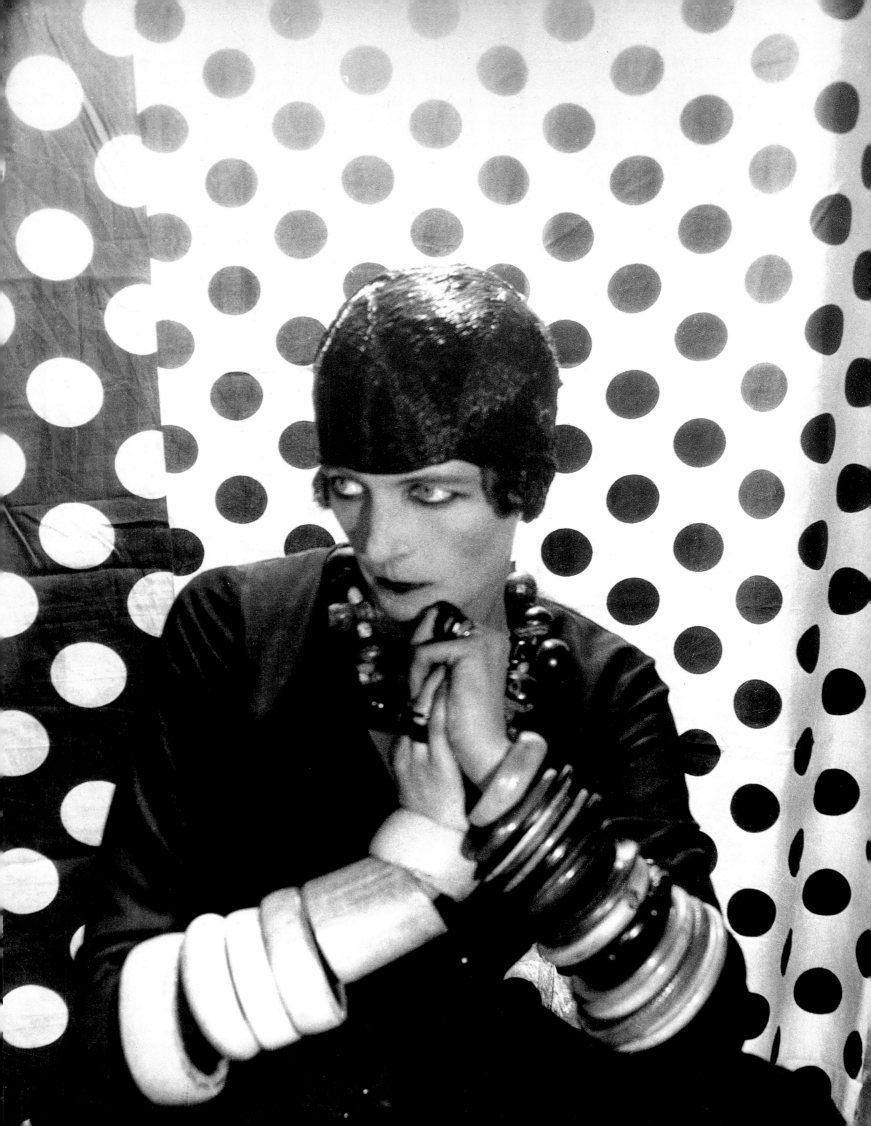

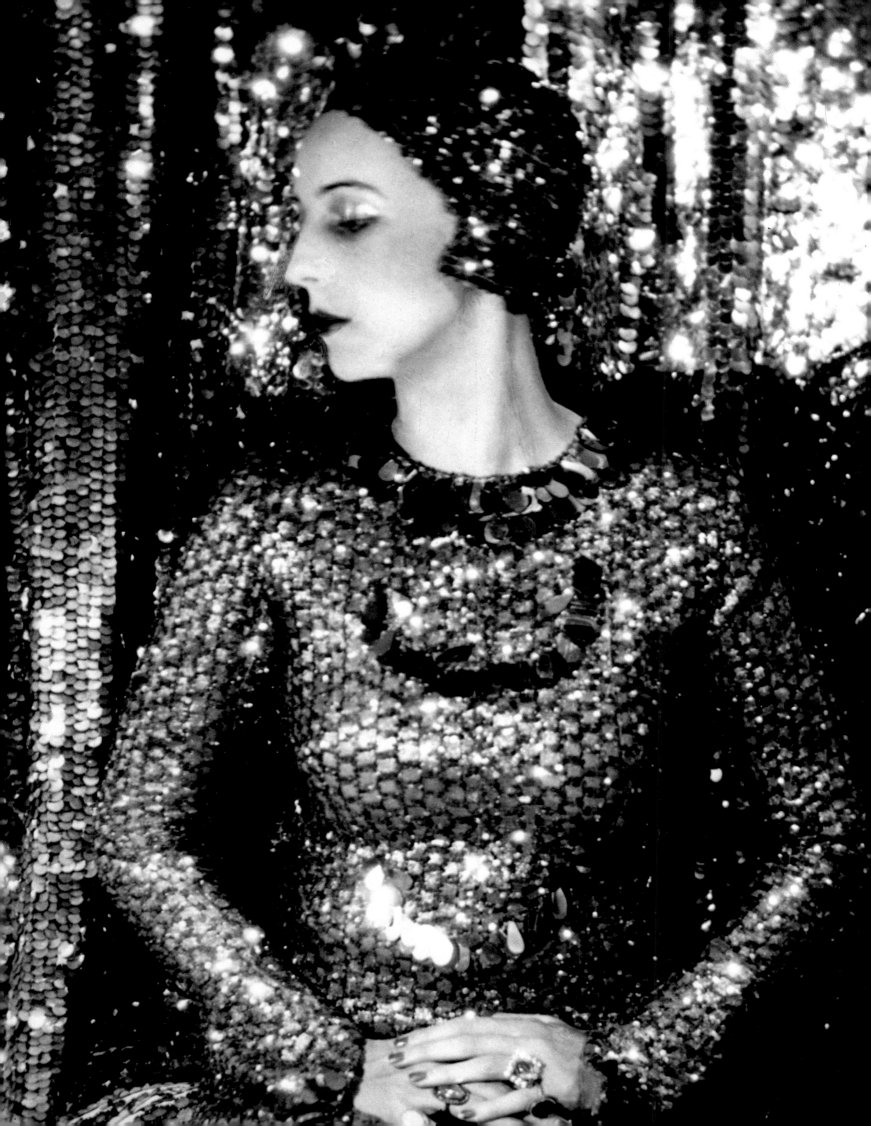

Countess
Castega,
c.1927

Following
pages: **Rex
Whistler,**
c. 1930

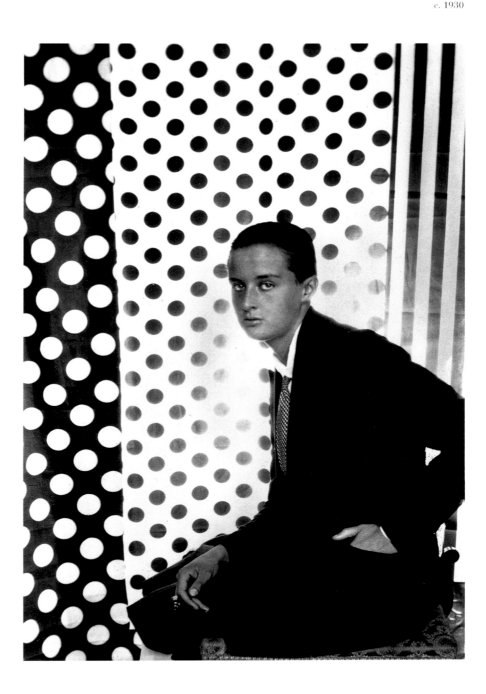

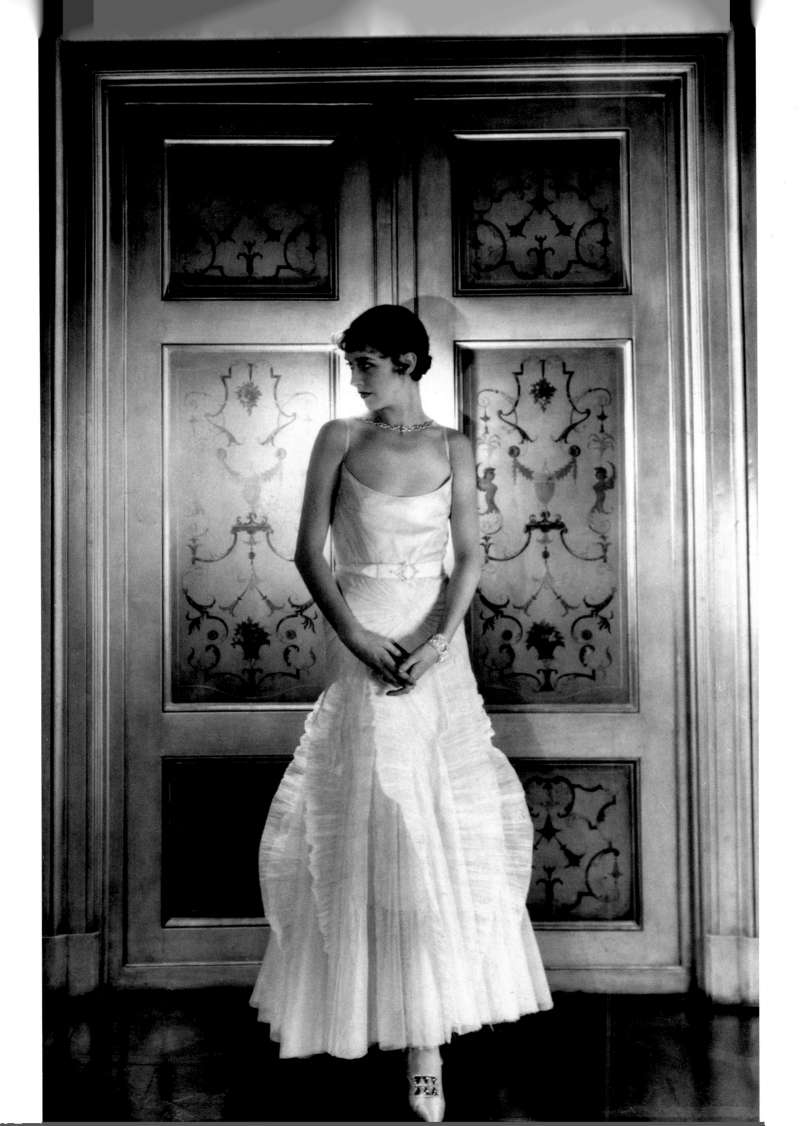

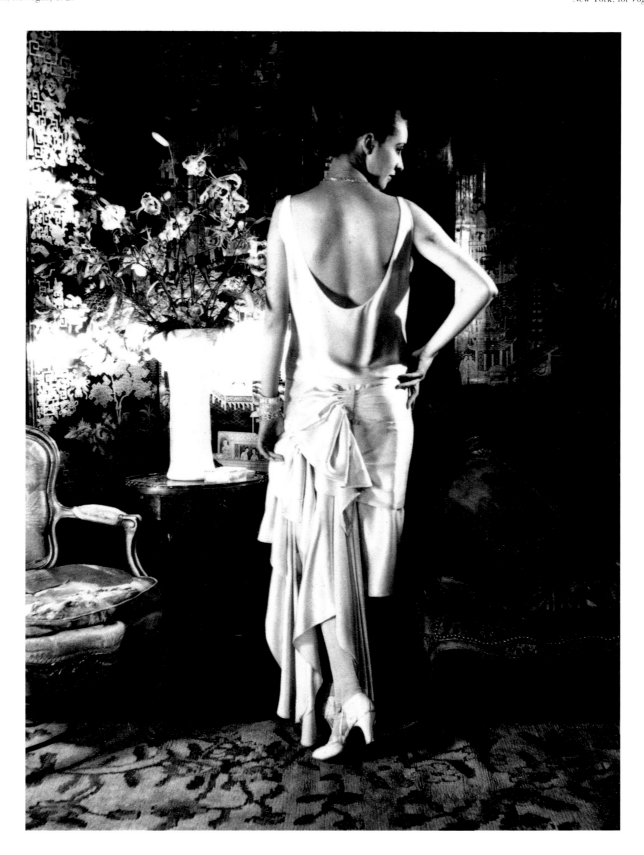

Cecil Beaton

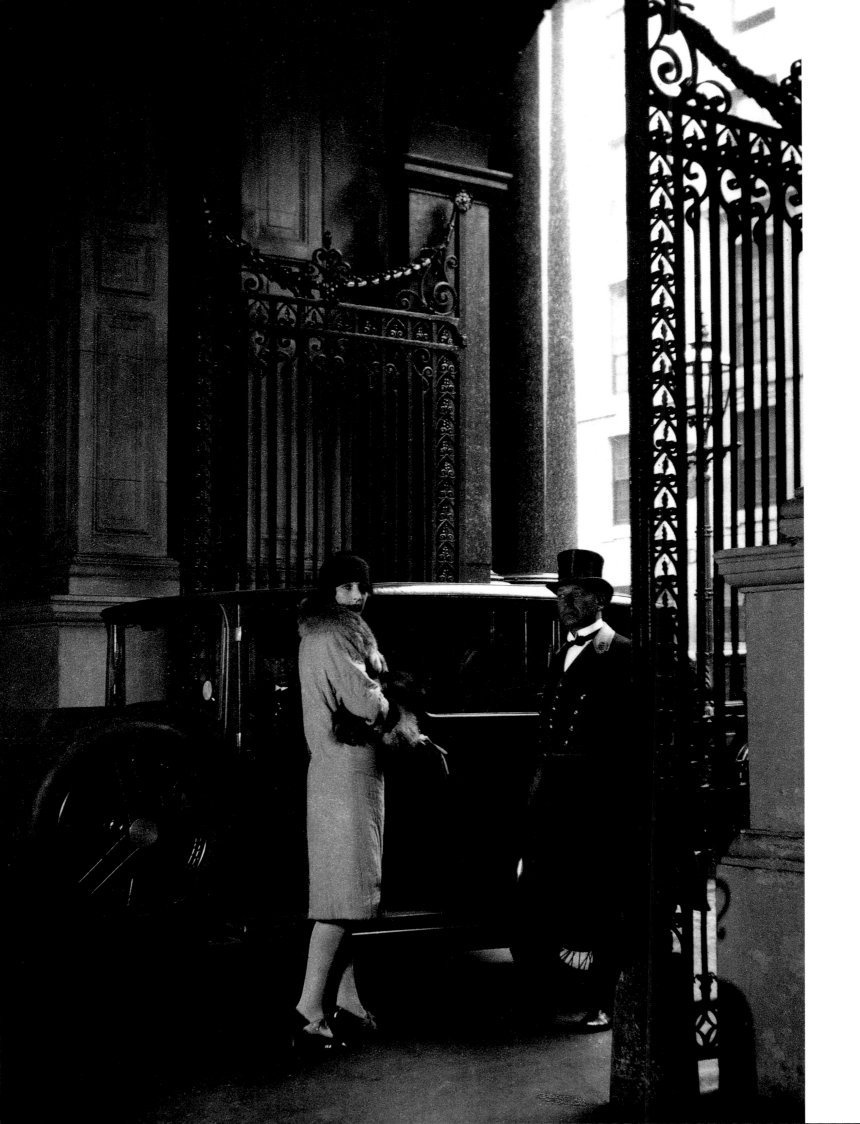

'Suddenly I found myself busy taking all sorts of exciting photographs … New and wonderful friends seemed to appear from nowhere.'

Photobiography, p.43

'… in America, I live at a much higher speed than I've ever known before.'

Diary entry for 5 April 1928. *The Wandering Years: Diaries 1922-1939*, p.185.

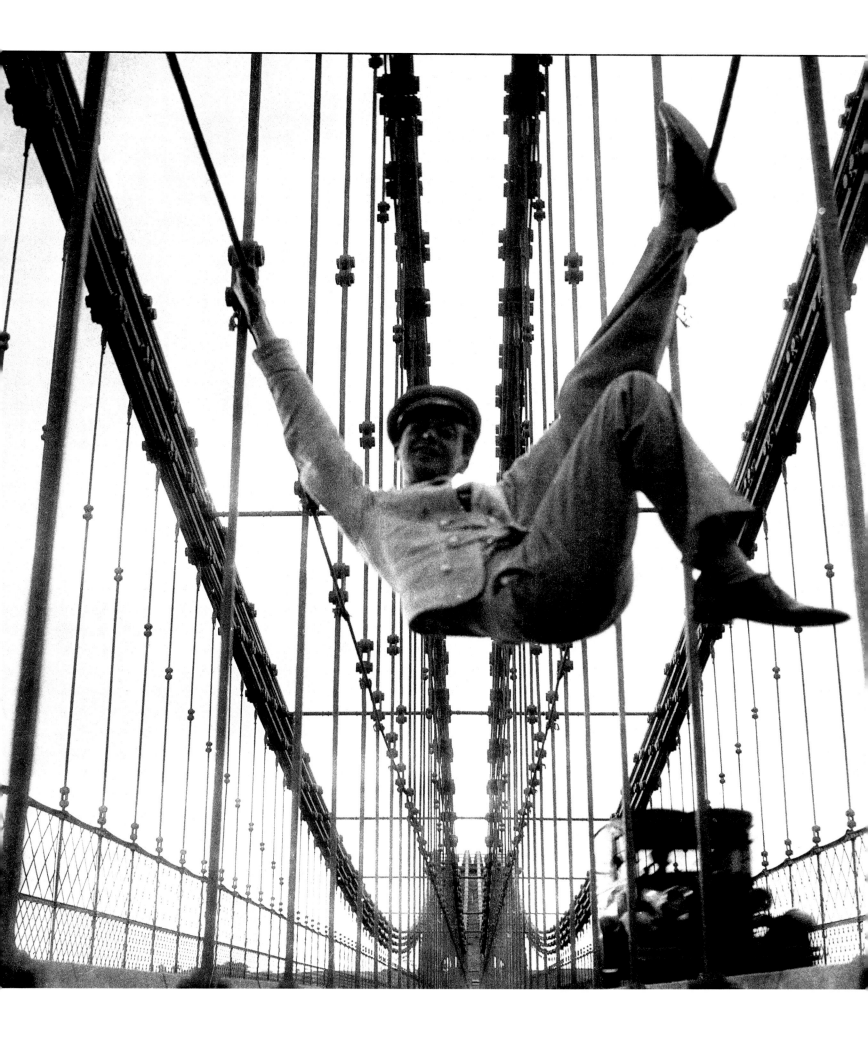

Cecil Beaton

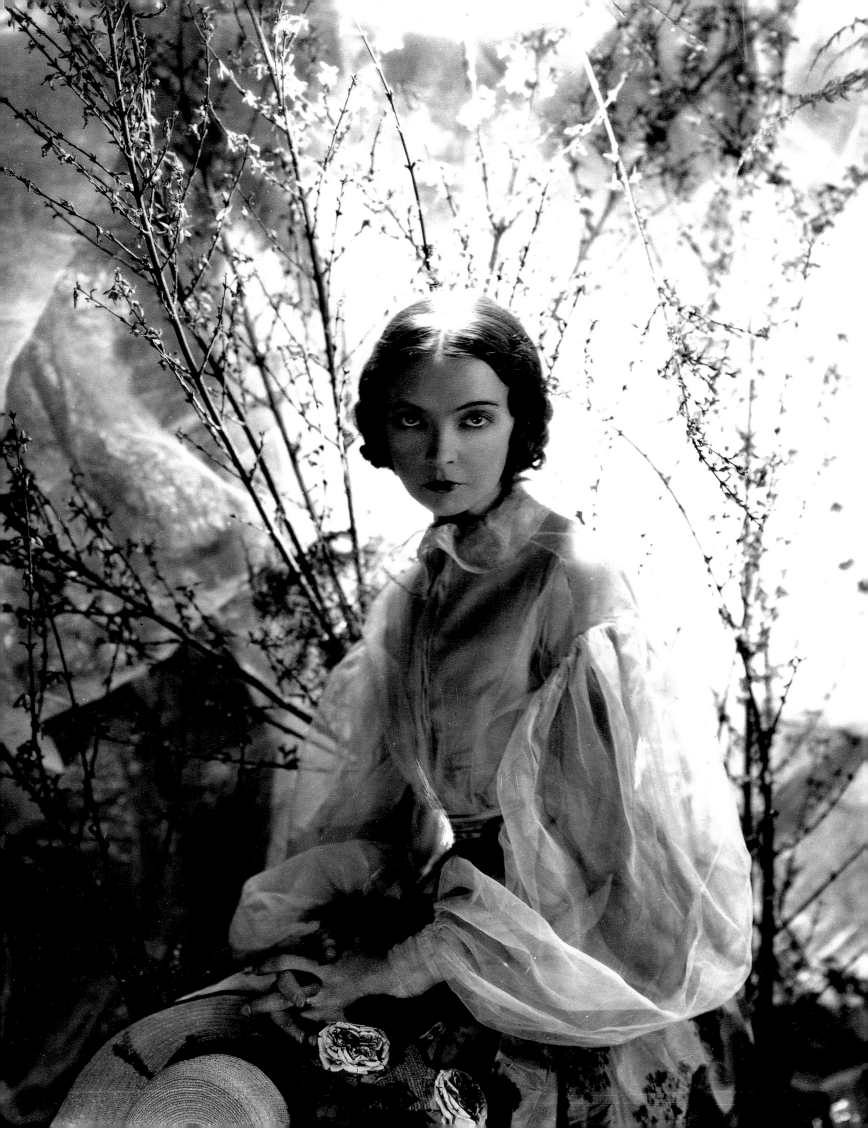

Previous pages:
Johnny Weissmuller,
Hollywood, 1932

Below left:
Buster Keaton,
1929

Below right:
John Wayne,
1930s

Opposite:
Gary Cooper,
early 1930s

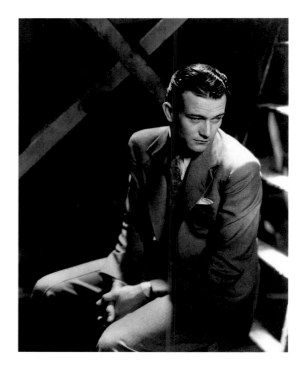

Cecil Beaton

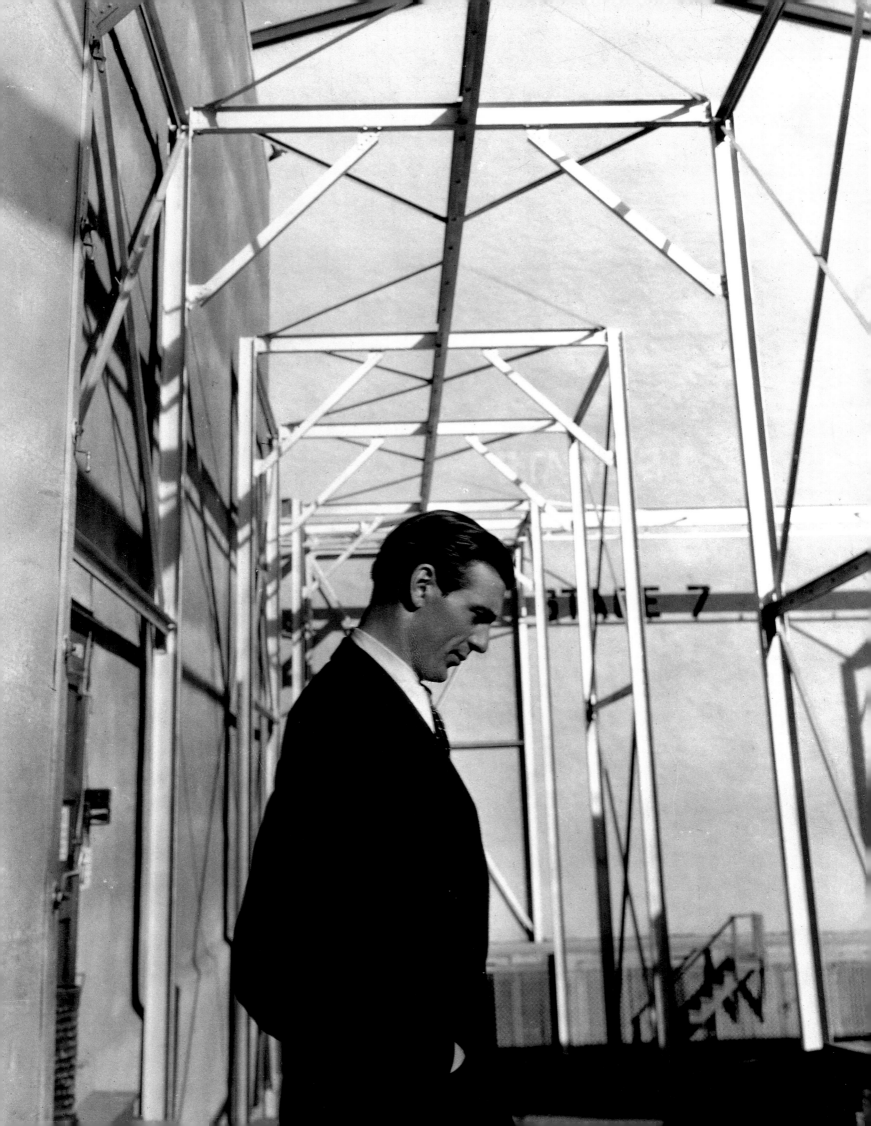

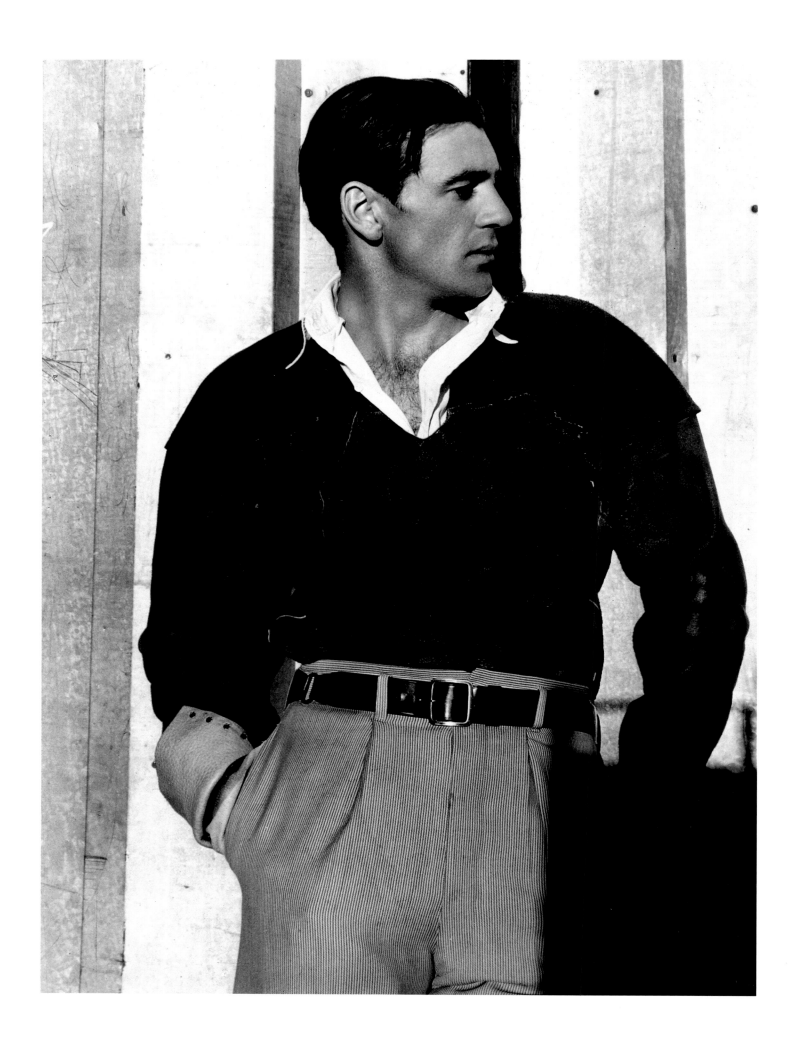

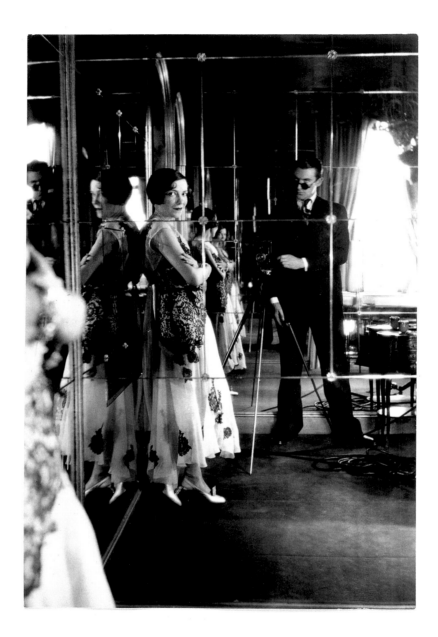

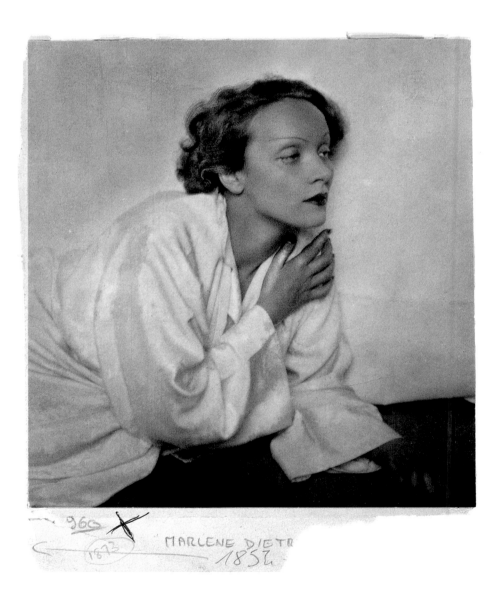

Cecil Beaton

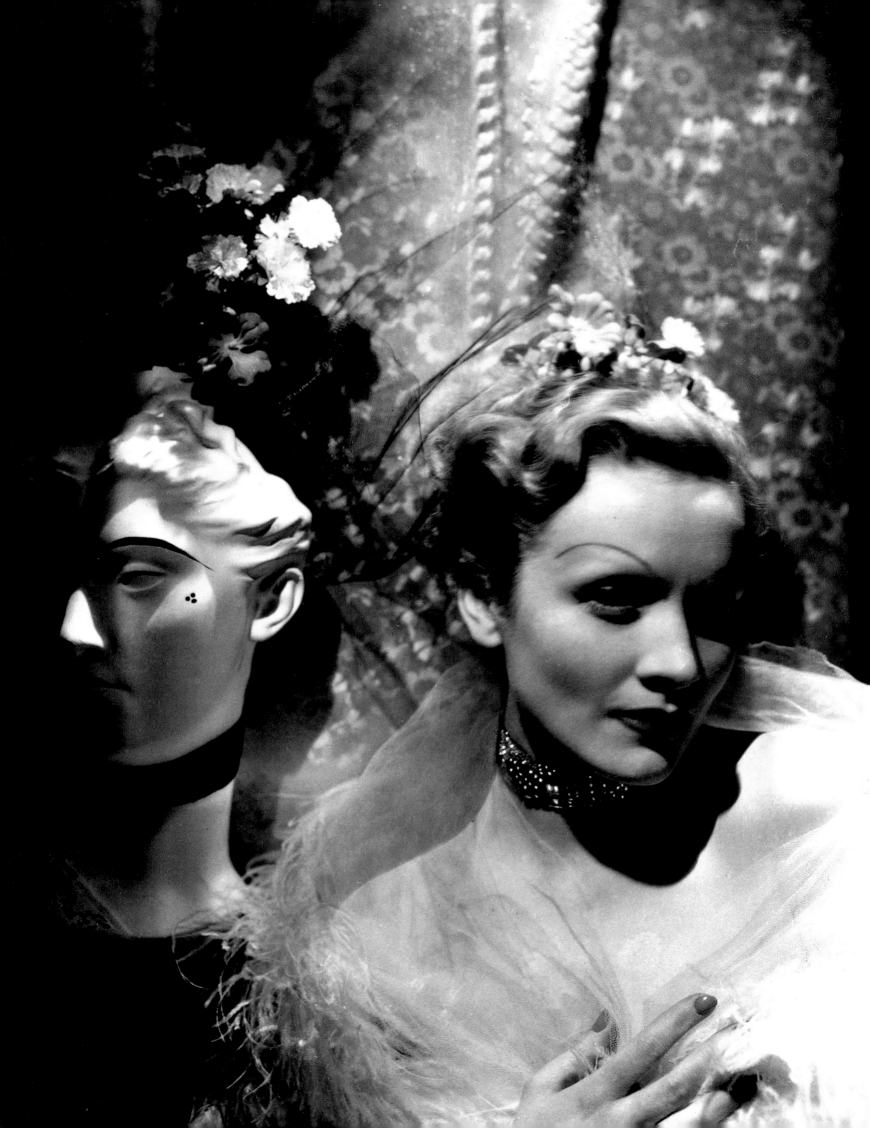

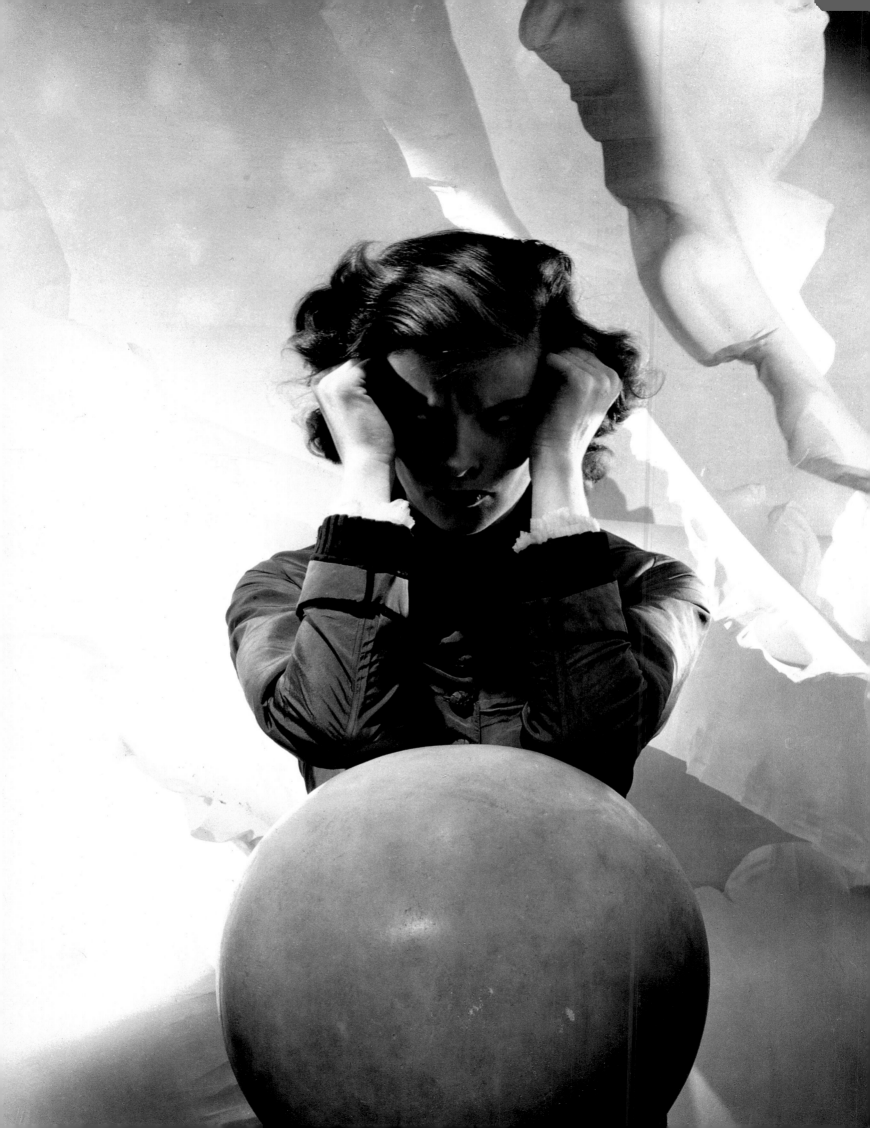

'Apollos and Venuses are everywhere. It is as if the whole race of gods had come to California.'

Diary entry for December 1930, *The Wandering Years: Diaries 1922-1939*, p.189

'It is interesting when an artist has sufficient strength of personality to be outré, yet be accepted by the most conservative elements of society.'

Diary entry, Spring 1936, *The Wandering Years: Diaries 1922-1939*, p.181

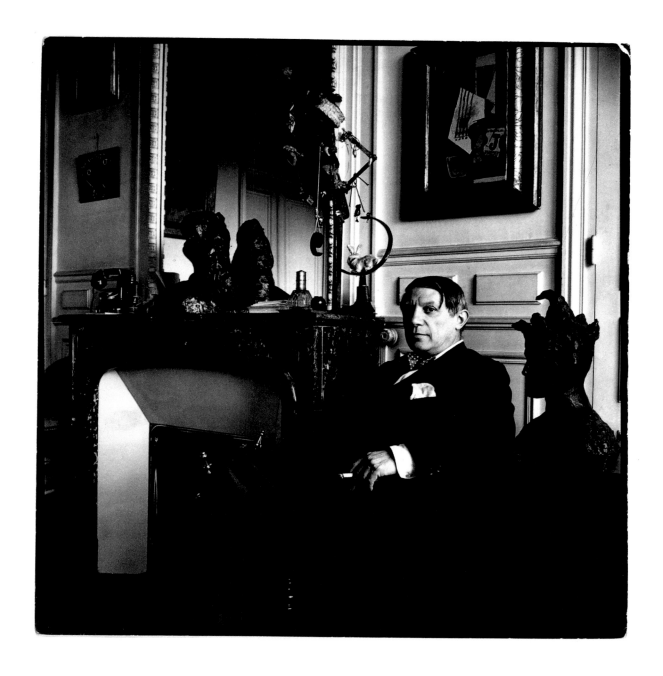

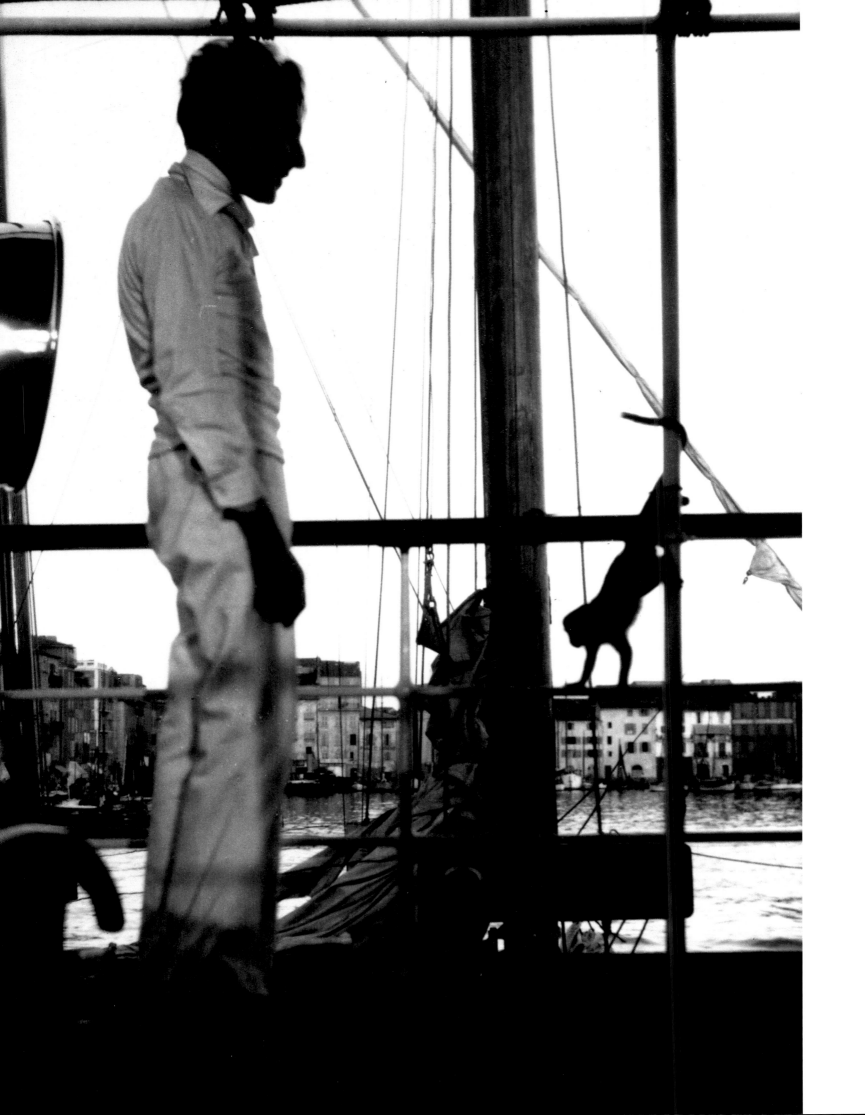

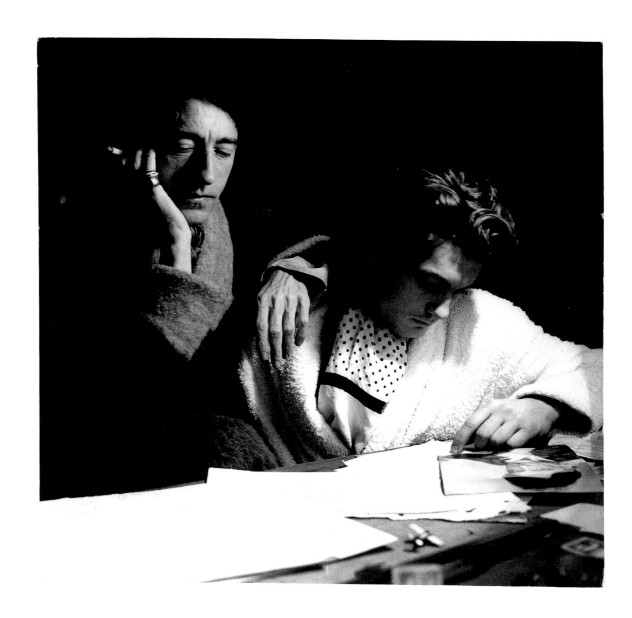

137

Cecil Beaton

138

Cecil Beaton

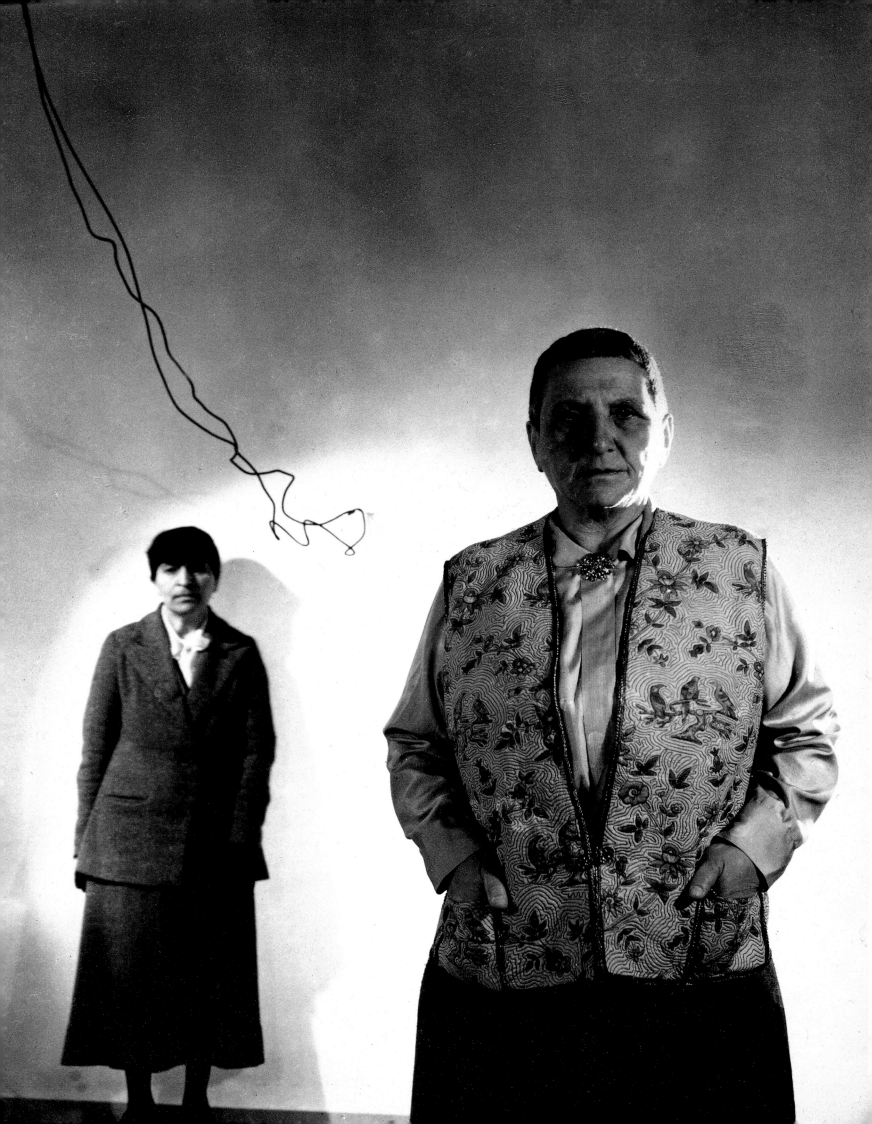

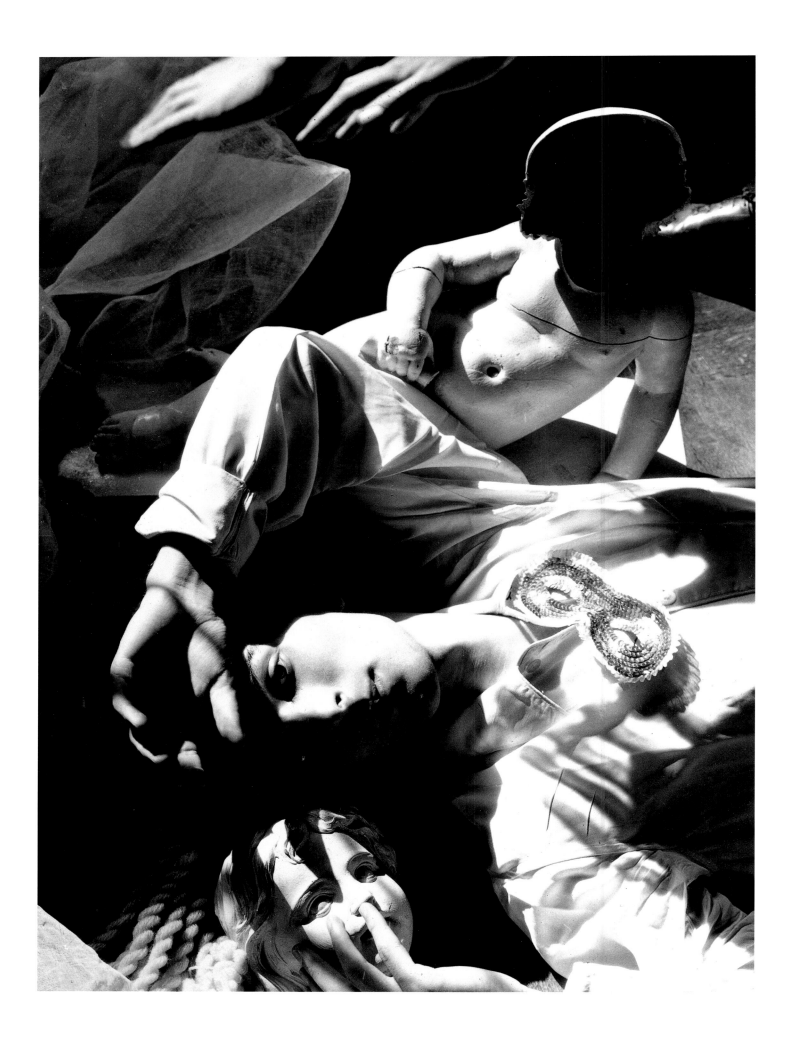

**Beaton with
Serge Lifar and
friends,** Venice,
1933

Mrs Reginald
Fellowes on her
yacht, the *Sister
Anne*, 1930s

Cecil Beaton

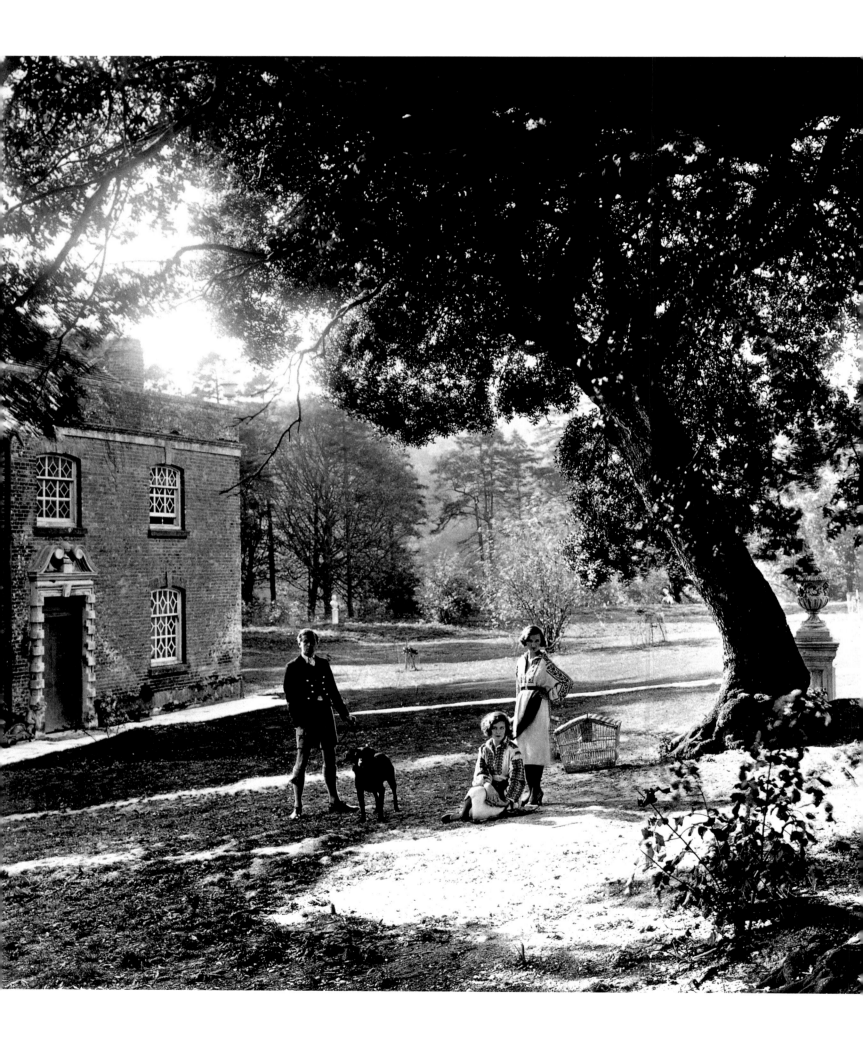

Tilly Losch,
Ashcombe.
1930s

146

Cecil Beaton

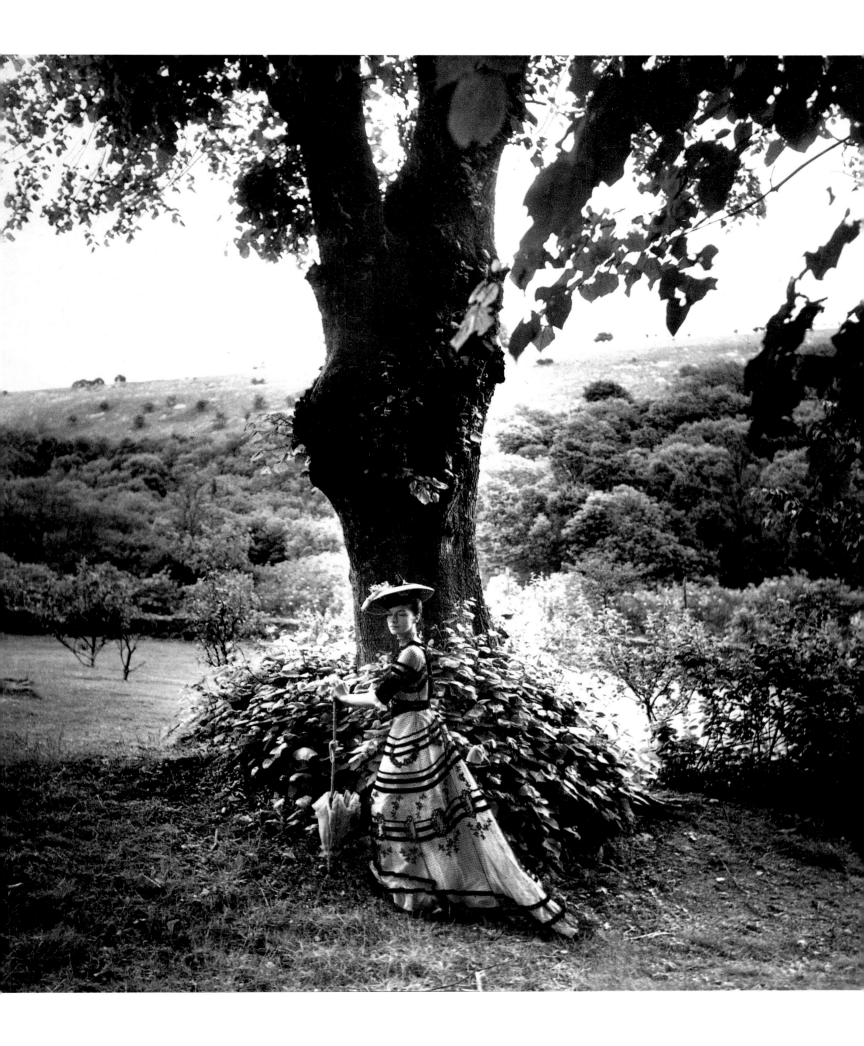

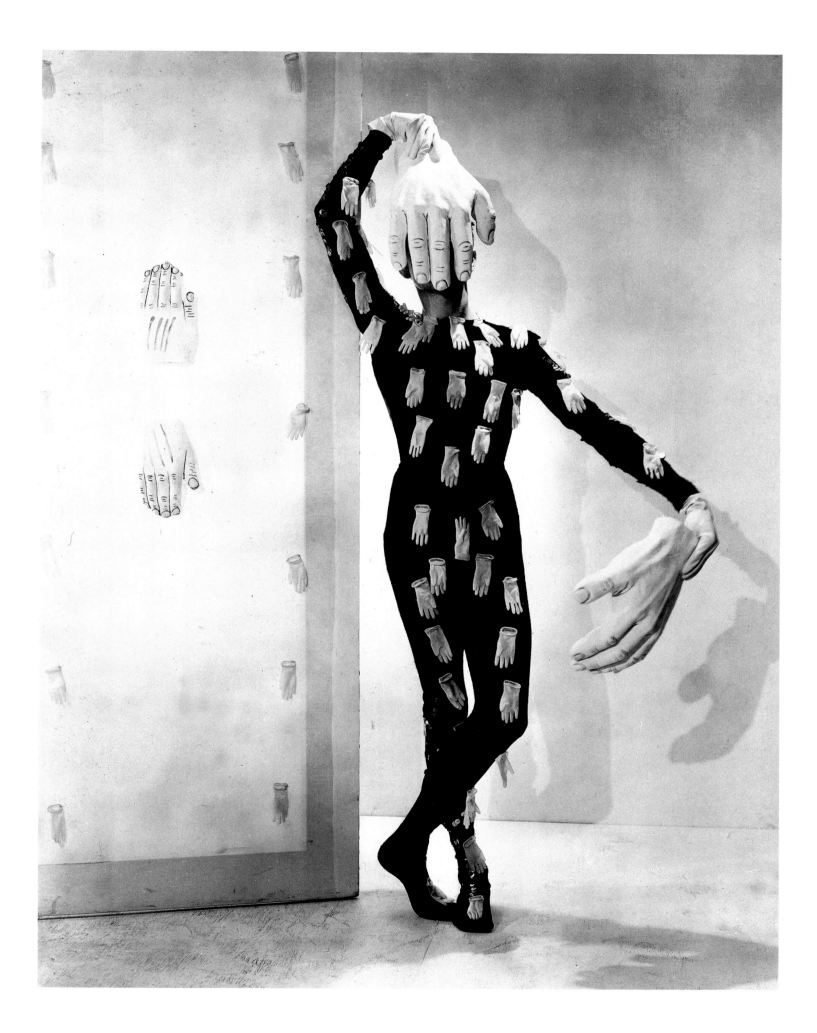

Cecil Beaton

Cecil Beaton

Cecil Beaton

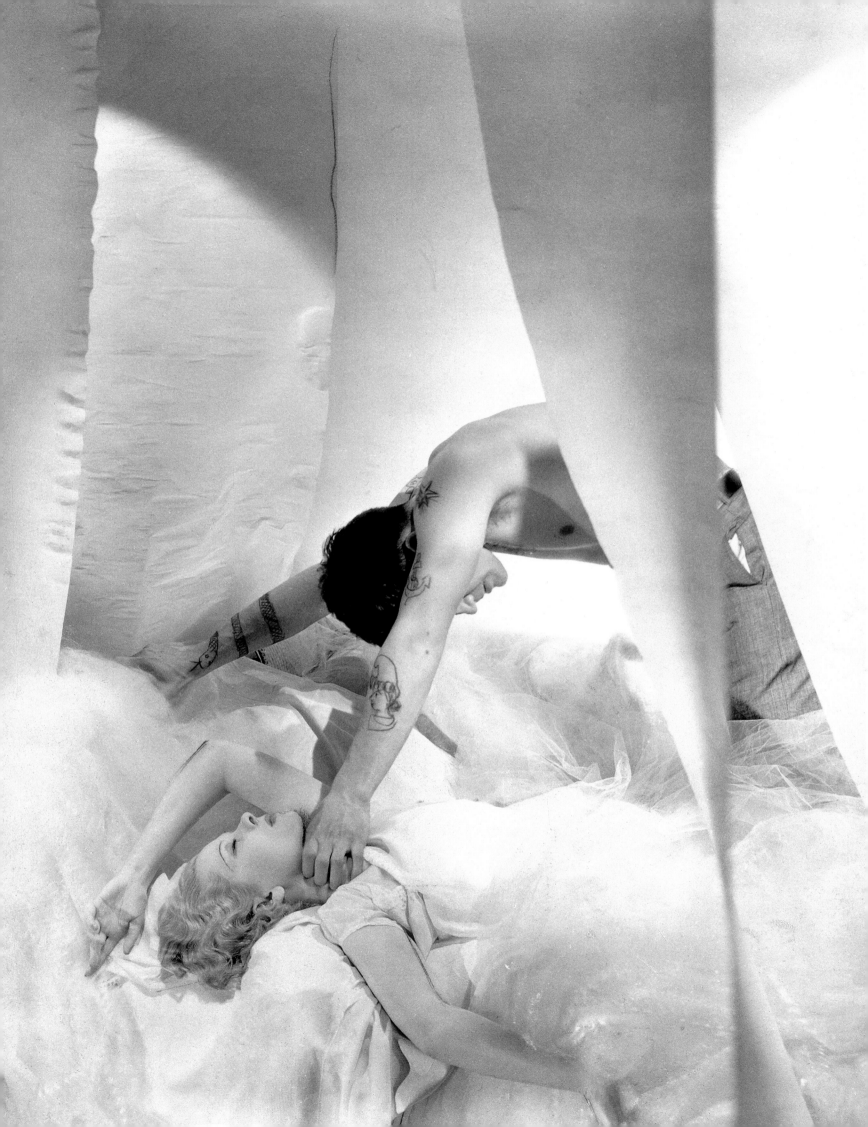

Cecil Beaton

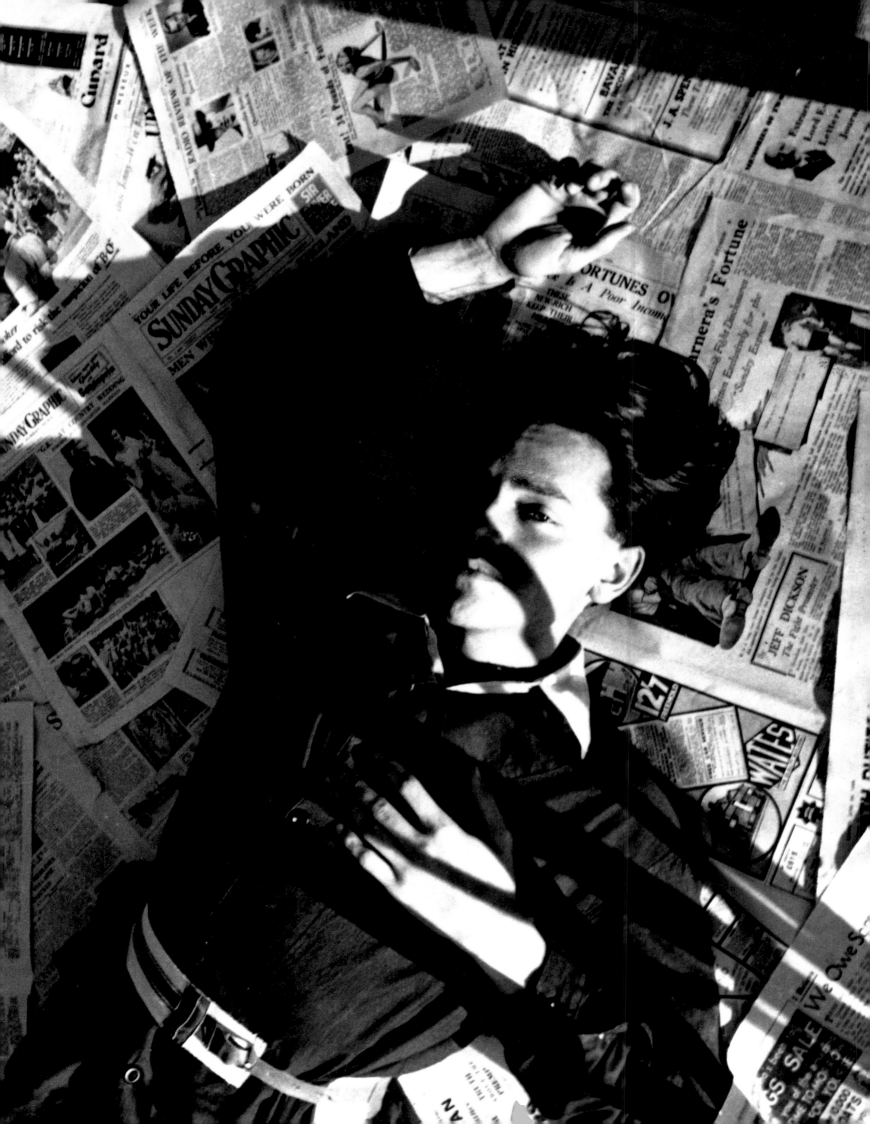

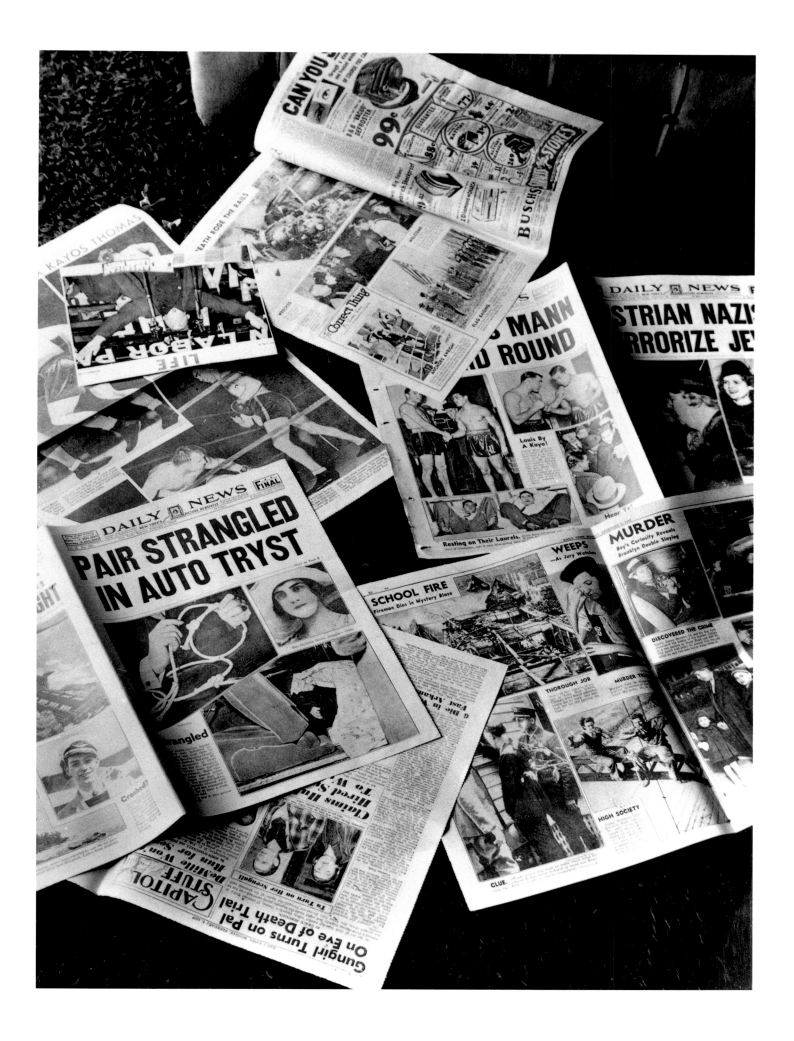

Cecil Beaton

634

Tea-party with ladies
with Pepet

CECIL BEATON
PLIC

NOT
C-3

**The Countess of
Jersey and child,
the Ladies
Caroline and
Elizabeth Paget
in Robert Adam's
Colonnade,**
Osterley, 1935

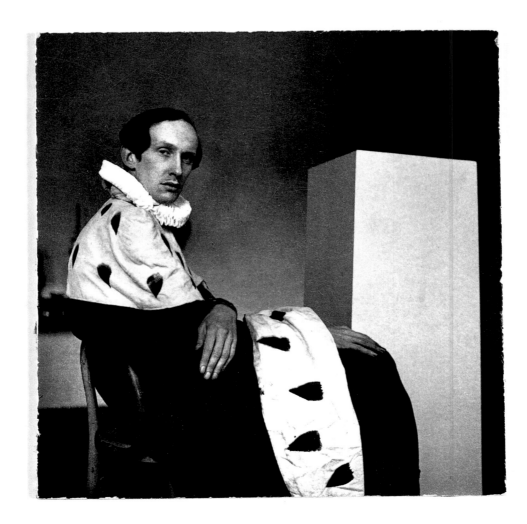

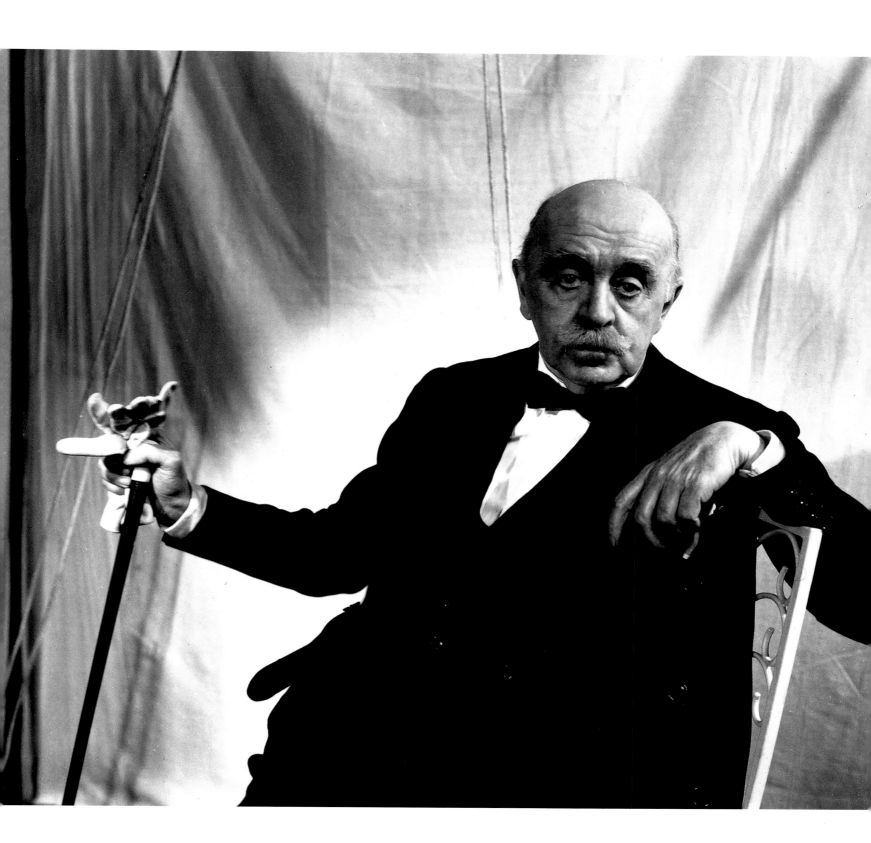

Cecil Beaton

Cecil Beaton

'… I have succeeded in spending my life in an unreality made up of fun …'

Diary entry, February 1935, quoted by Hugo Vickers, *Cecil Beaton*, p.181

'In my photographs … the models had given up pretence. They were young and fresh, and, to my mind, infinitely more alluring …'

Photobiography, p.72

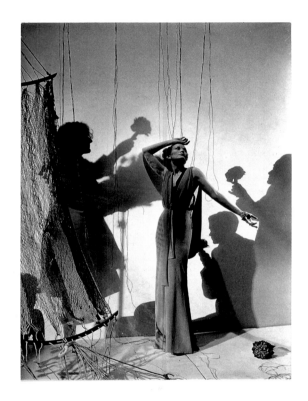

Cecil Beaton

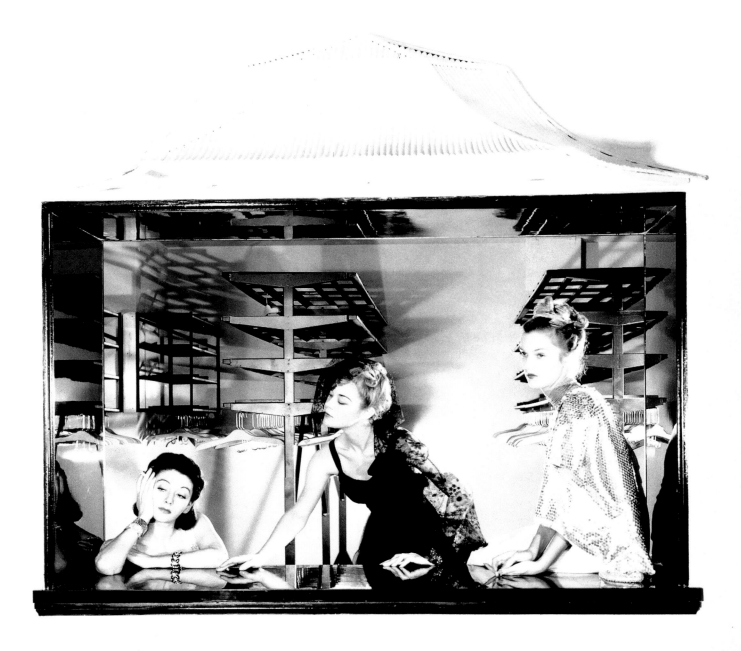

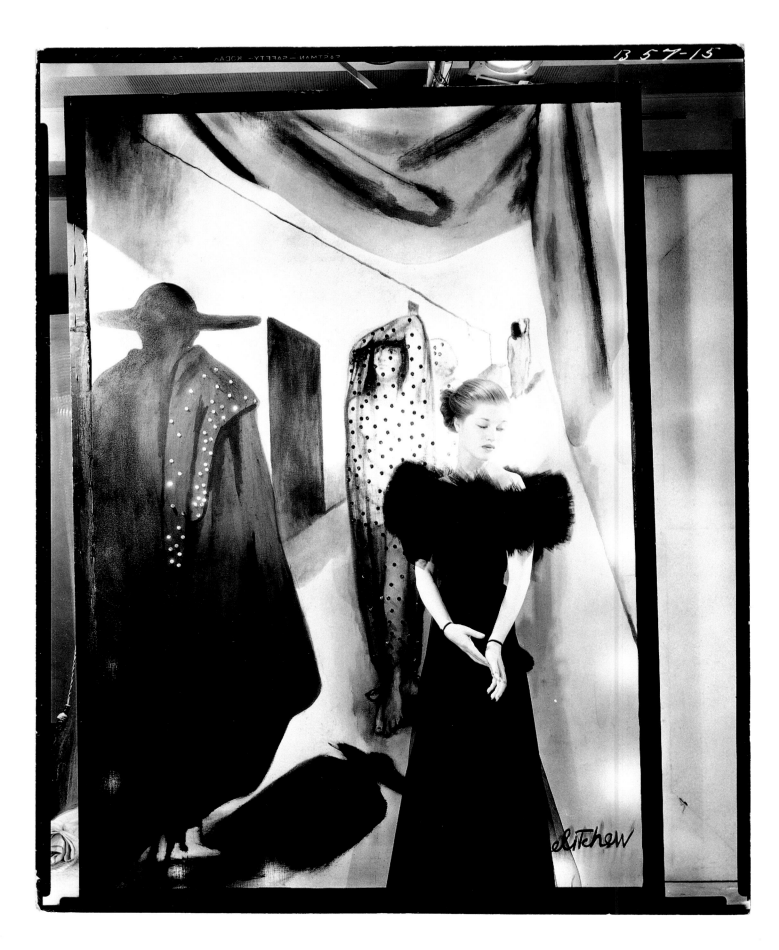

Mary Taylor
posed before a
painting by Pavel
Tchelitchew, for
Vogue, 1935

Below left: 'Lights!
Camera! Focus on
Mainbocher...', for
Vogue, 1934

Below right:
Fashion study, for
Vogue, 1936

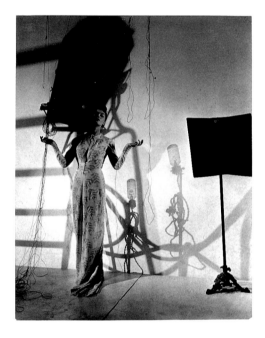

Below: 'Shadow
her: she is the
new image...',
for *Vogue*, 1935

'For the Lace
Ball', Natalie
Paley, for
Vogue, 1936

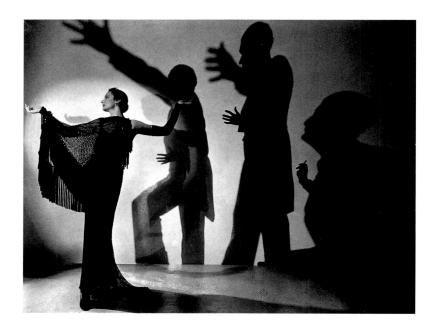

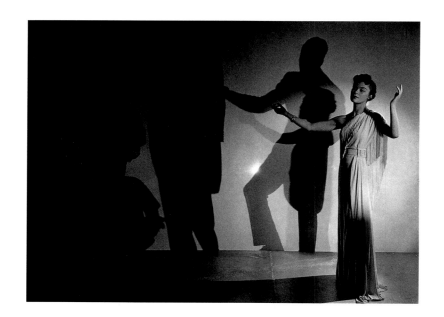

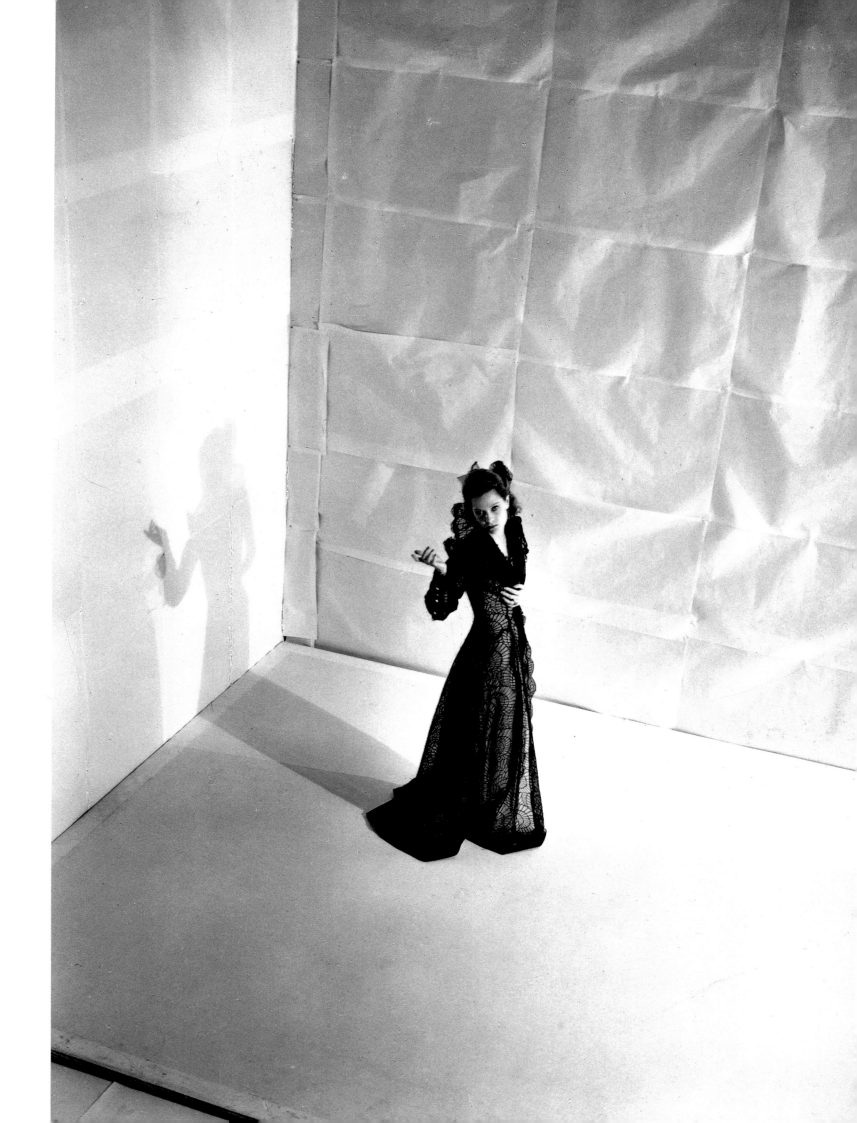

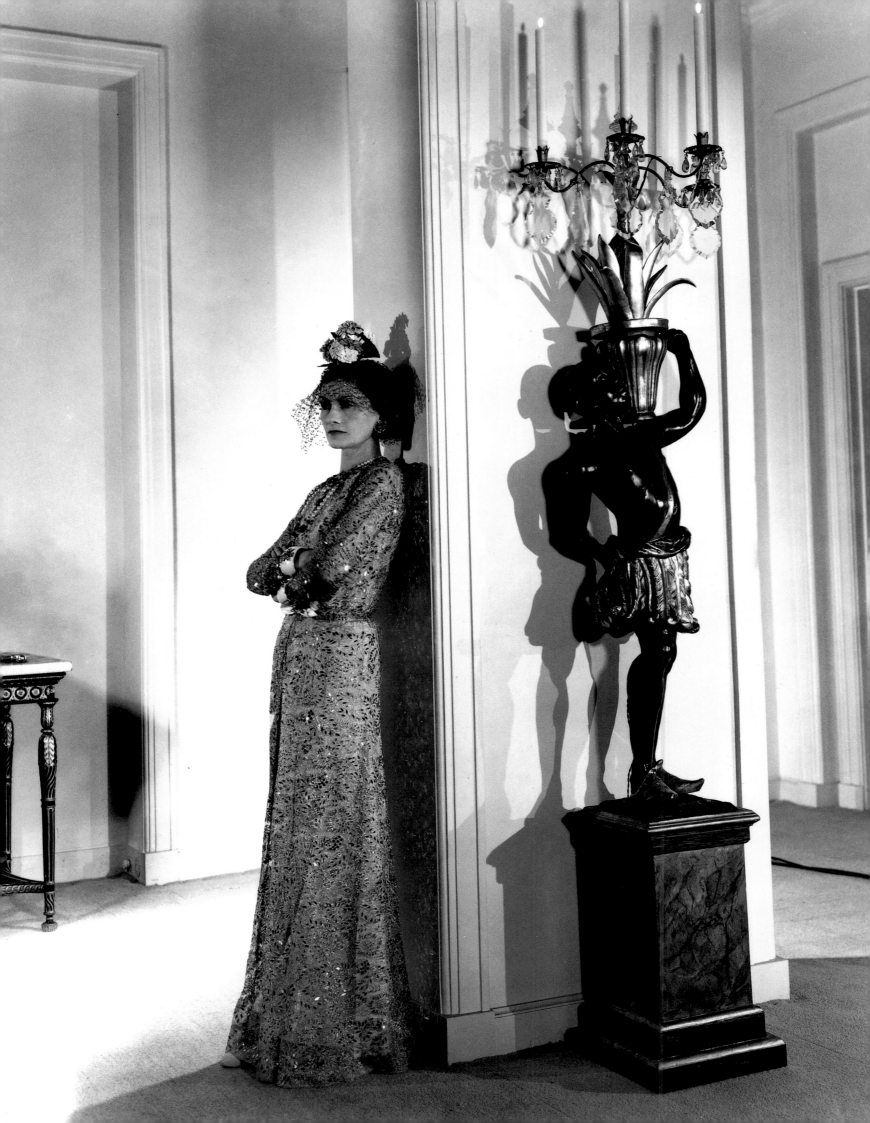

Coco Chanel,
1937

Elsa Schiaparelli,
1930s

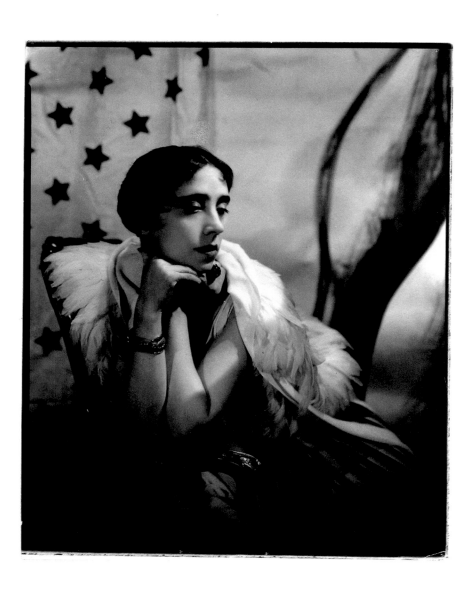

179

Cecil Beaton

'Ilka Chase in "The Florist's Box", A Tragedy in three acts', fashion studies, for *Vogue*, 1937

Charles James, 1930s

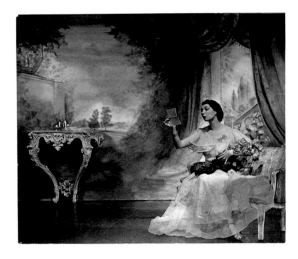

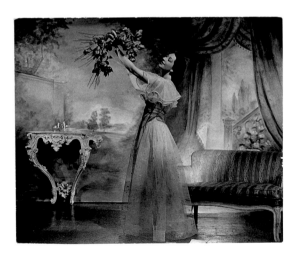

Cecil Beaton

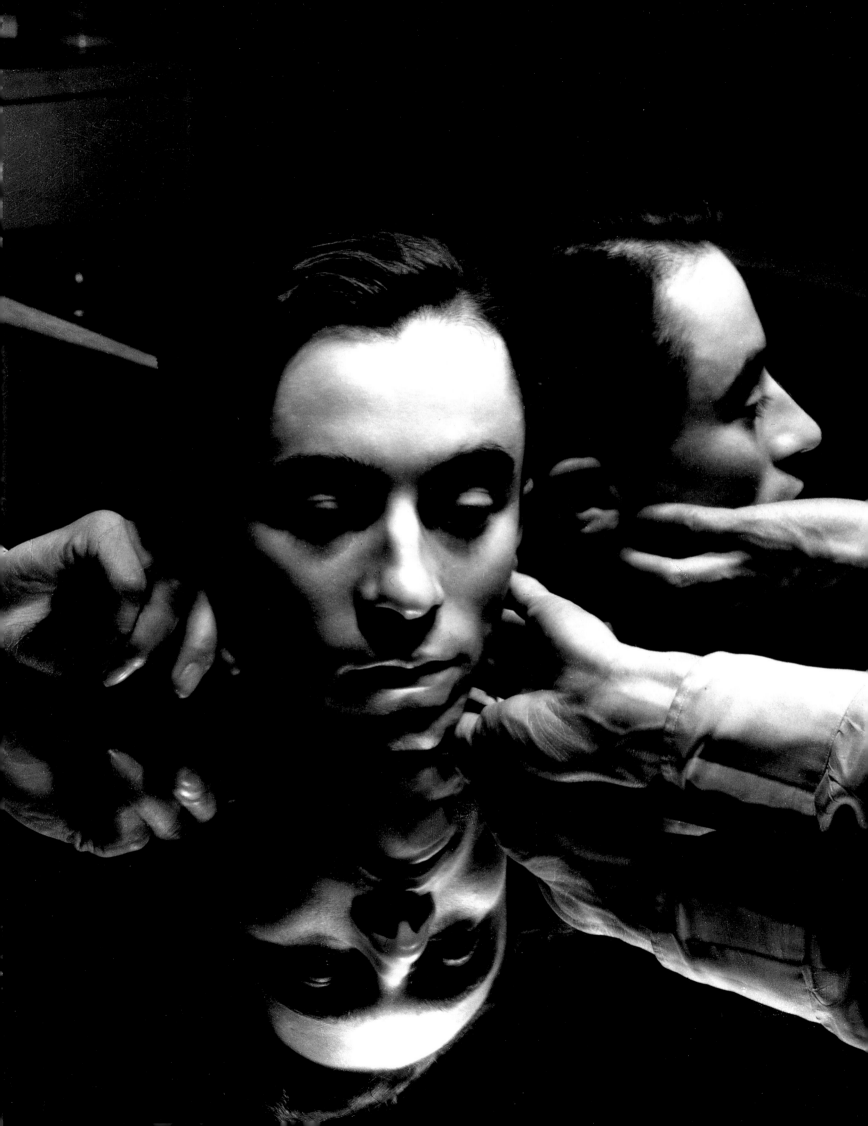

Cecil Beaton

'… glamour is returning … were it not for the fact that ugliness is at a premium …'

The Book of Beauty, p.9

'Soon war had started; nobody had peace of mind or leisure ...'

Photobiography, p.137

Cecil Beaton

Marie Laure
de Noailles,
late 1930s

'Fashion is
indestructible', for
Vogue, 1941

Cecil Beaton

Cecil Beaton

Cecil Beaton

Cecil Beaton

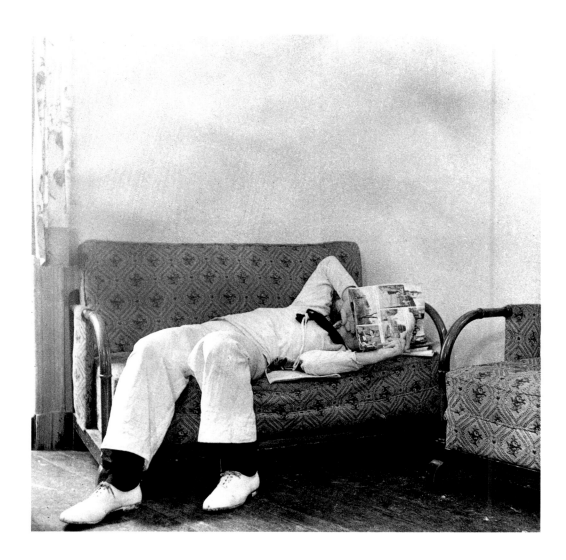

Cecil Beaton

**Mrs Reginald
Fellowes wearing a
Paquin hat and fire-
fighting gloves,** for
Vogue, 1941

Cecil Beaton
1945

Cecil Beaton

Cecil Beaton

'… one is conscious of so much continuing suffering throughout the world …'

Diary entry, 4 May 1945, *The Happy Years, 1944-1948*, p.38

'My earliest recollection was of a lady dancing on a table at Maxim's.'

The Book of Beauty, p.1

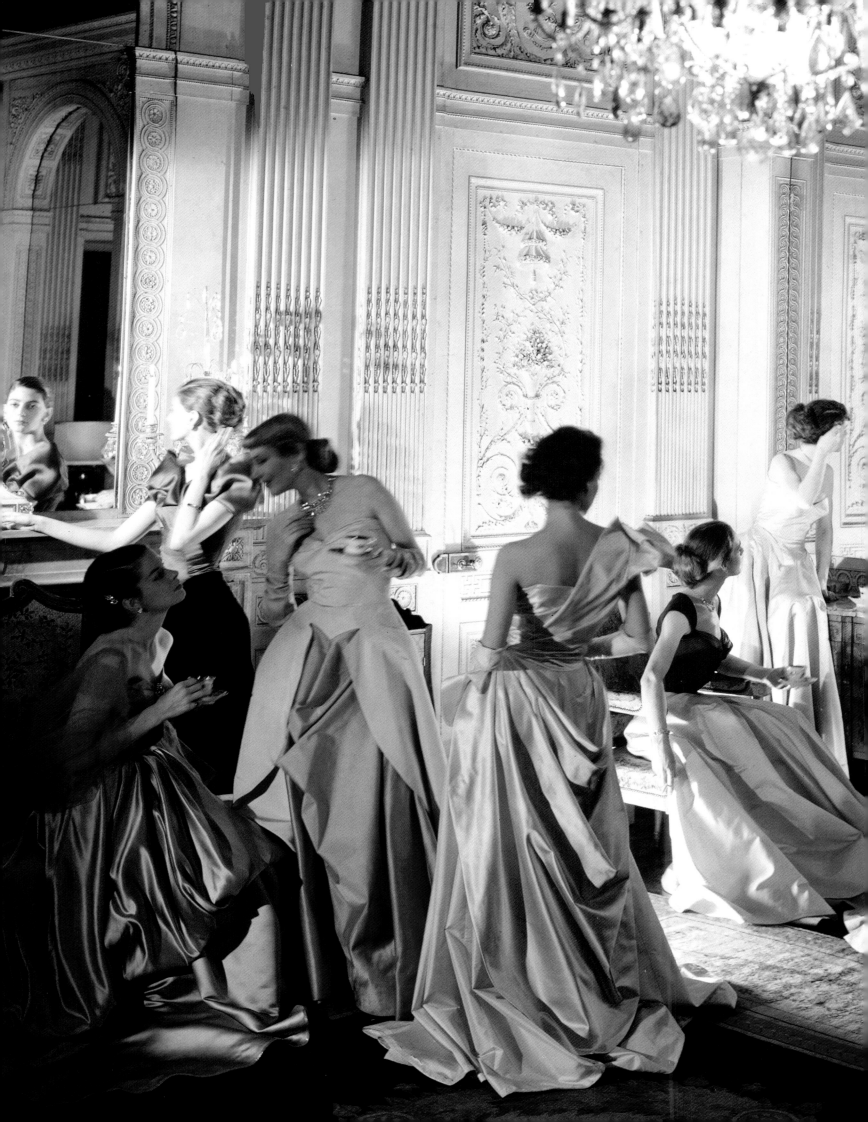

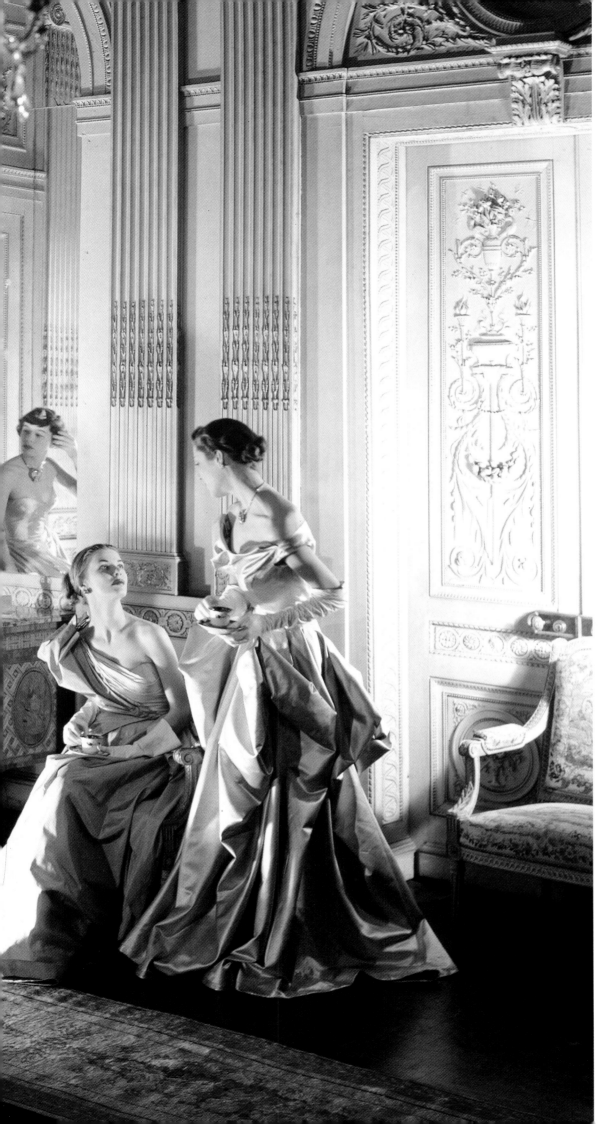

**Fashion study
with painting by
Jackson
Pollock,** Betty
Parsons Gallery,
New York, for
Vogue, 1951

Cecil Beaton

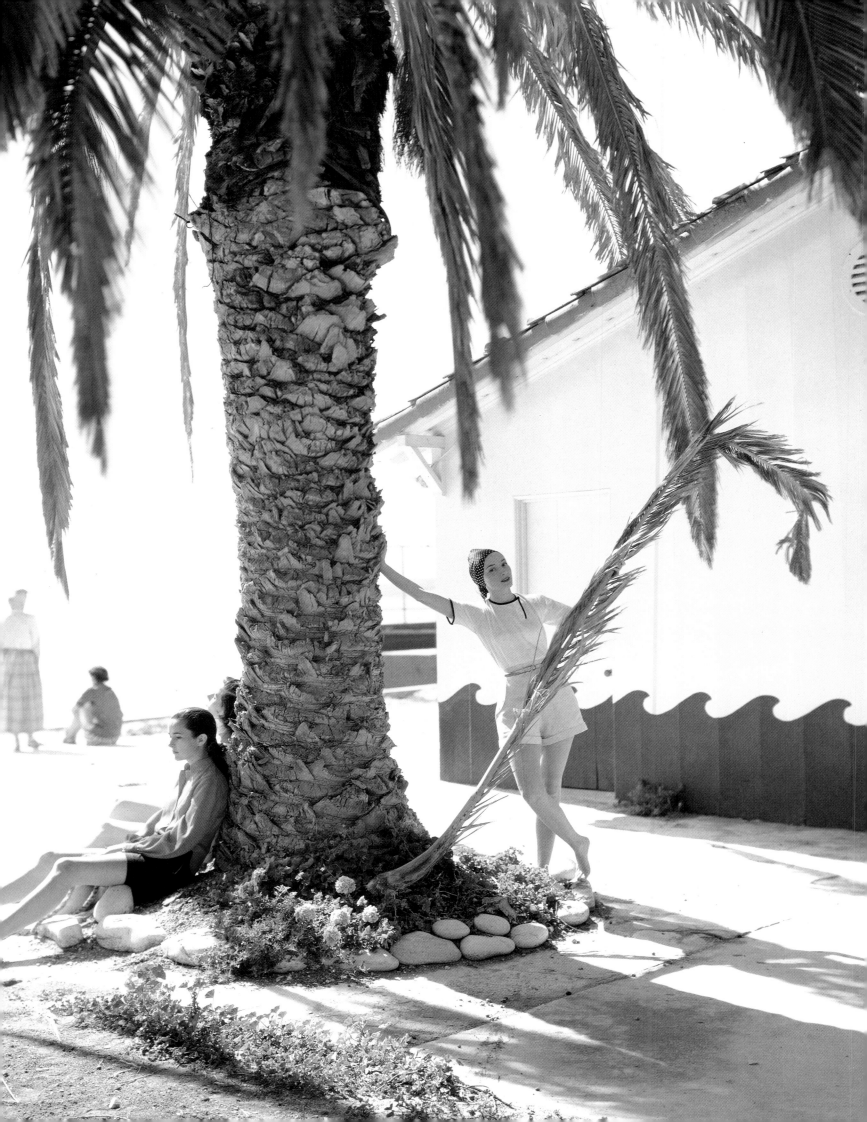

The Hon. Mrs Reginald Fellowes
dressed as 1750s America with
James Caffery holding the
parasol at the Beistegui Ball,
Venice, 1951

'Charles James
shapes a jacket
of black faille',
for *Vogue*, 1948

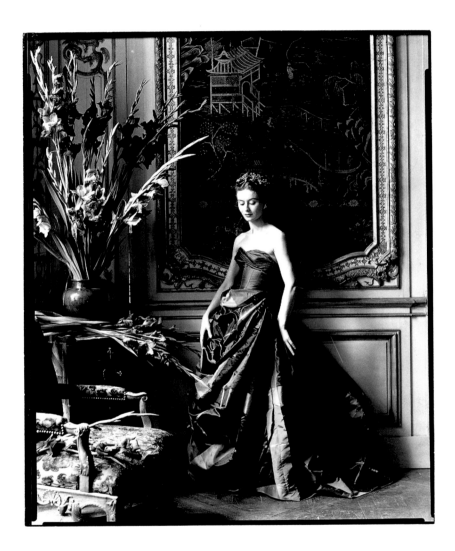

Cecil Beaton

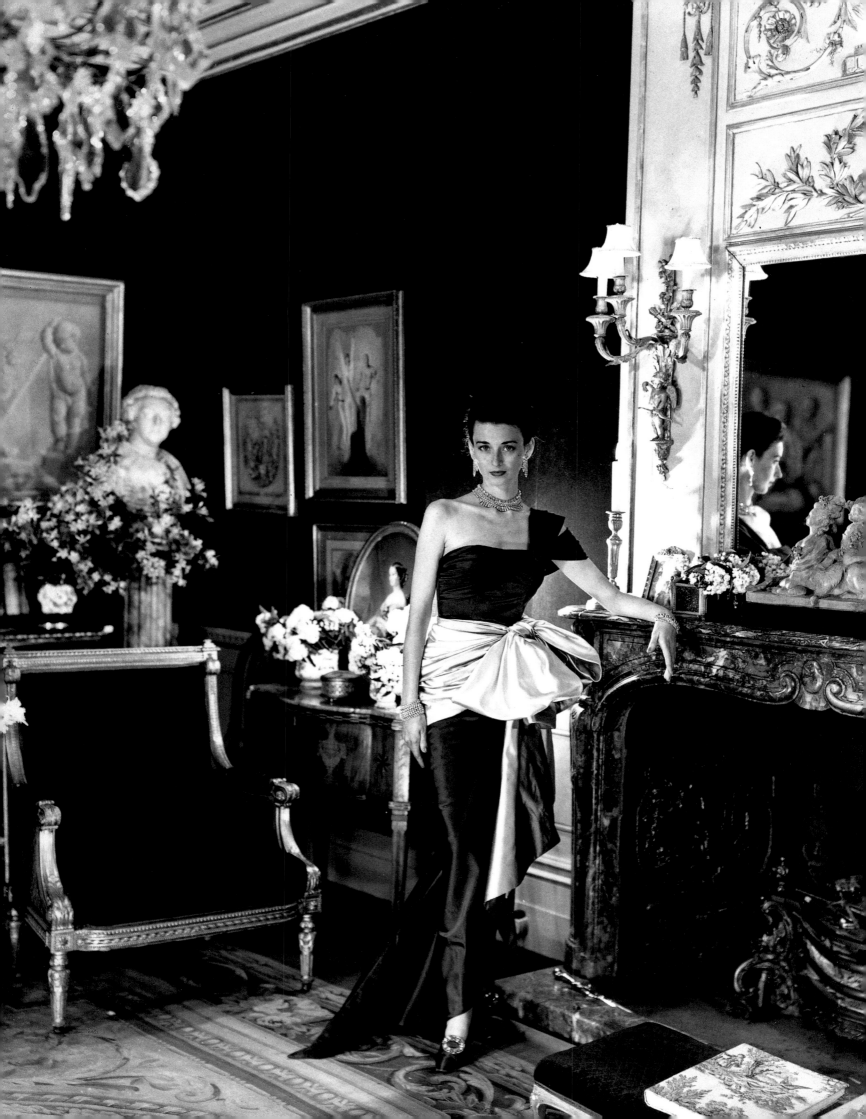

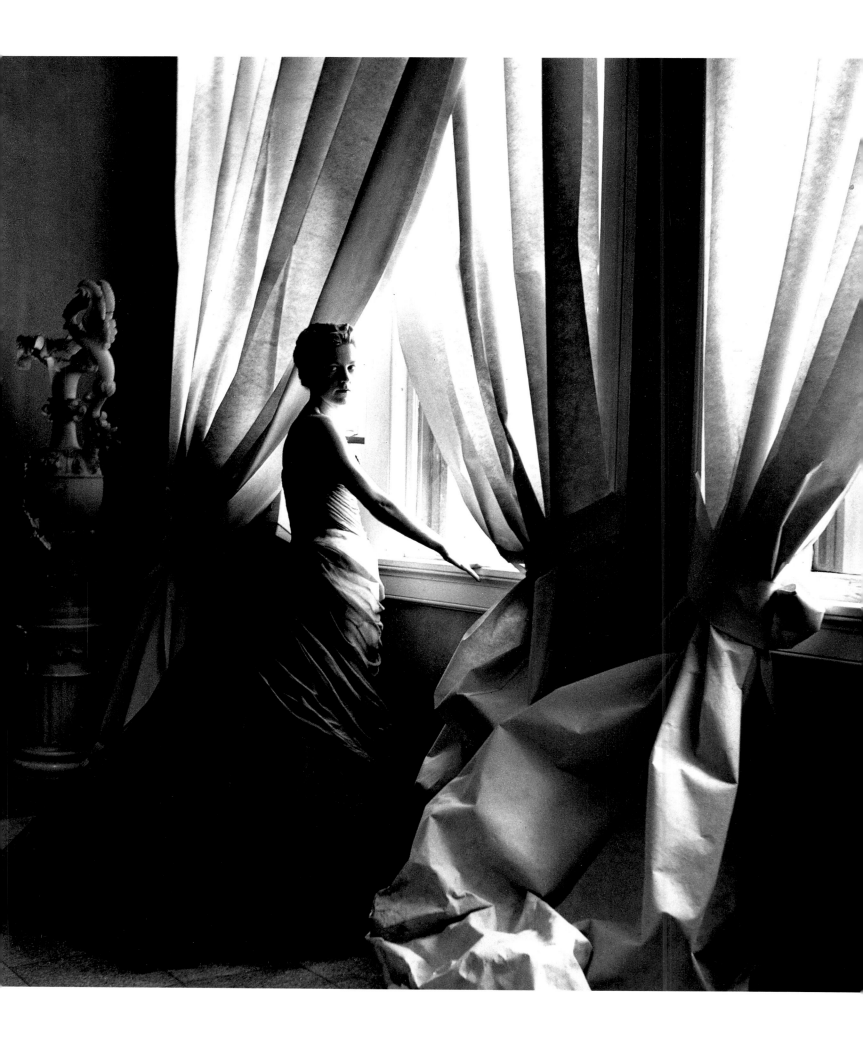

**Mrs Charles
James,** Madison
Avenue, 1955

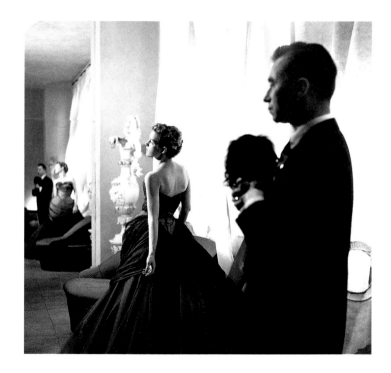

Cecil Beaton

'The success
of a picture often
depends on capturing
those fleeting
moments … "Don't
move! Don't
move! Please don't
move!" …'

Photobiography. p.161

'England in
Spring. Wild
Flowers',
c.1960

Walter Sickert
and his wife,
Therese Lessore,
1942

Cecil Beaton

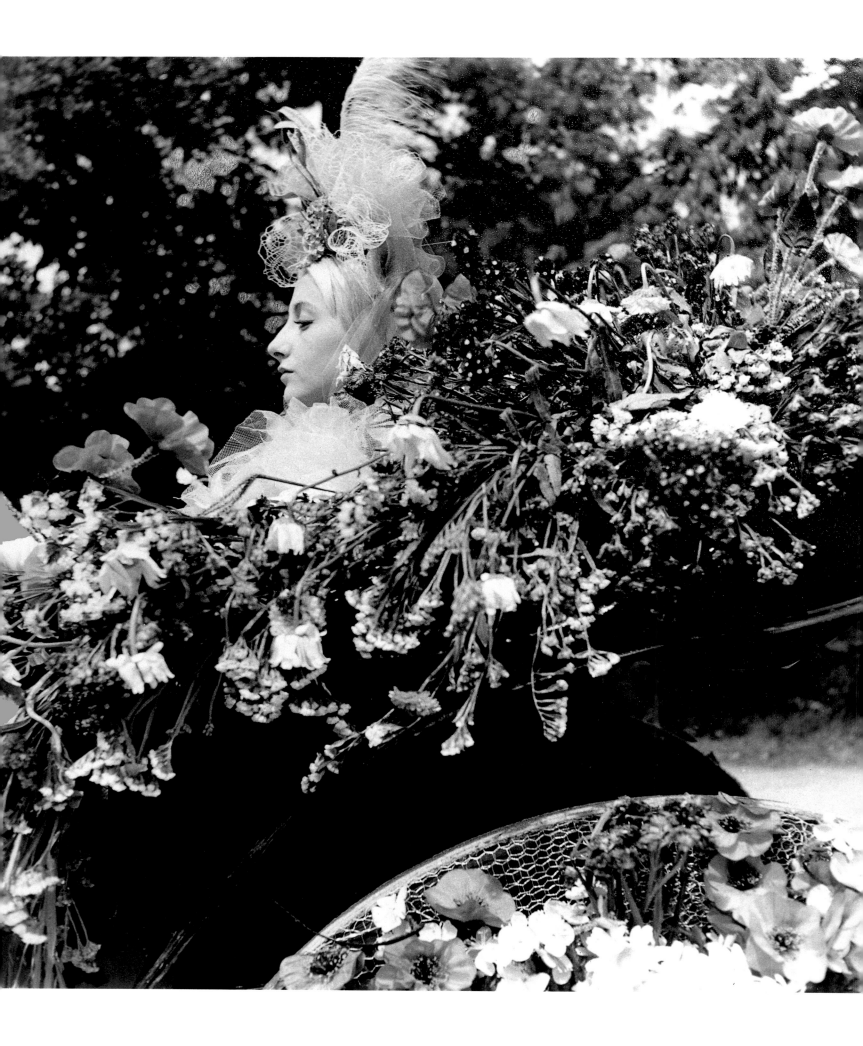

**Demi-mondaine
and the Battle
of Flowers, from
'Gigi'**, 1957

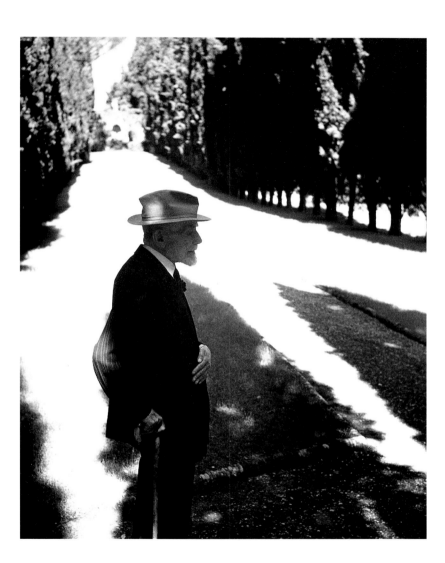

Cecil Beaton

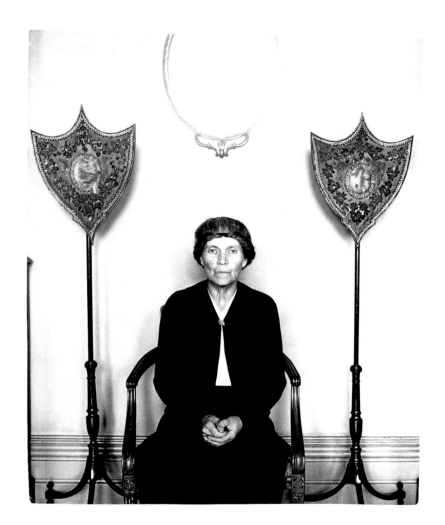

Cecil Beaton

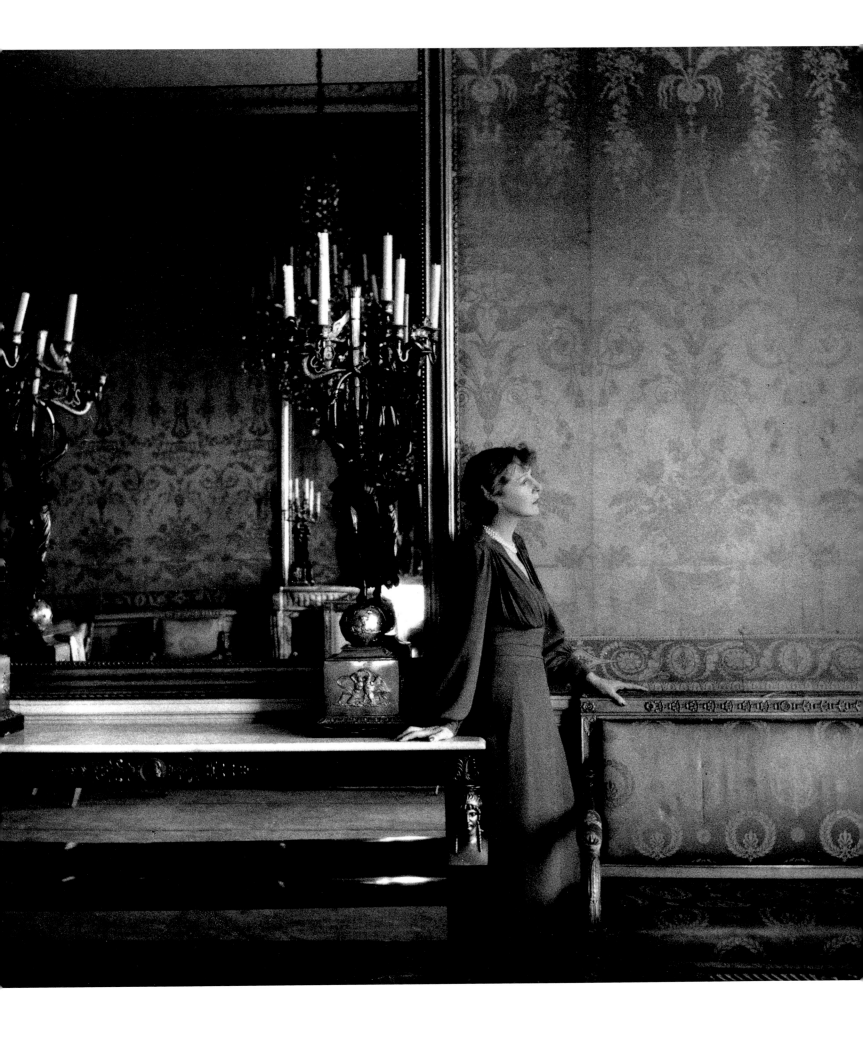

Marlon Brando,
1947

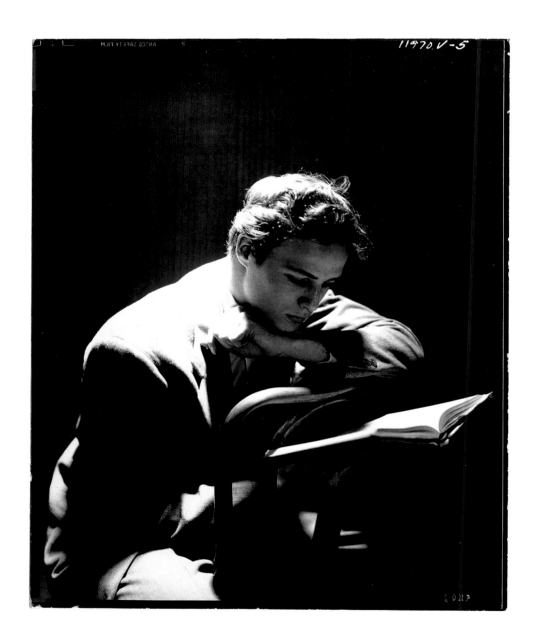

Cecil Beaton

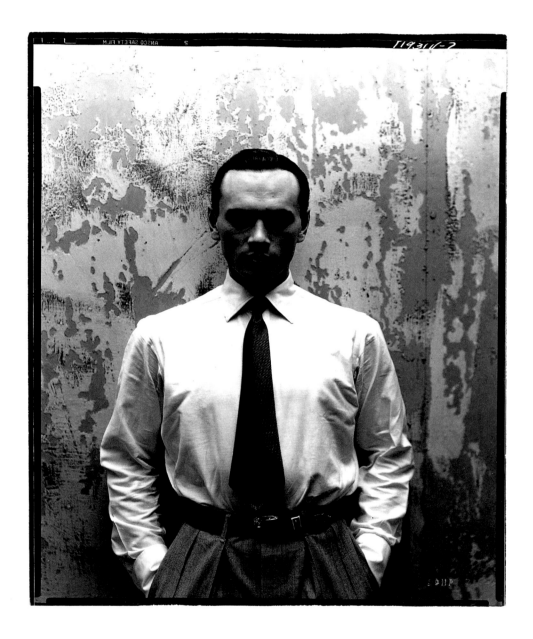

Cecil Beaton

Left: **Lucian
Freud,** 1950s

Below: **Graham
Sutherland,**
1940

Right: **Benjamin
Britten,** 1940s

226

Cecil Beaton

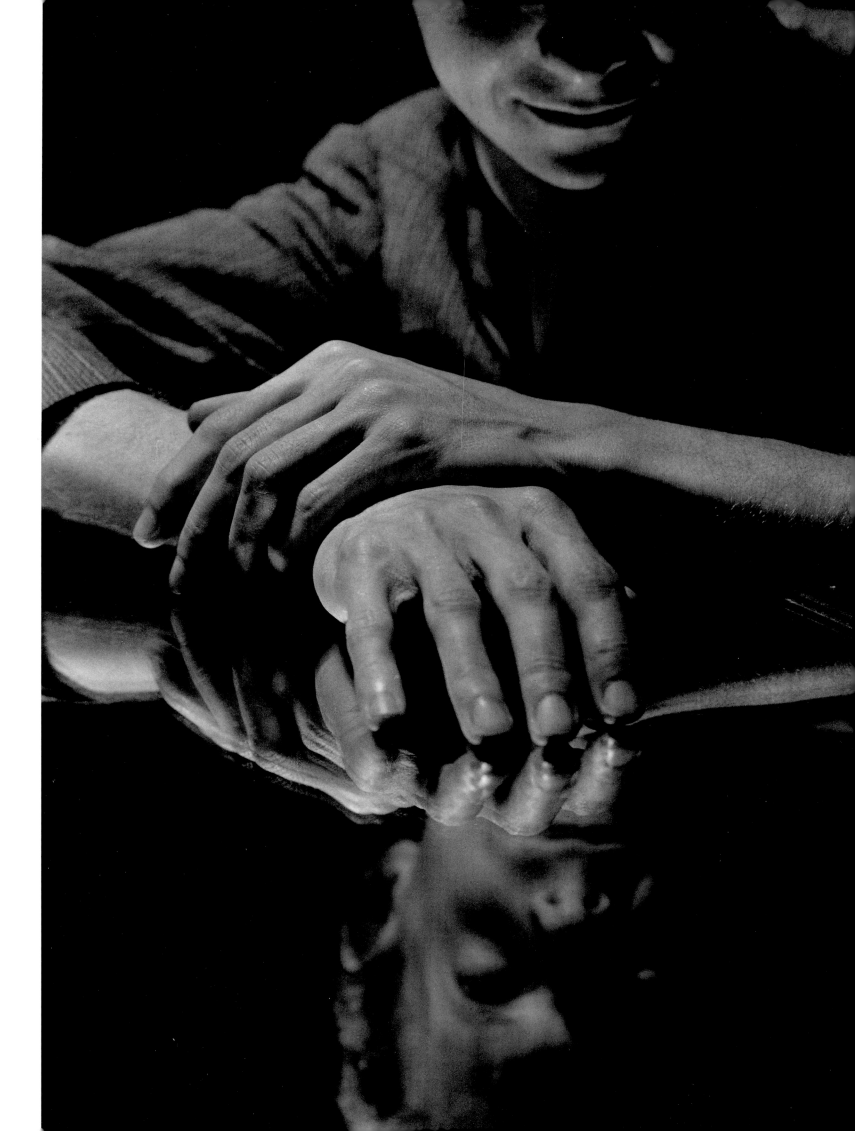

Cecil Beaton

Antonia, Lady
Aberconway's
cat at Bodnant,
1950

Lady Diana Cooper
as Tiepolo's
Cleopatra at the
Beistegui Ball,
Venice, 1951

Cecil Beaton

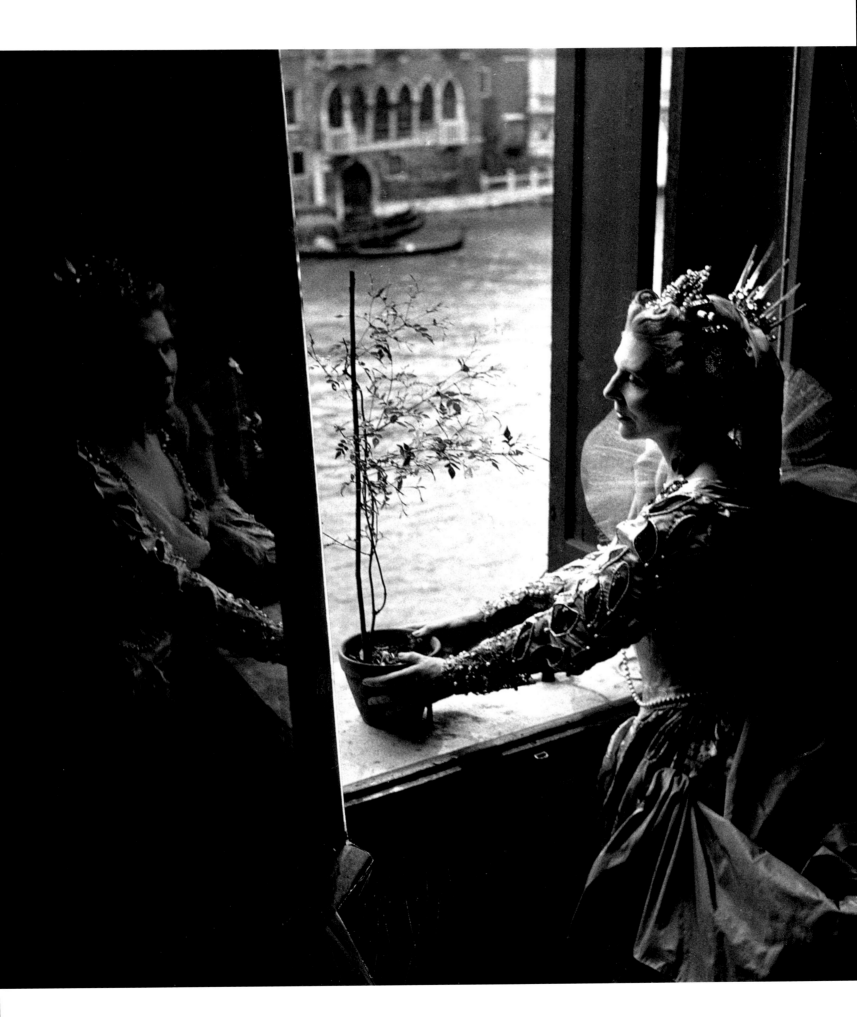

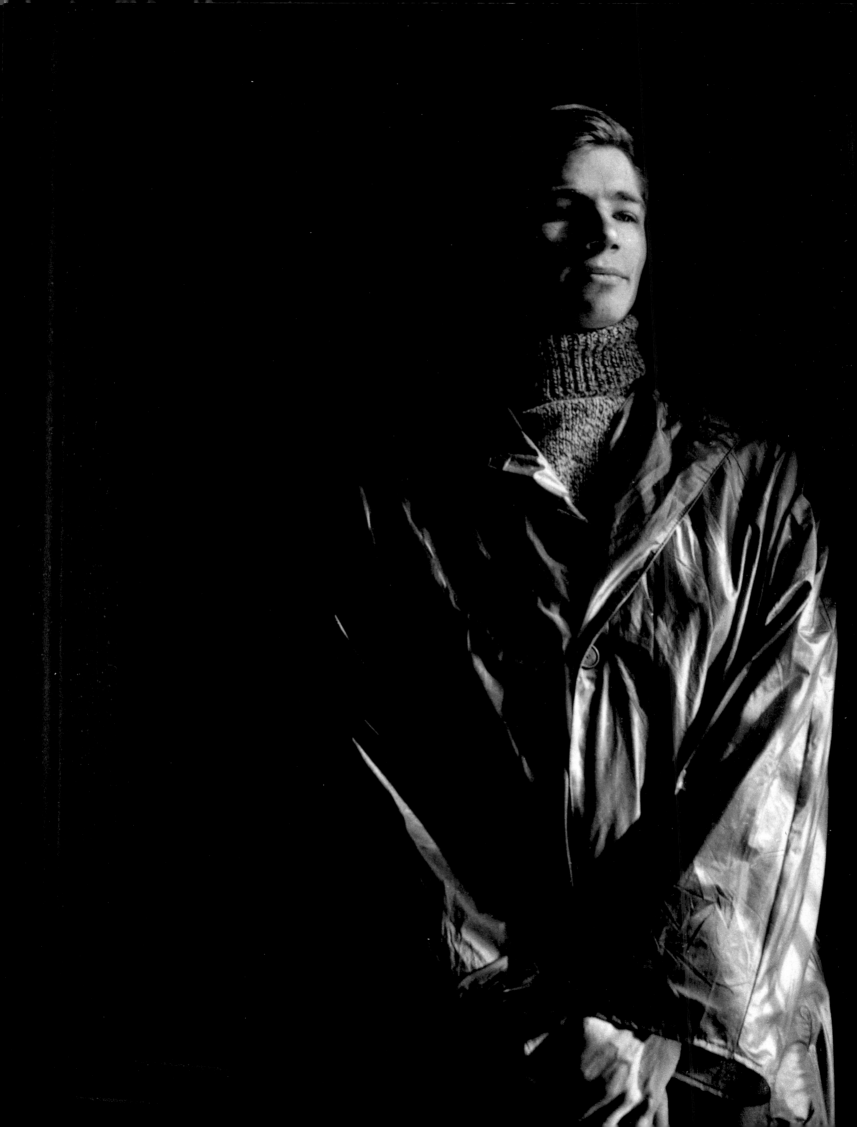

233

Cecil Beaton

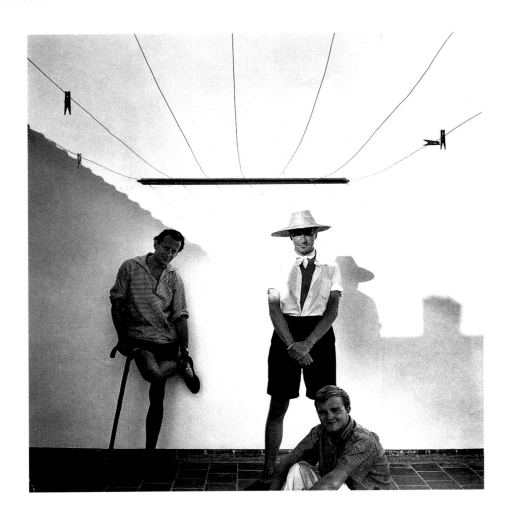

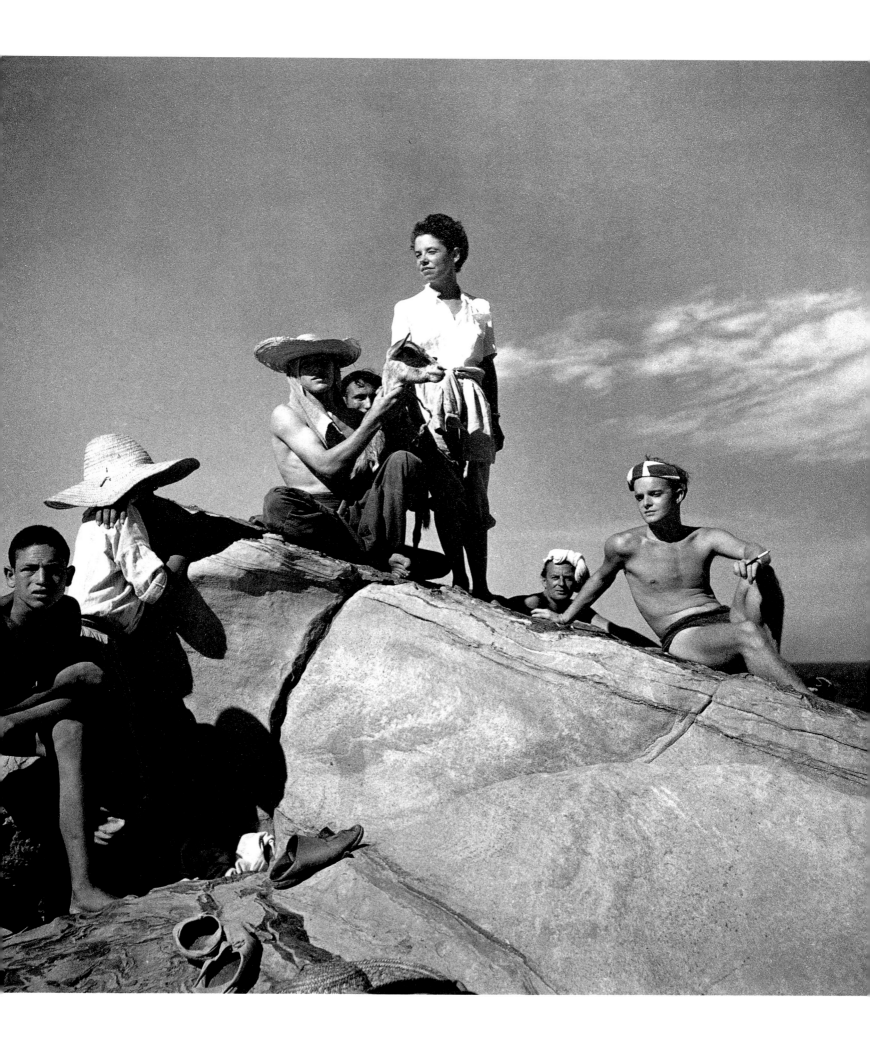

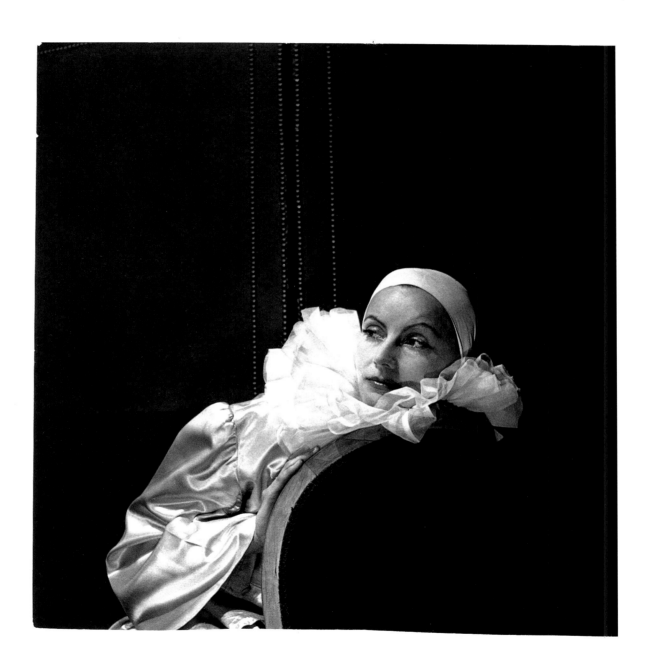

Cecil Beaton

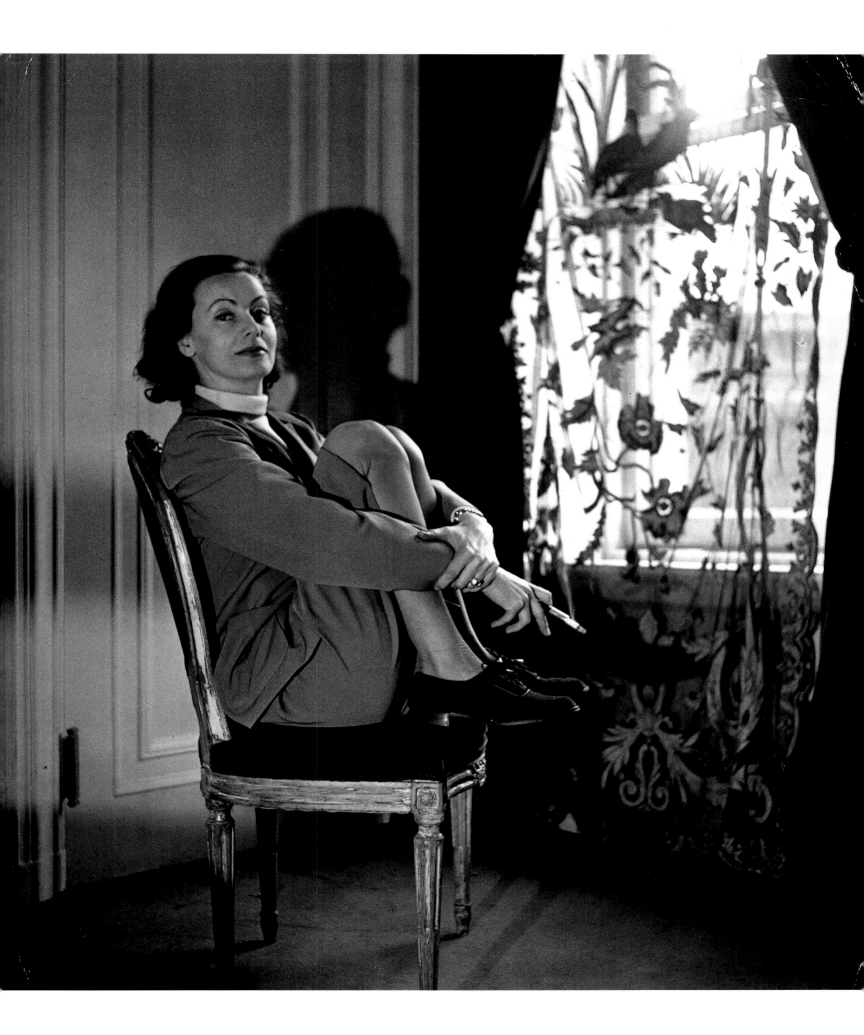

The Wyndham
Quinn sisters,
after Sargent's
'Wyndham
Sisters', 1950

Isabel Jeans
in the London
production
of 'Lady
Windermere's
Fan', 1945

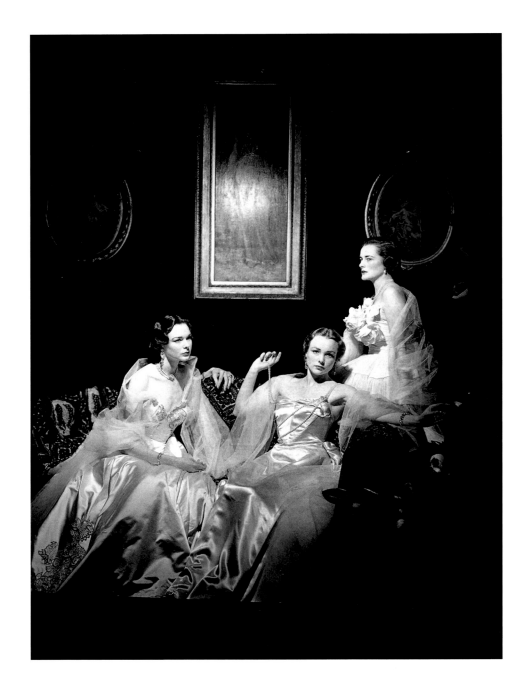

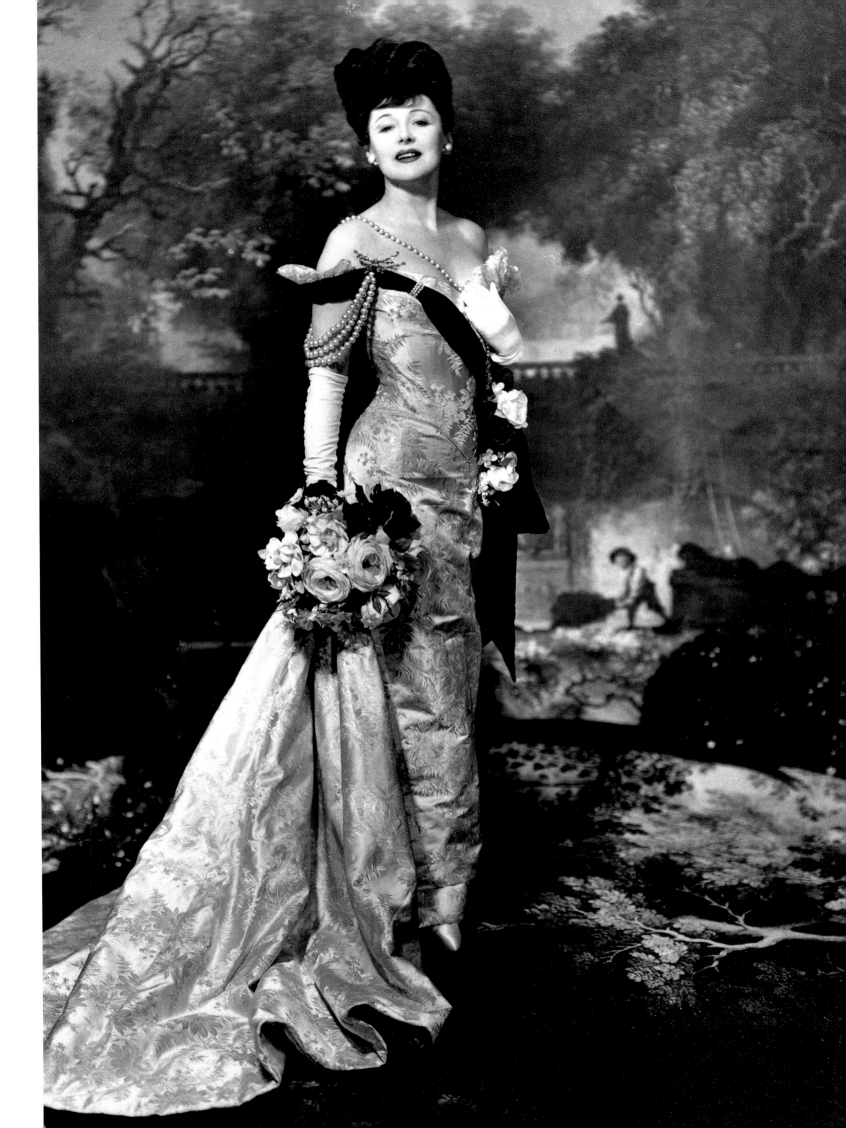

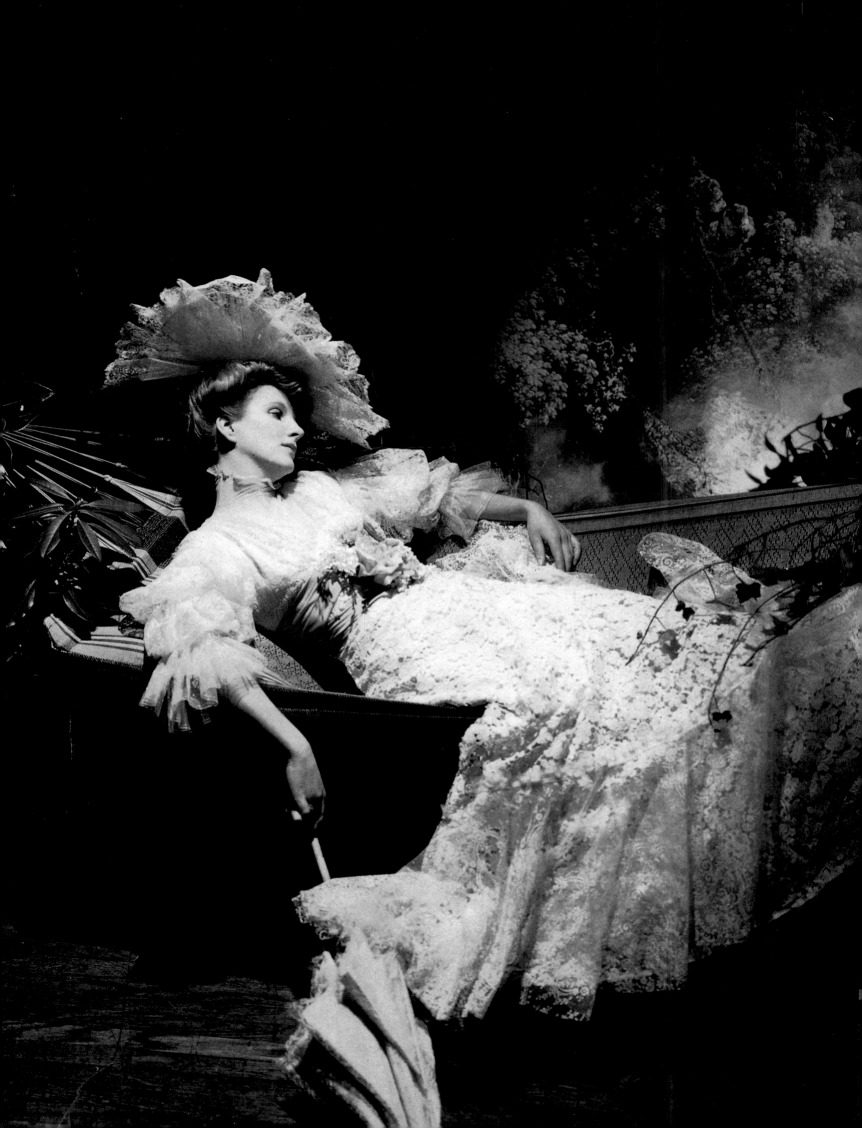

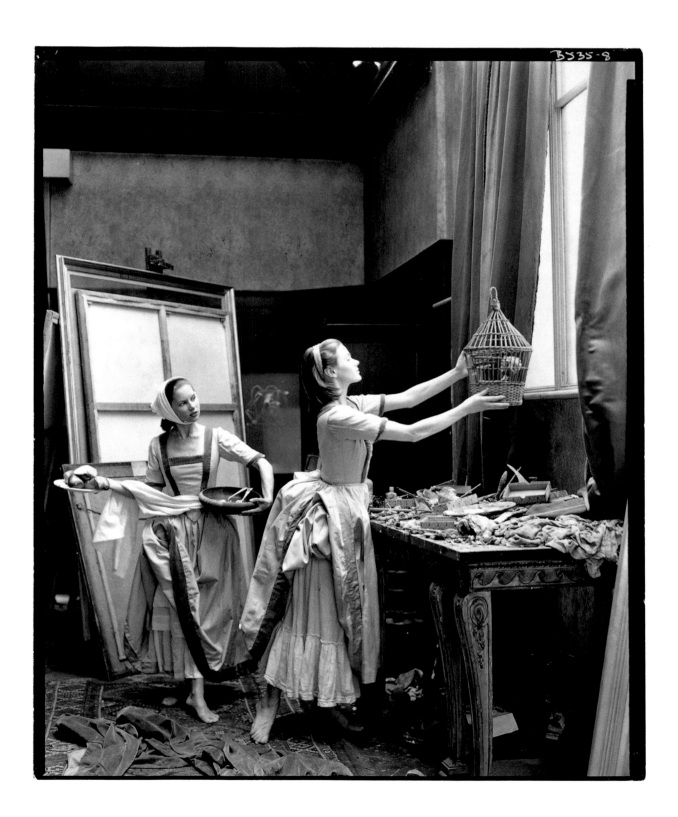

Mrs Peter Thorneycroft modelling a Vernier hat of pink roses, for *Vogue*, 1954

Leslie Caron as Gigi, 1957

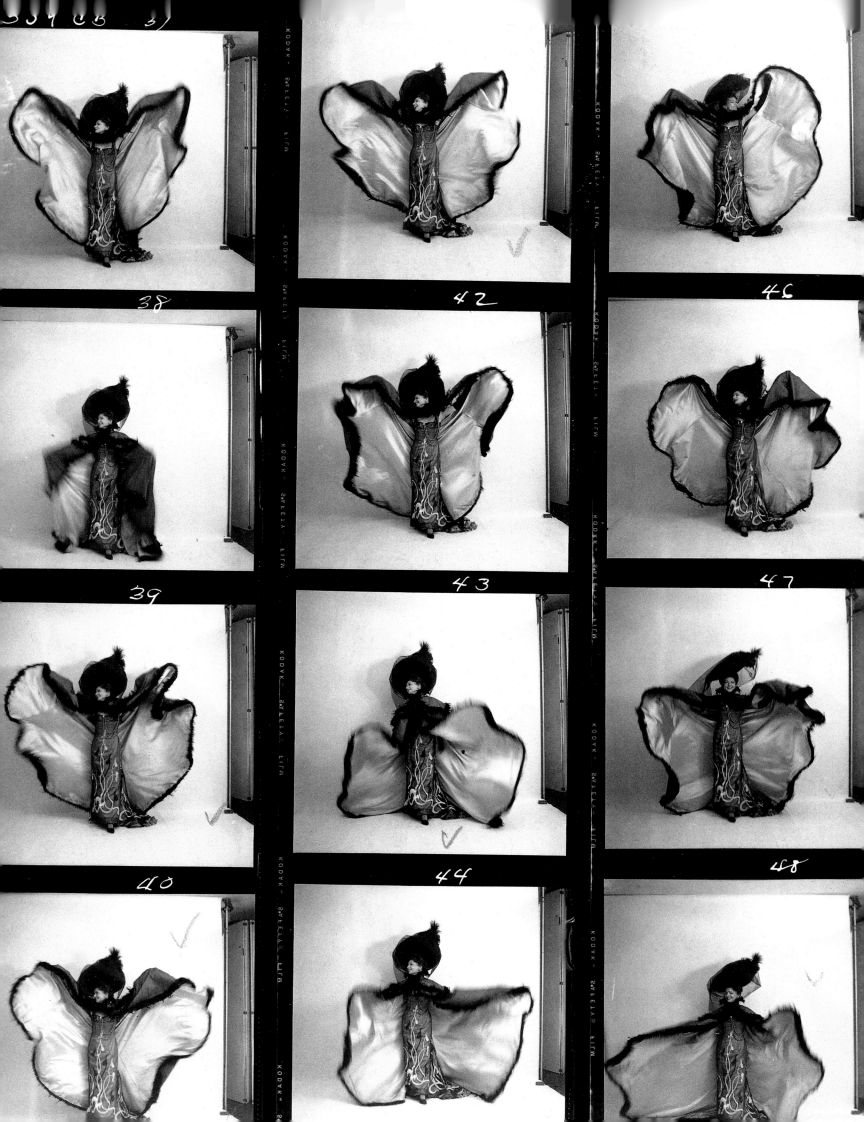

#46-B

6 moves

#47-B

6 moves

#48-B

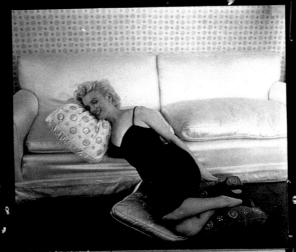

#42-B

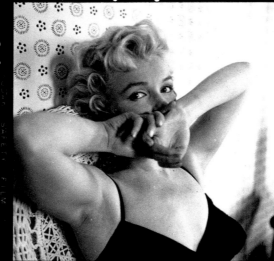

#43-B

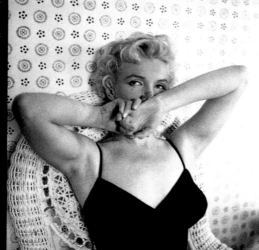

#44-B

#49-B

#50-B

#51-B

Previous pages:
**Contact sheet from
'Great Expectations',**
1946

**Costume for 'Look after
Lulu' inspired by Loïe
Fuller,** 1959

Left: **Marilyn
Monroe**, 1956

Marilyn Monroe,
1956

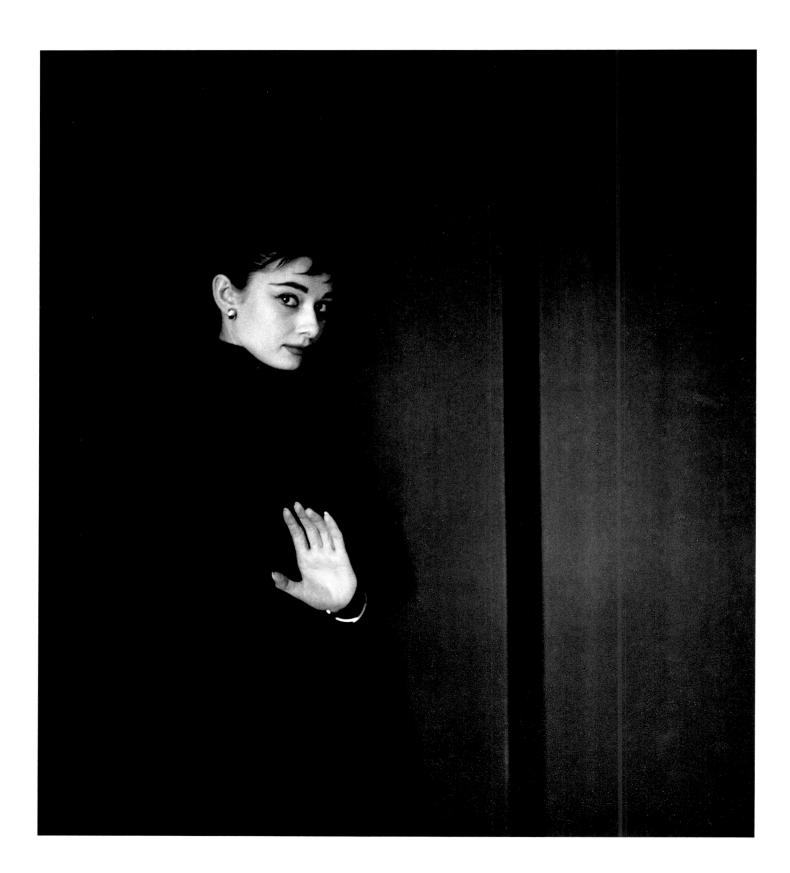

Cecil Beaton
1954

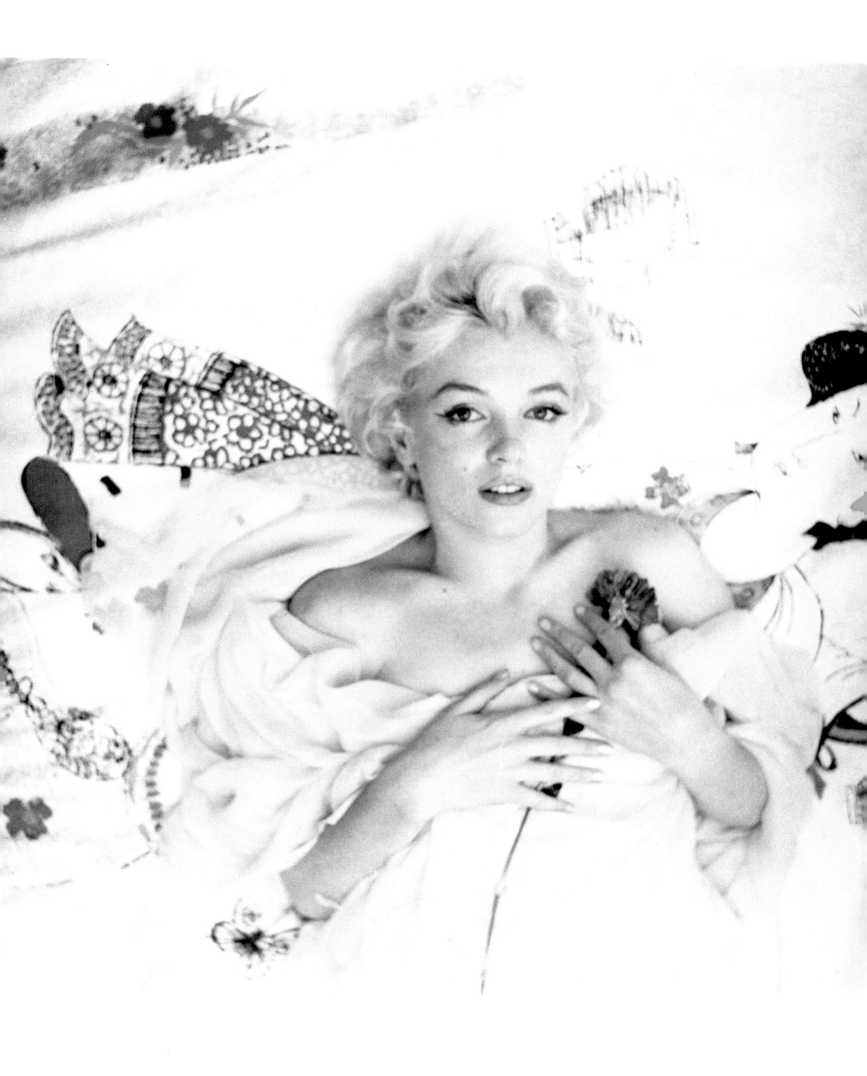

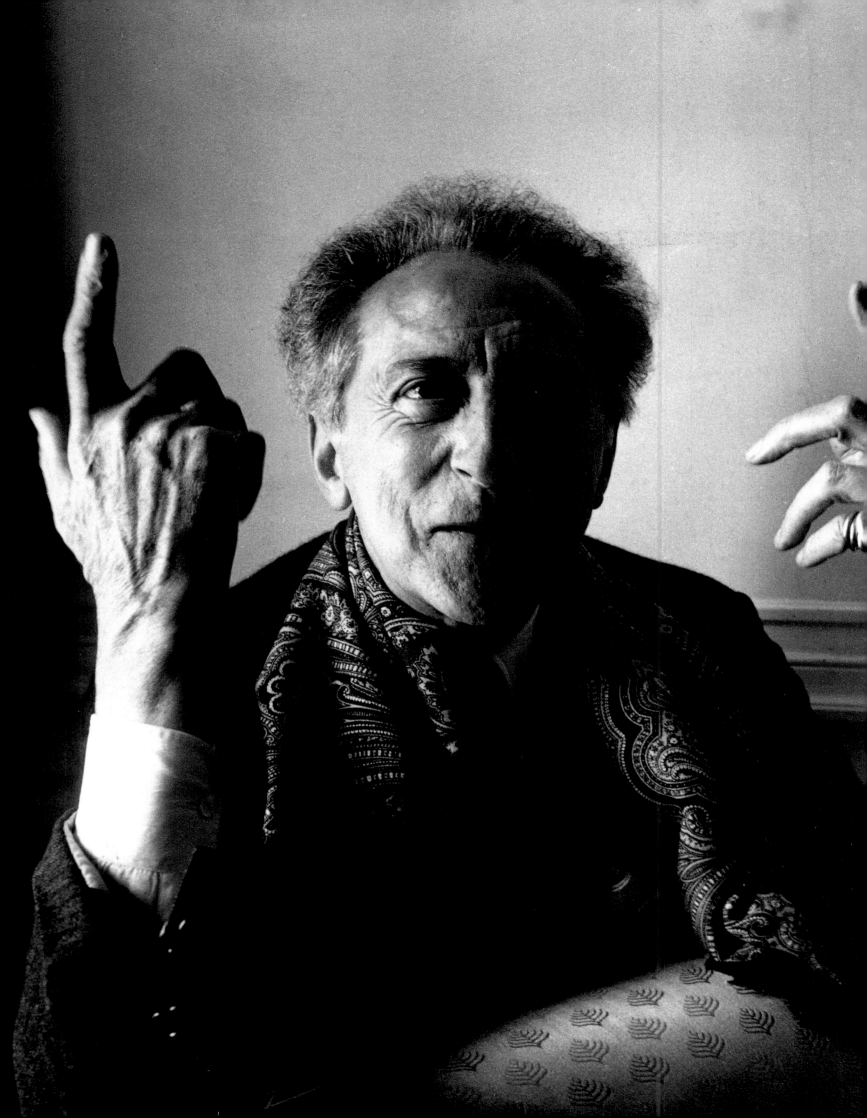

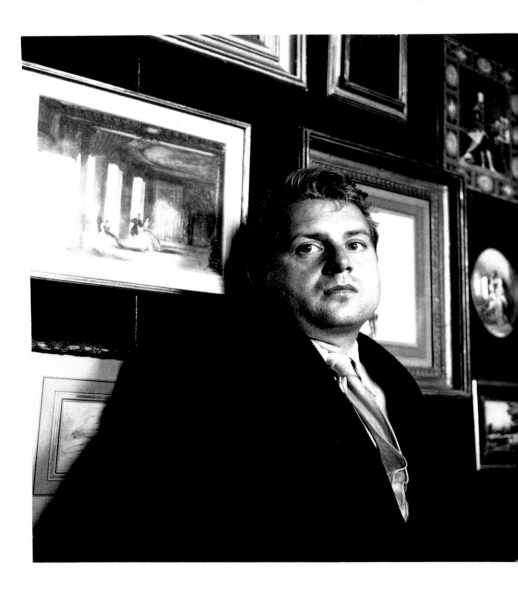

253

Cecil Beaton

**Fiona Campbell-
Walter modelling a
mink jacket by
Calman Links,** for
Vogue, 1954

**Cecil Beaton,
self-portrait,**
1951

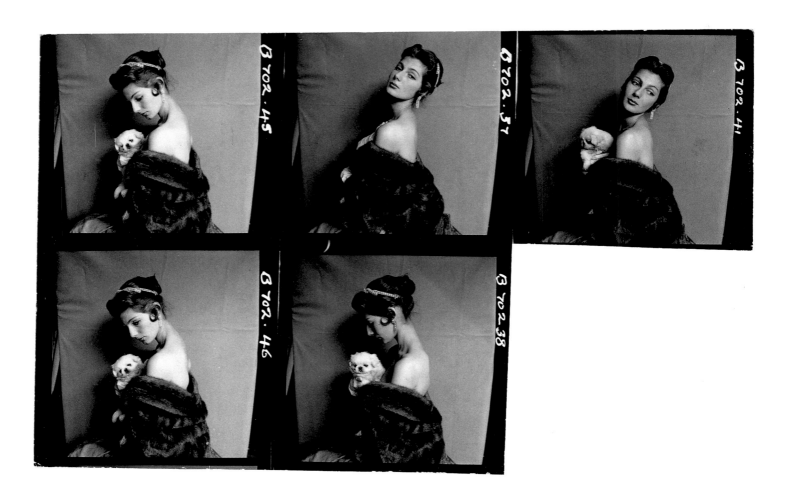

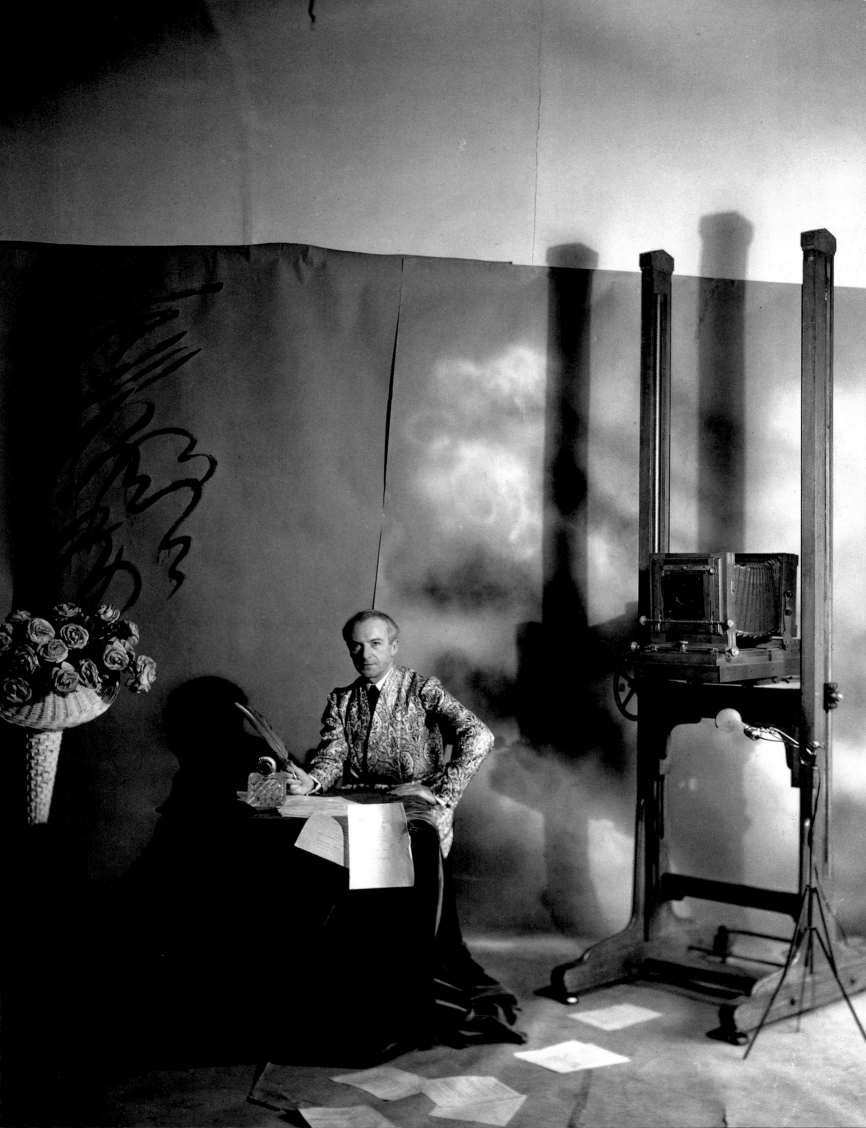

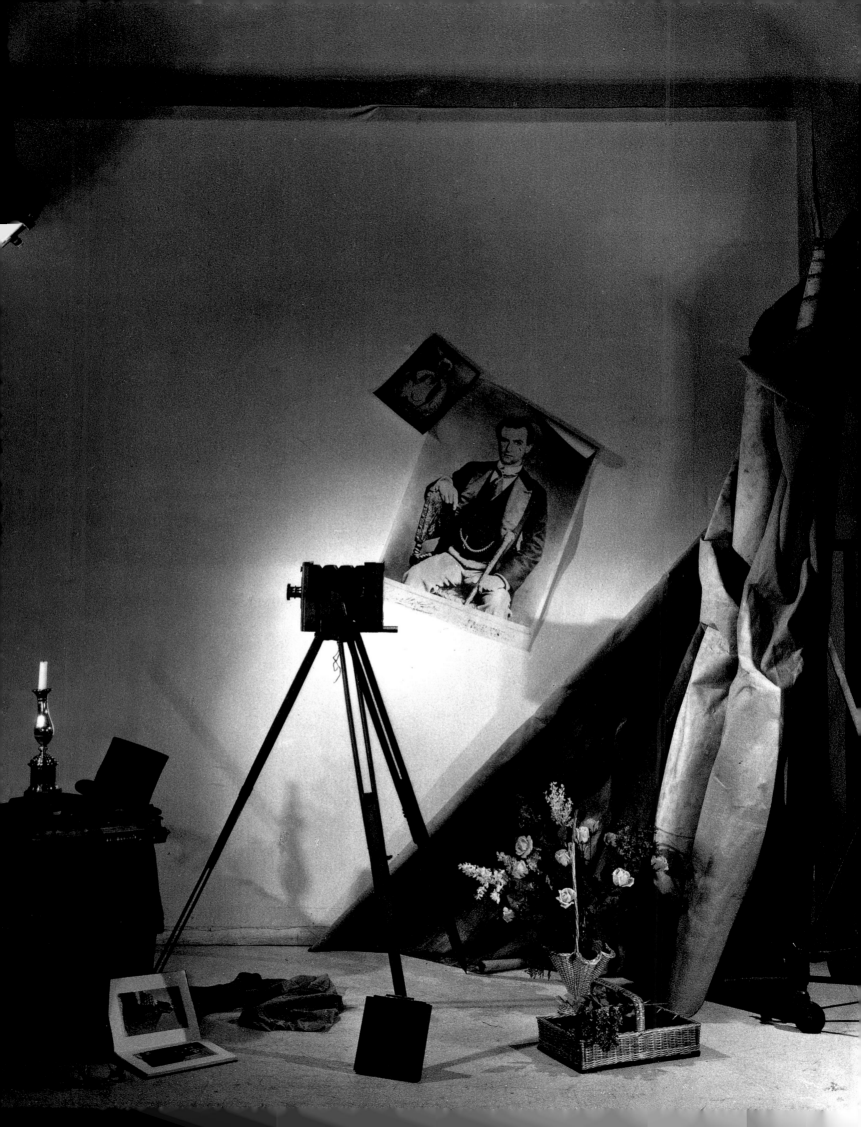

'There is the element of magic in exposing a plate and afterwards waiting to see the image ...'

Photobiography, p.165

'...I find ... the young seem so different, so beautiful, so energetic. They are like creatures from another planet ...'

Diary entry, February 1974, quoted in Hugo Vickers, *Cecil Beaton*, p.570

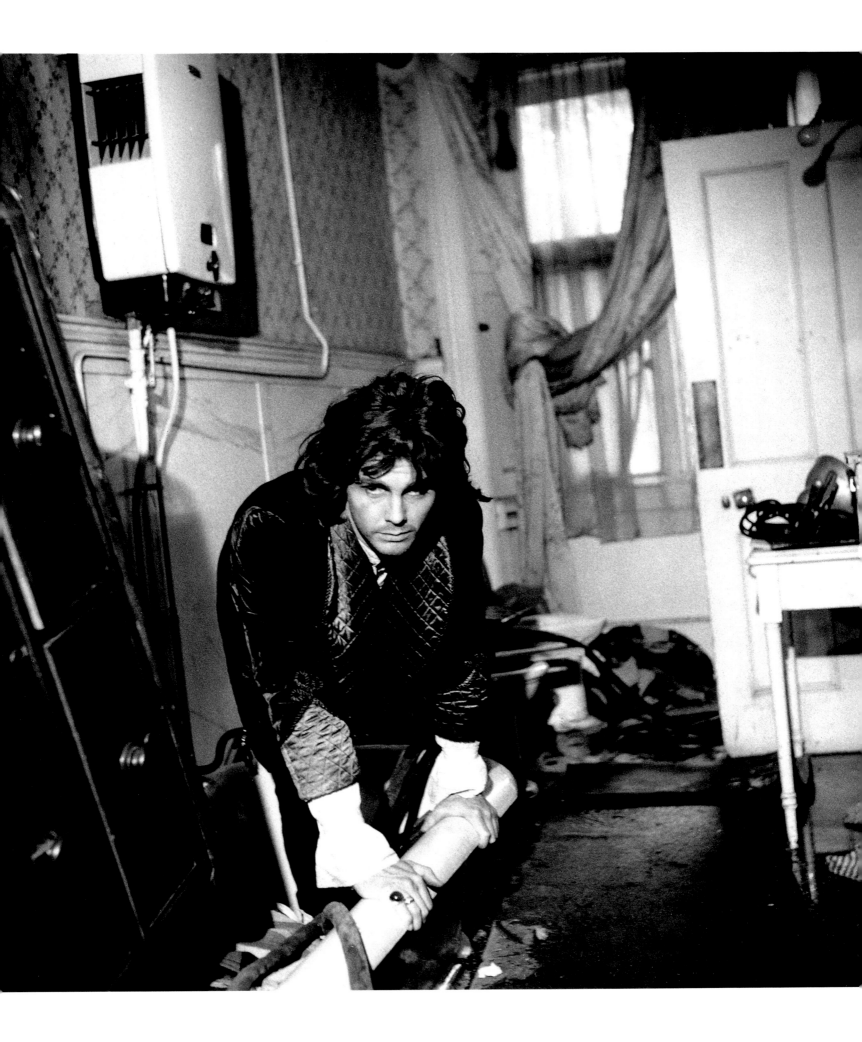

Previous pages: **Cecil Beaton, self-portrait photographing Viva,** New York. January 1970

Left: **Viva,** New York. January 1970

Right: **Andy Warhol and Candy Darling,** 1969

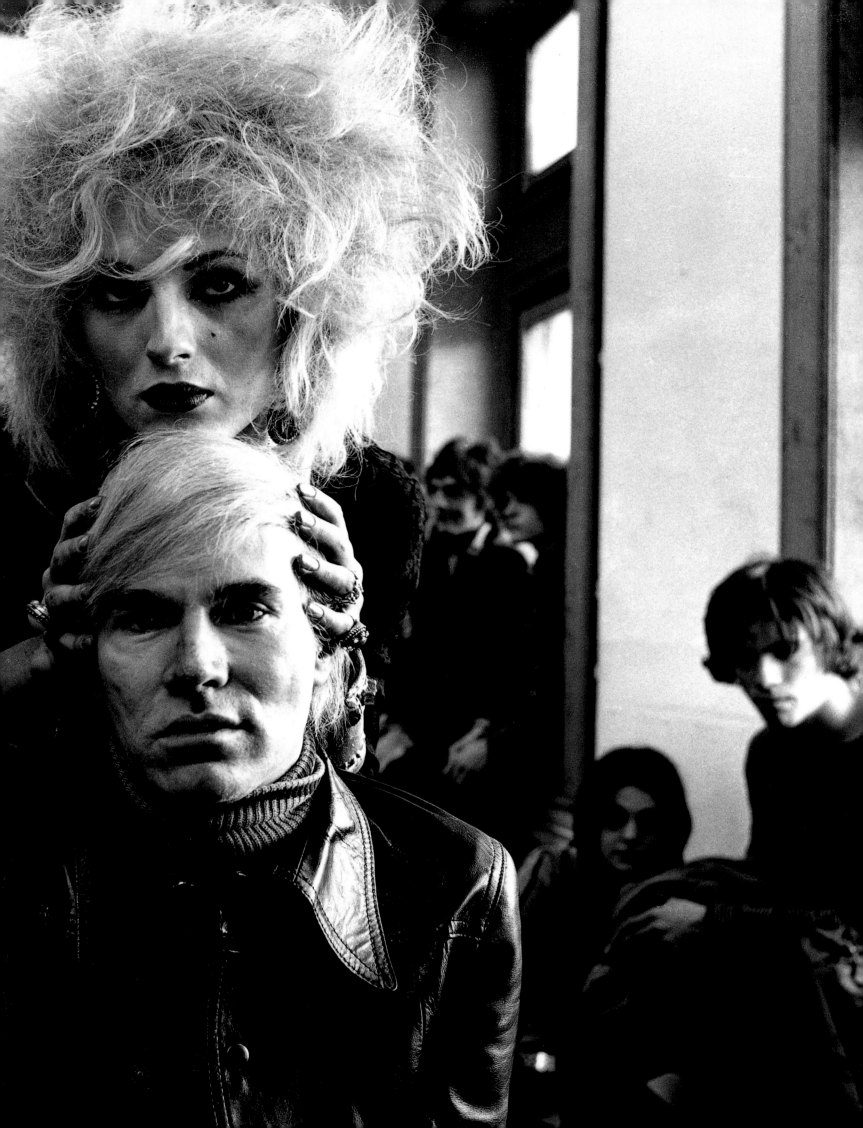

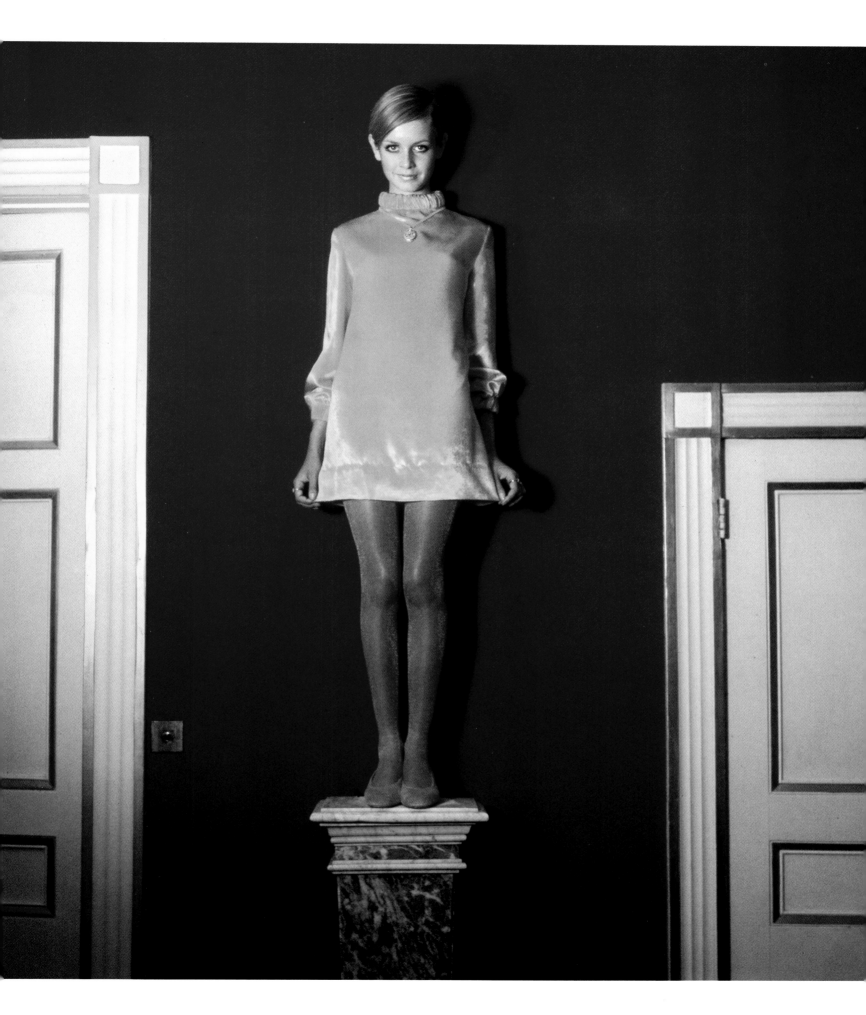

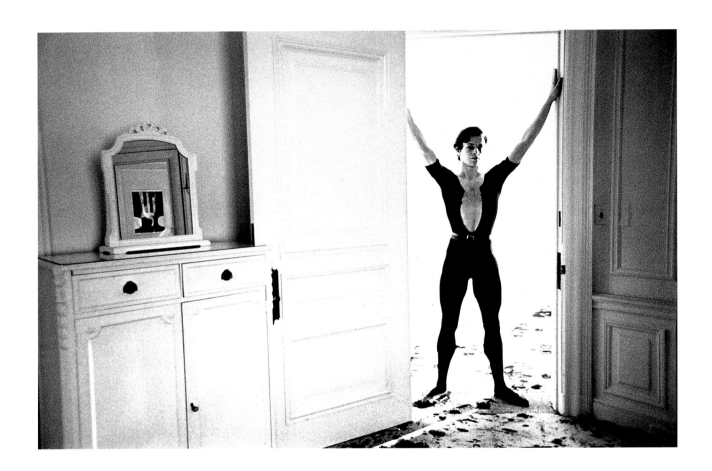

Cecil Beaton

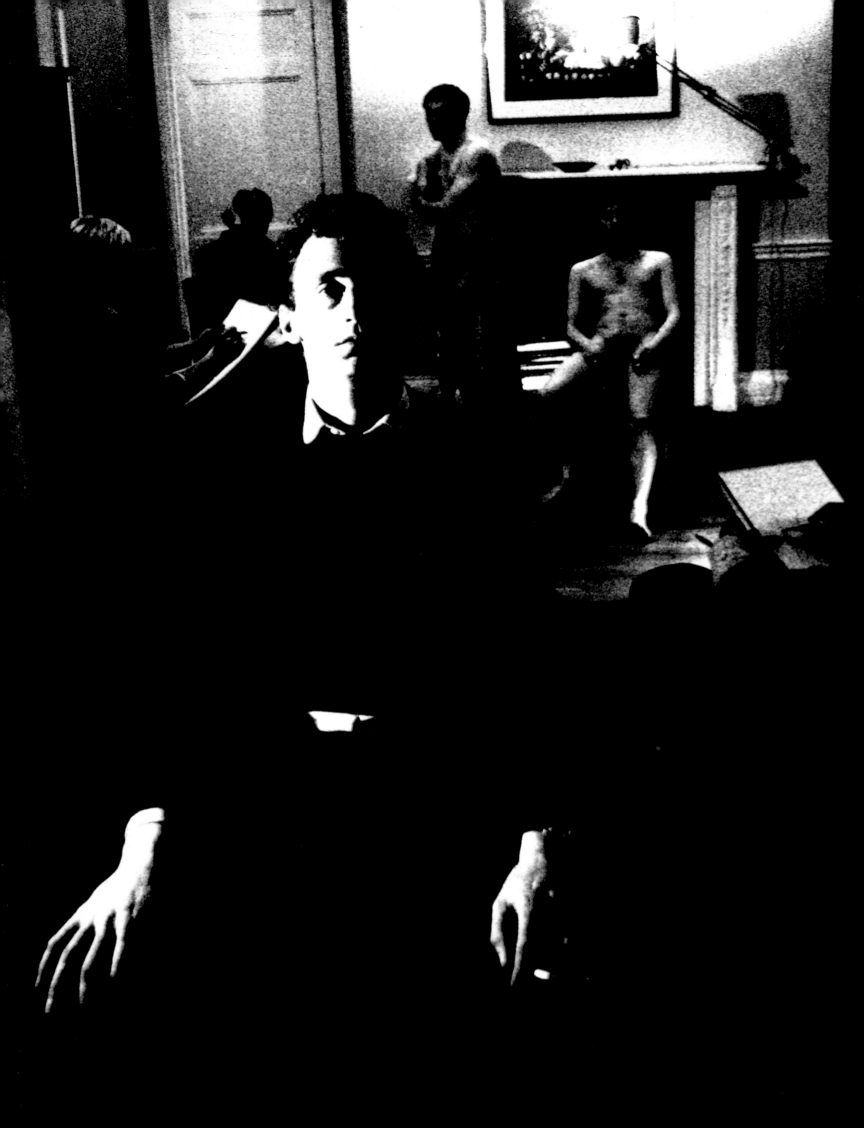

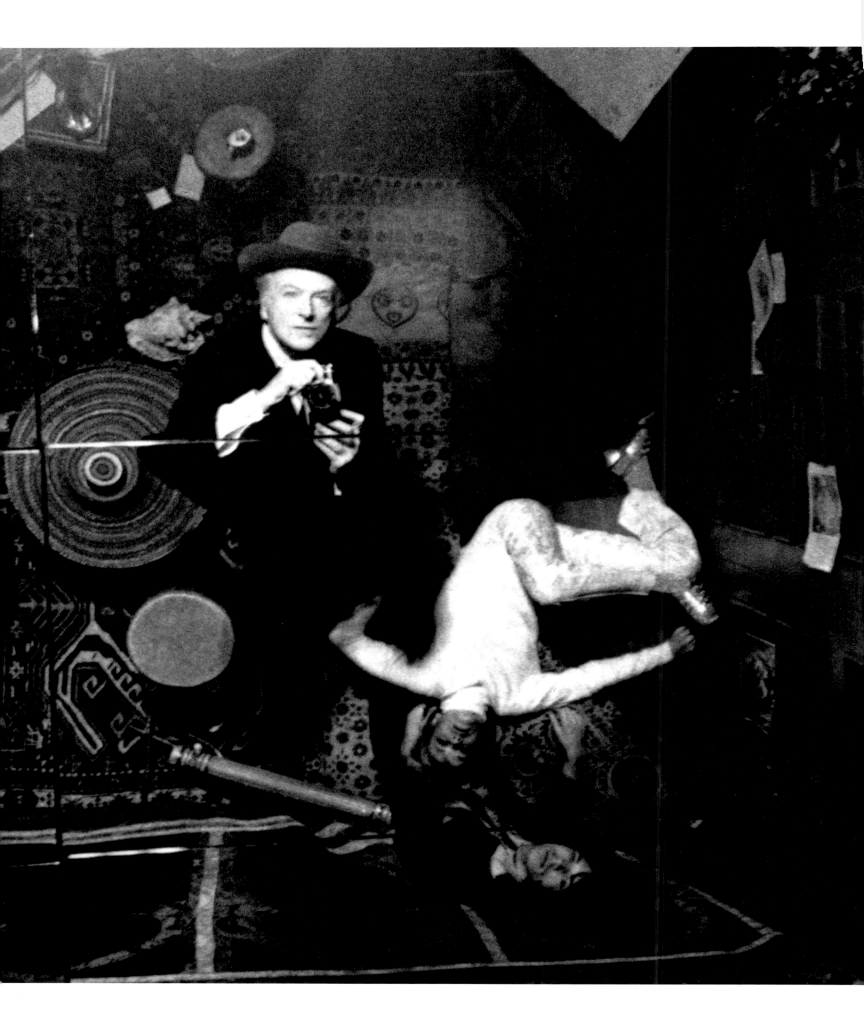

Self-portrait
with Anita
Pallenberg and
Mick Jagger,
on the set of
'Performance',
1968

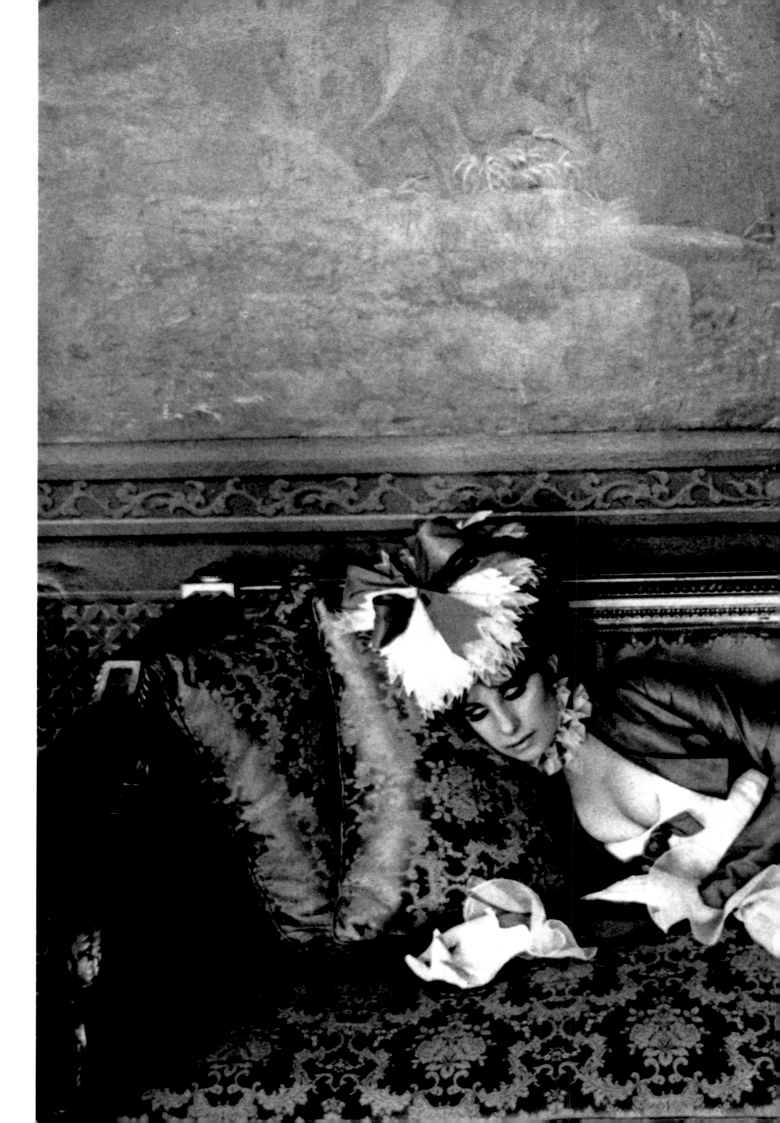

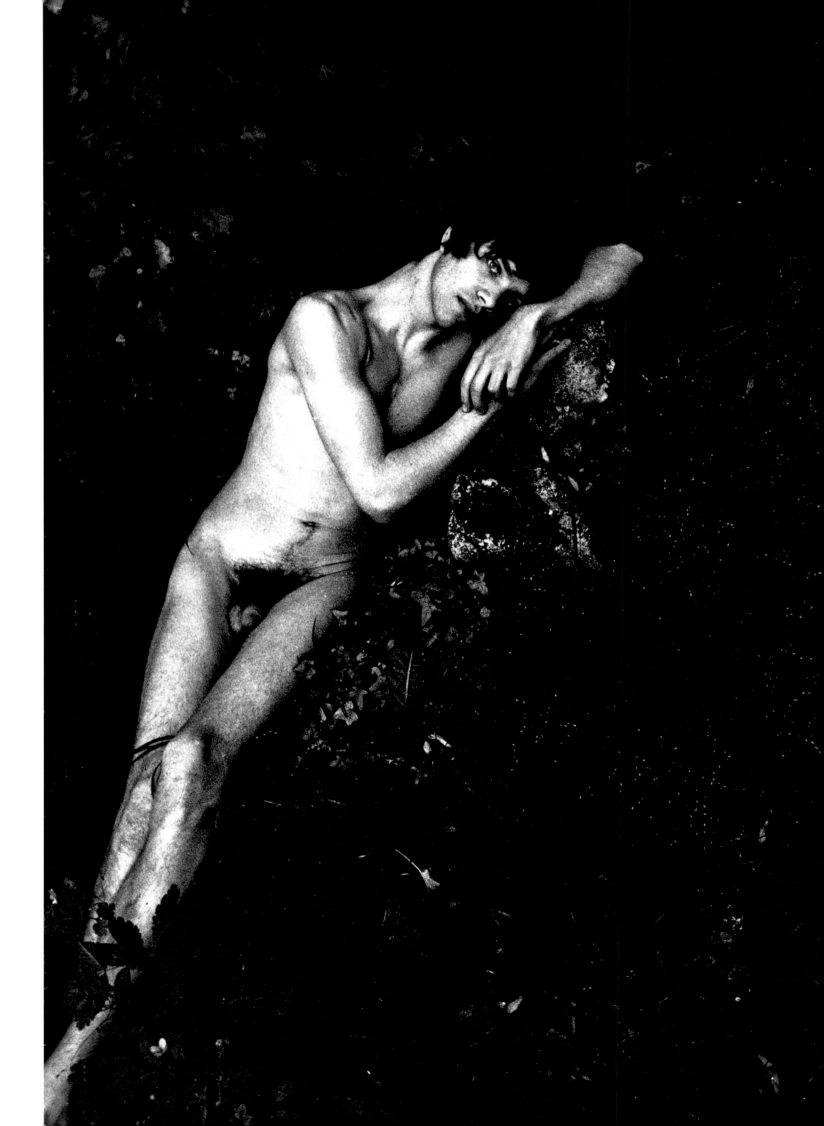

Previous pages: **Barbra Streisand,** during the filming of 'On a Clear Day You Can See Forever', The Royal Pavilion, Brighton, 1969

Left: **Gervase**, 1968

Below: **The Hon. Mark Palmer**, 1965

Cecil Beaton

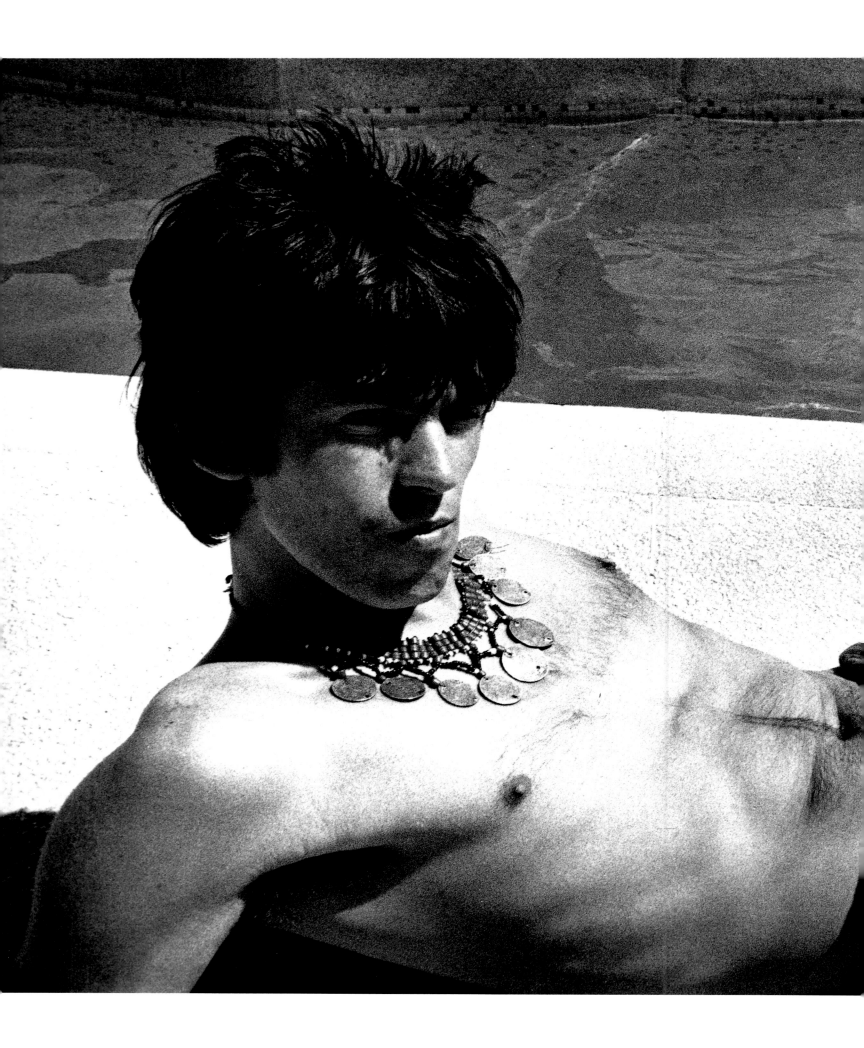

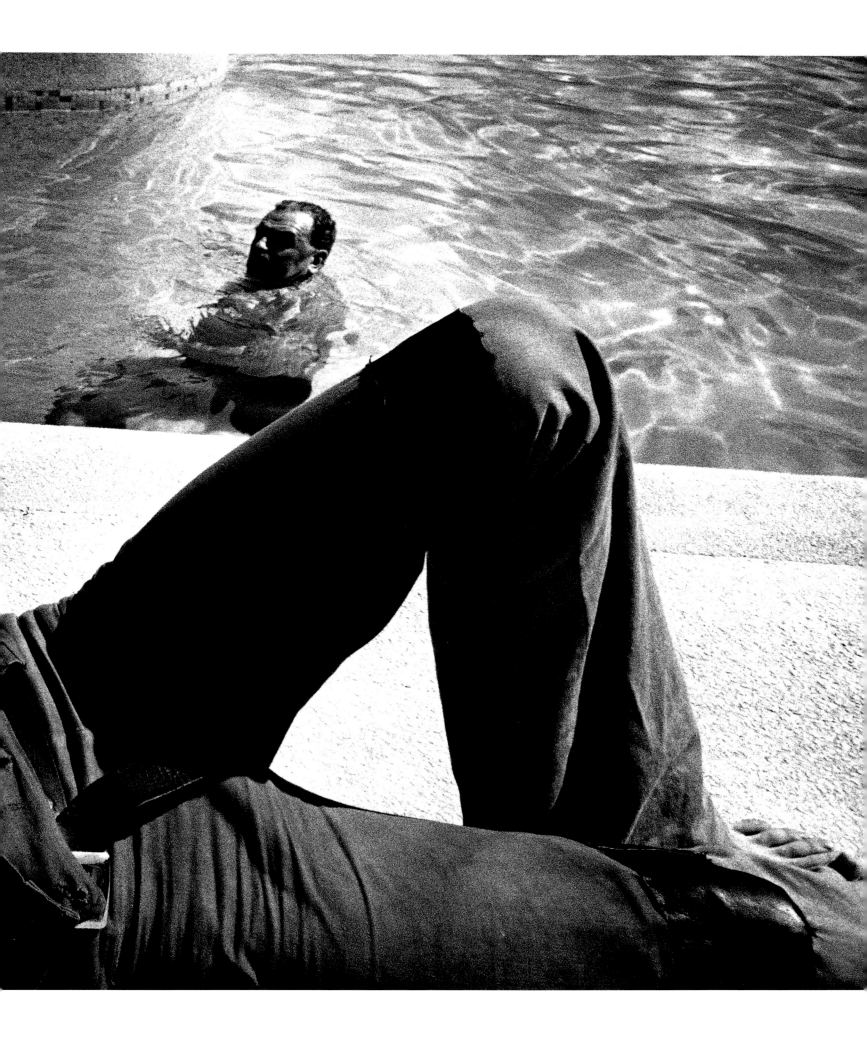

Previous pages:
Keith Richard,
Marrakesh,
1967

Below: **David**
Hockney, 1970

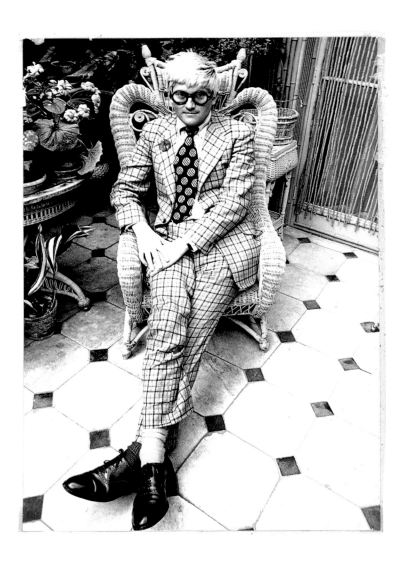

Cecil Beaton

Cecil Beaton

Tom Wolfe,
1969

Jean Shrimpton,
for *Vogue*, June
1964

Cecil Beaton

Left: **Picnic Fashion Group including the models Jean Shrimpton and Celia Hammond,** for *Vogue,* 1965

Below: **Mrs Harmsworth and her children,** 1973

283

Cecil Beaton

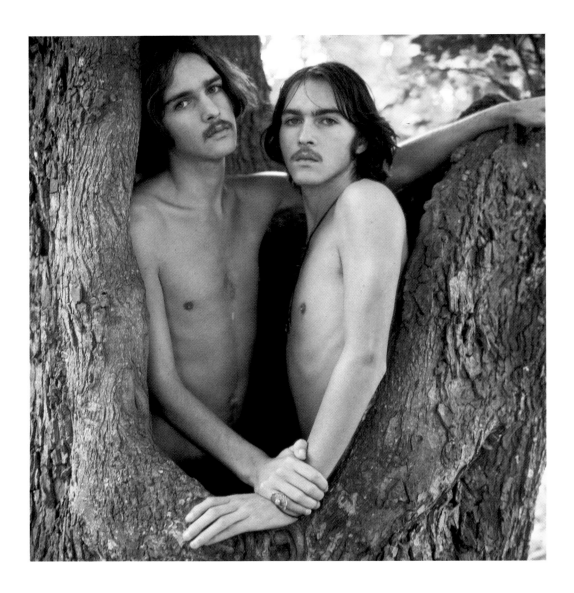

Cecil Beaton

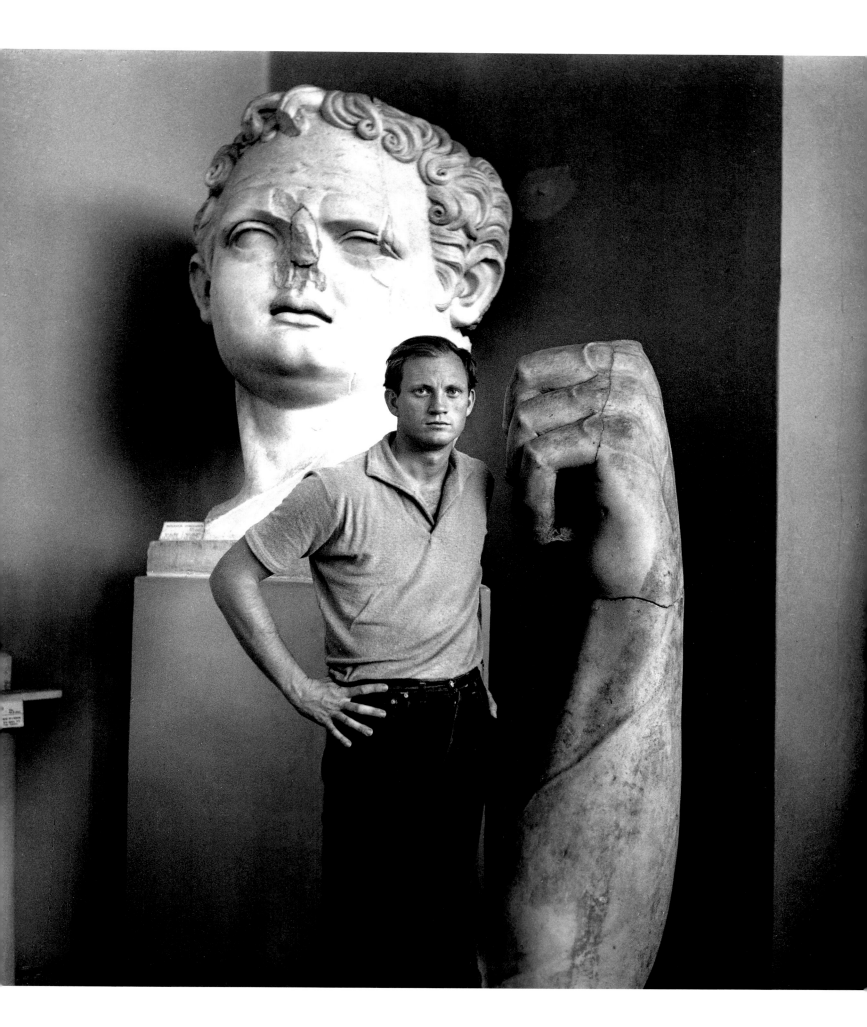

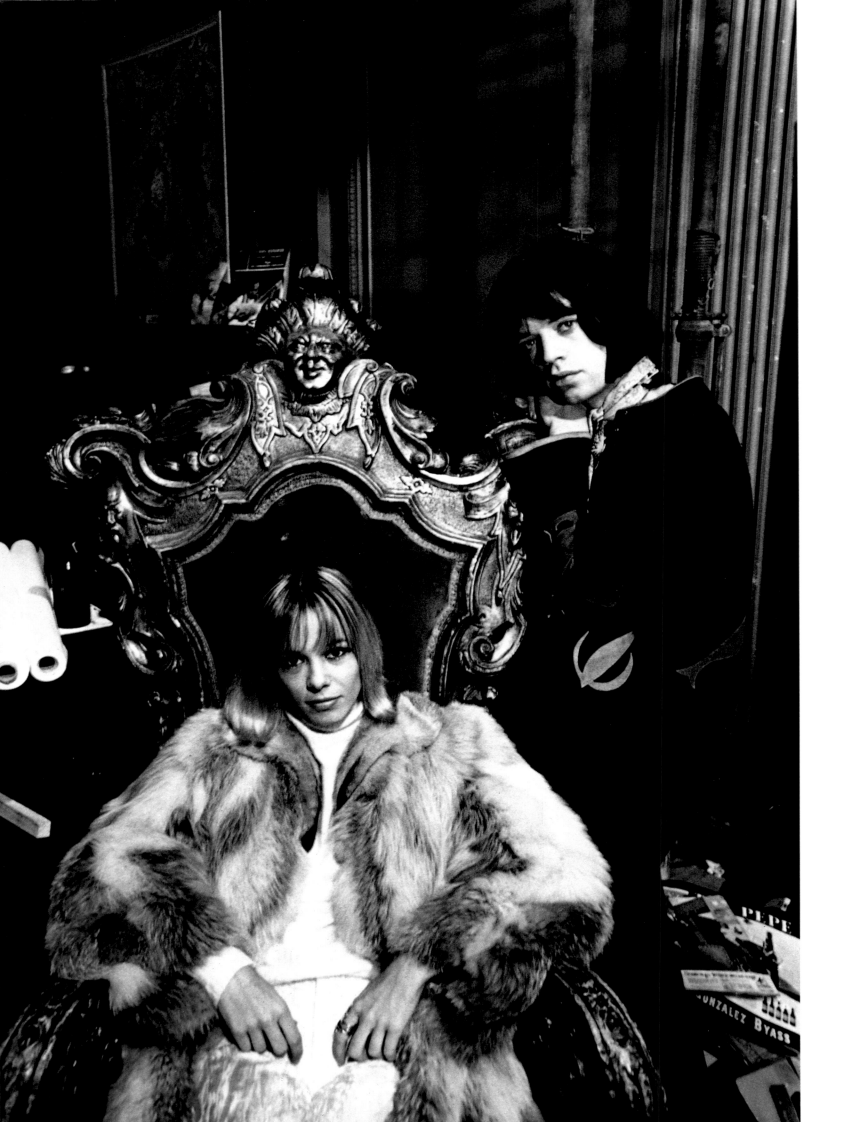

**Mick Jagger
and Anita
Pallenberg,**
on the set of
'Performance',
1968

**Maudie James
and the Myers
Twins,** for
Vogue, 'The
Great Indoors',
December 1968

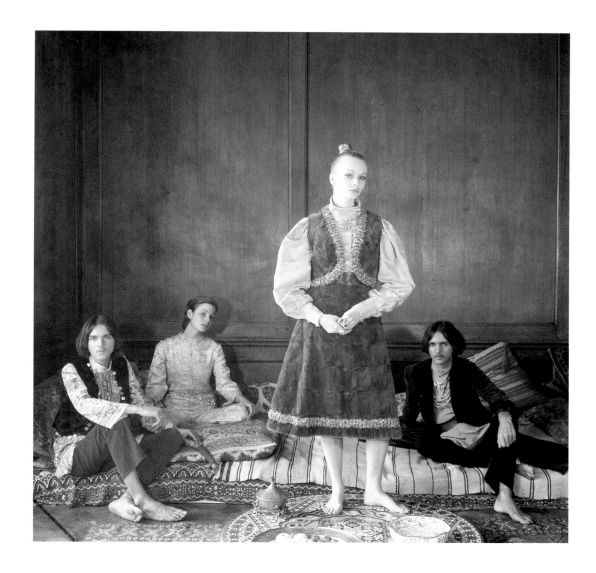

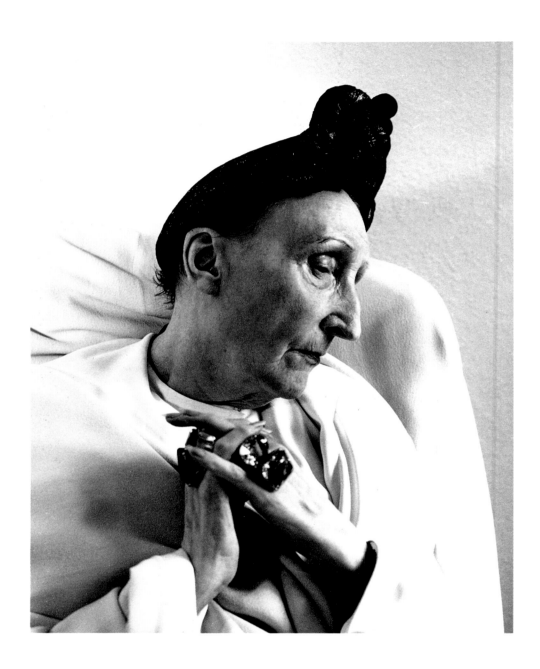

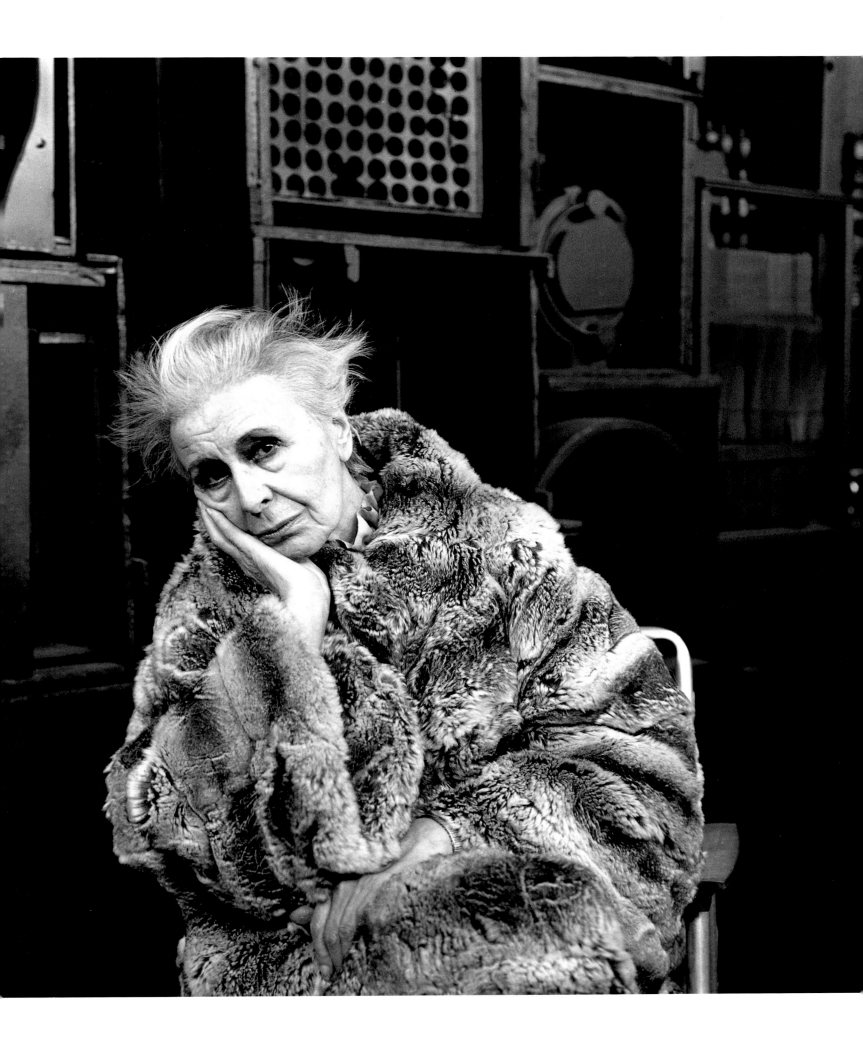

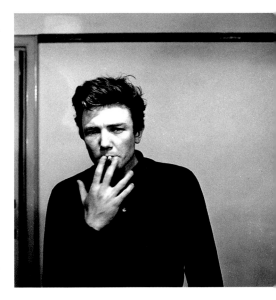

291

Cecil Beaton

Jane Birkin in
costume for
the Rothschild
Proust Ball,
1971

Marisa Berenson
dressed as the
Marchesa Casati
for the Rothschild
Proust Ball, 1971

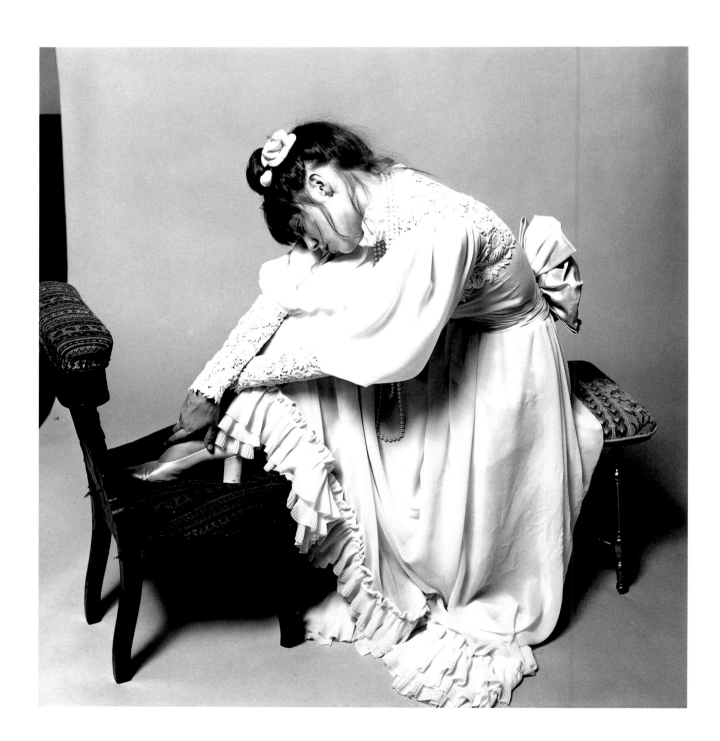

Cecil Beaton

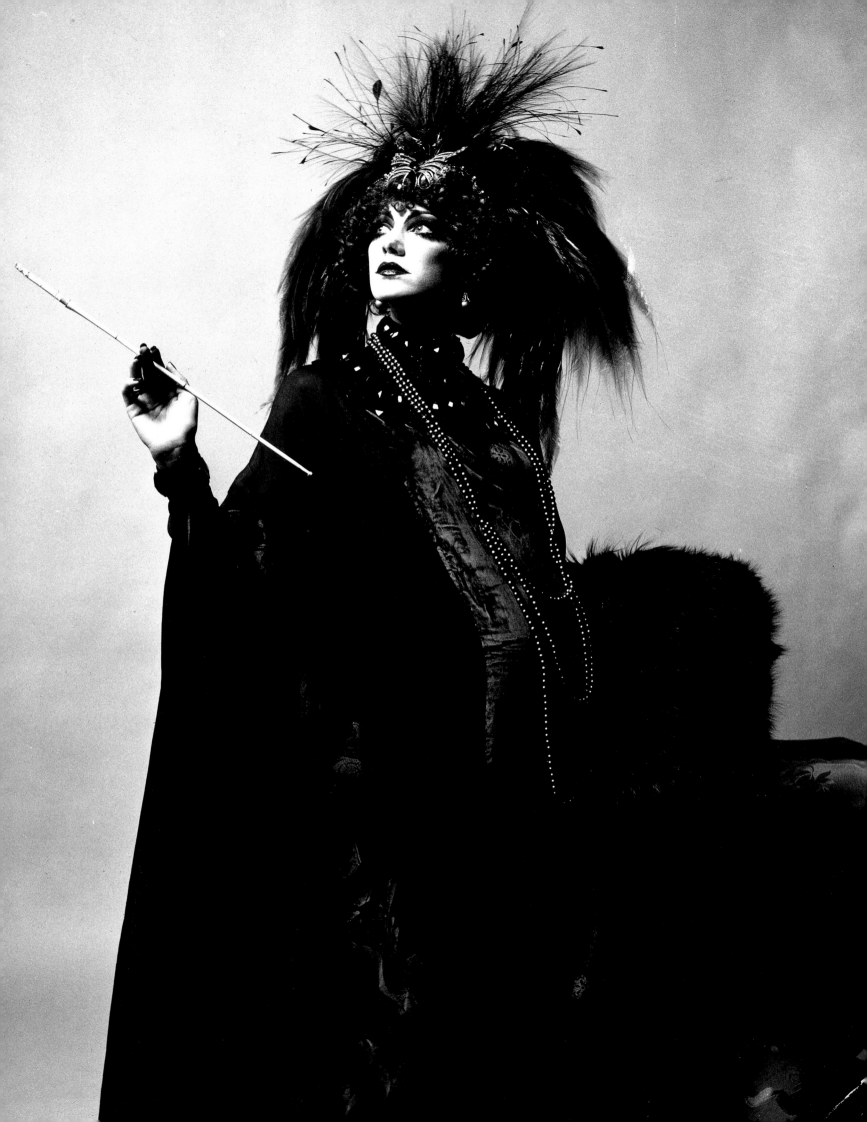

**Baroness Fiona Thyssen,
formerly Fiona Campbell-
Walter,** modelling for
the *Weekend Telegraph*.
2 September 1966

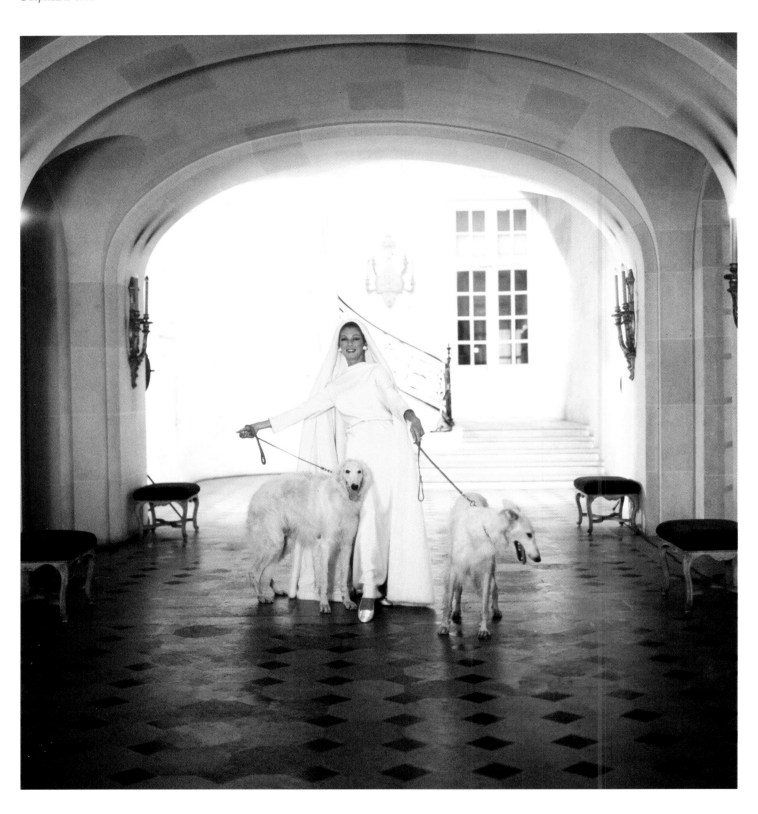

Cecil Beaton

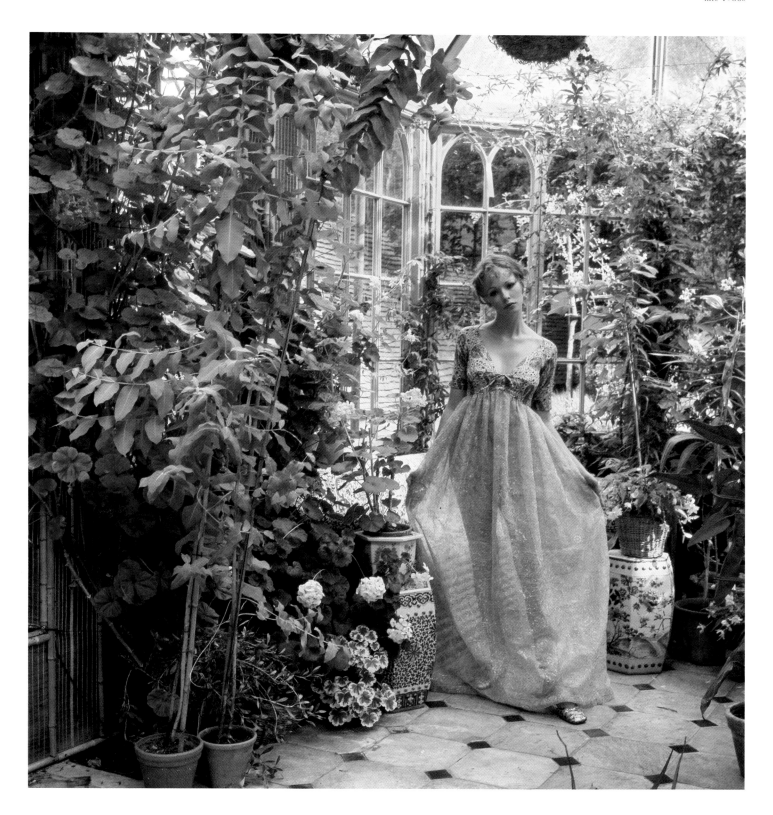

Cecil Beaton

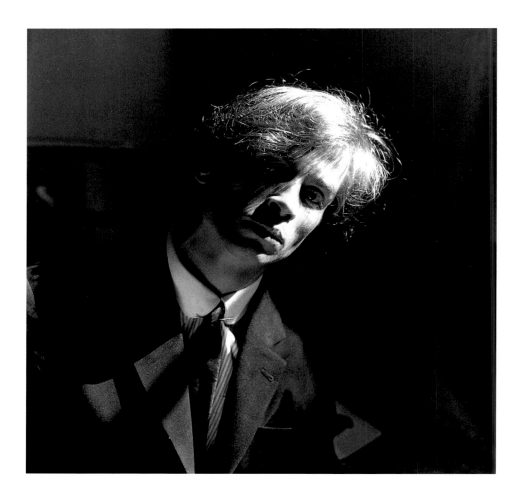

Cecil Beaton

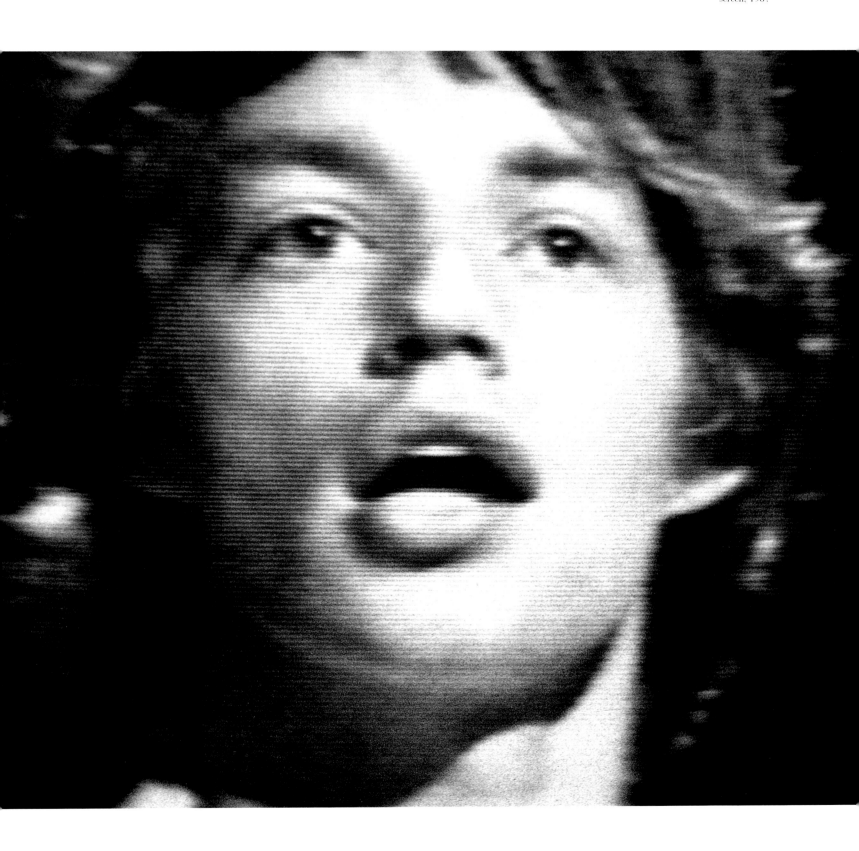

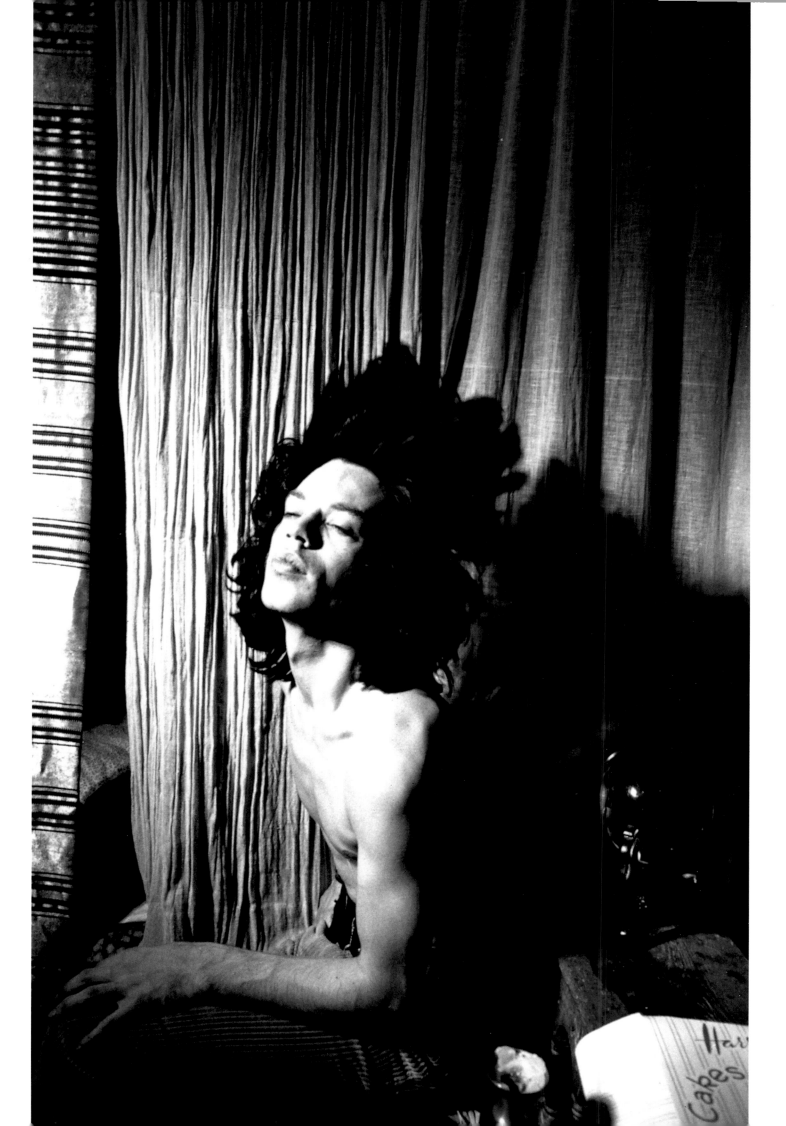

Previous pages:
Lord Harewood,
1968

Left: **Mick Jagger,**
on the set of
'Performance'.
1968

**Julian, Jane
and Victoria
Ormsby-Gore,**
1965

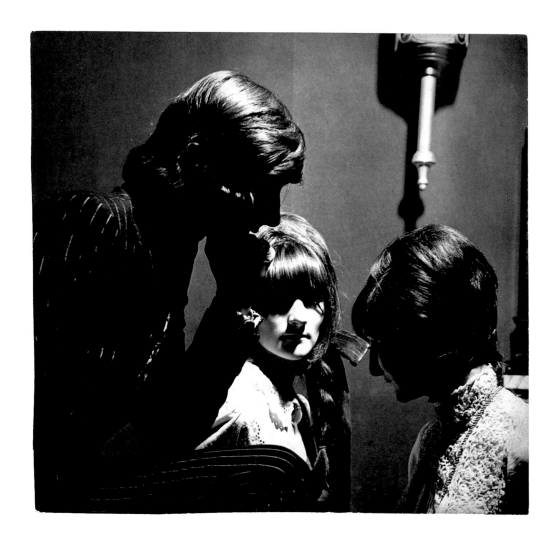

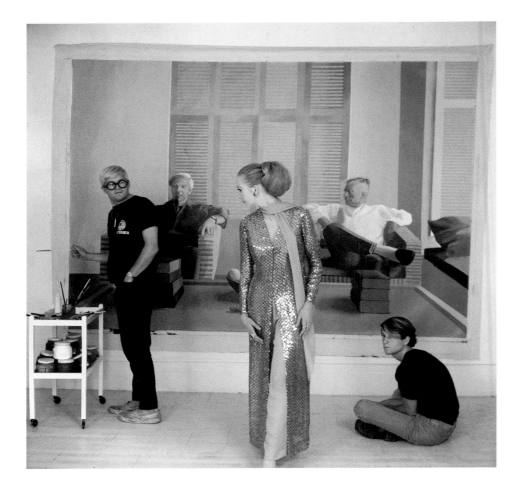

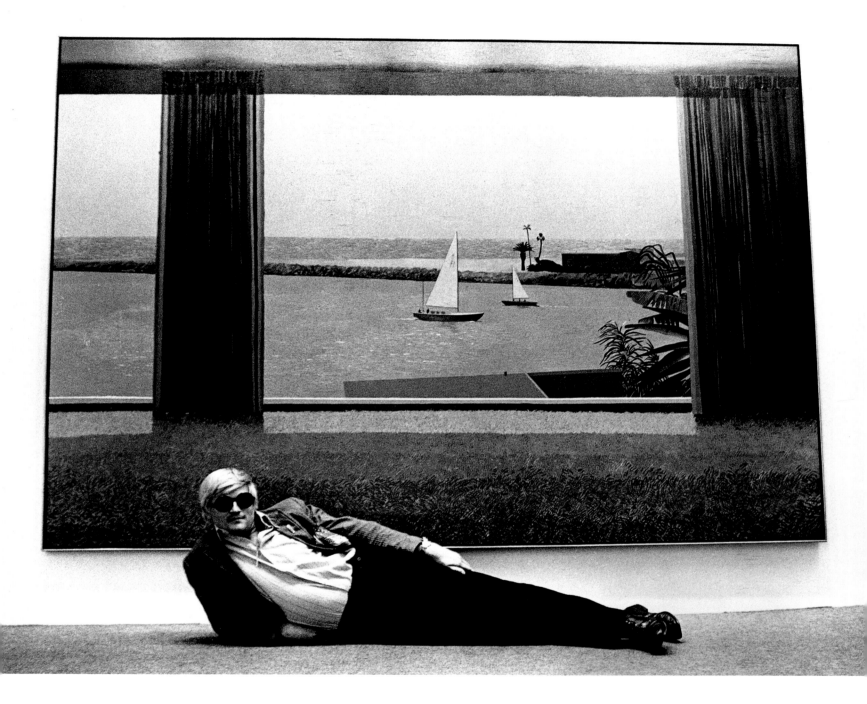

Cecil Beaton

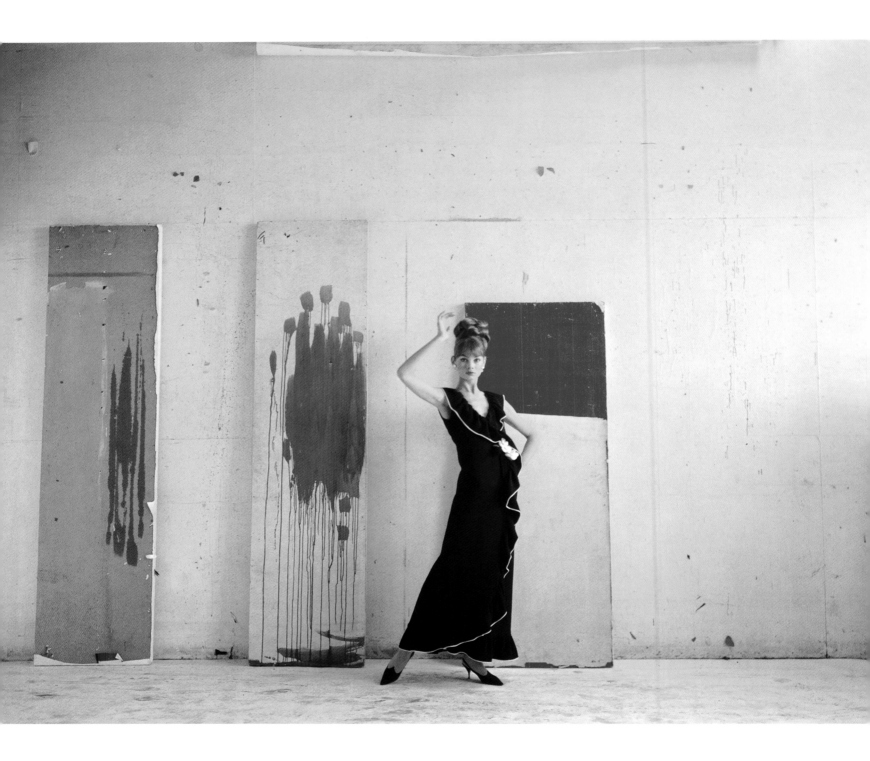

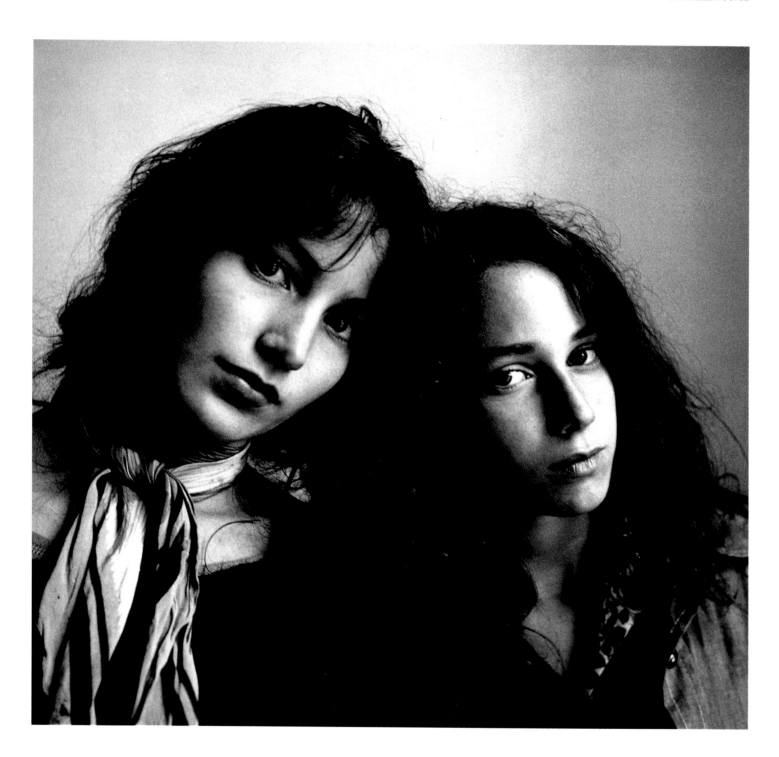

305

Cecil Beaton

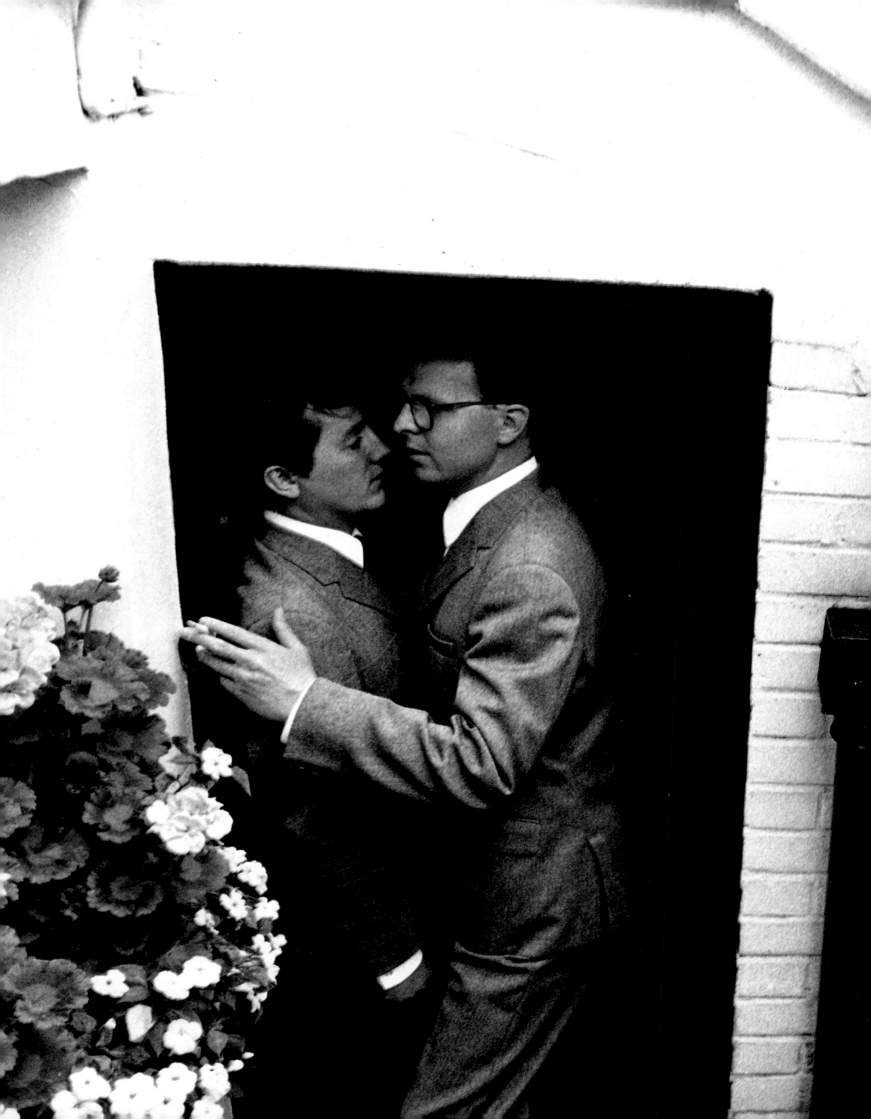

Previous pages:
**Gilbert and
George,** 1974

Below: **Gervase
and Patrick
Prockter posed
in the drawing-
room,** Reddish
House, 1969

**Stephen Tennant
and David Hockney,**
Wilsford, 1971

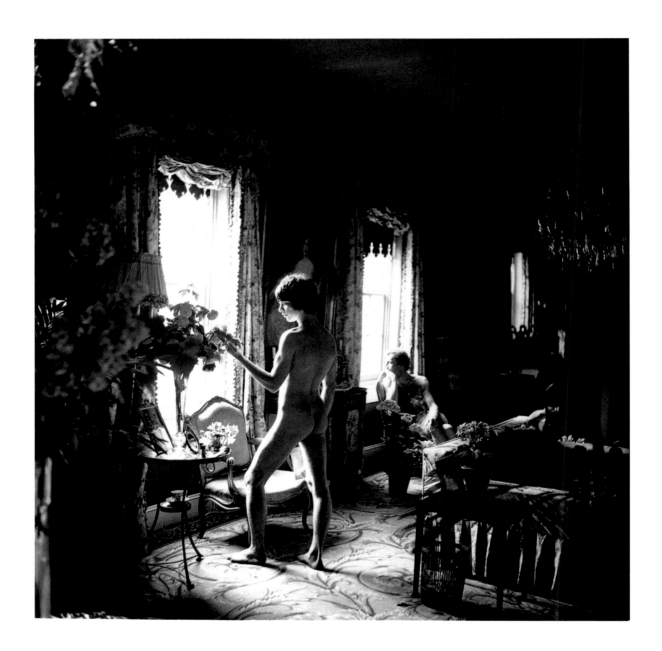

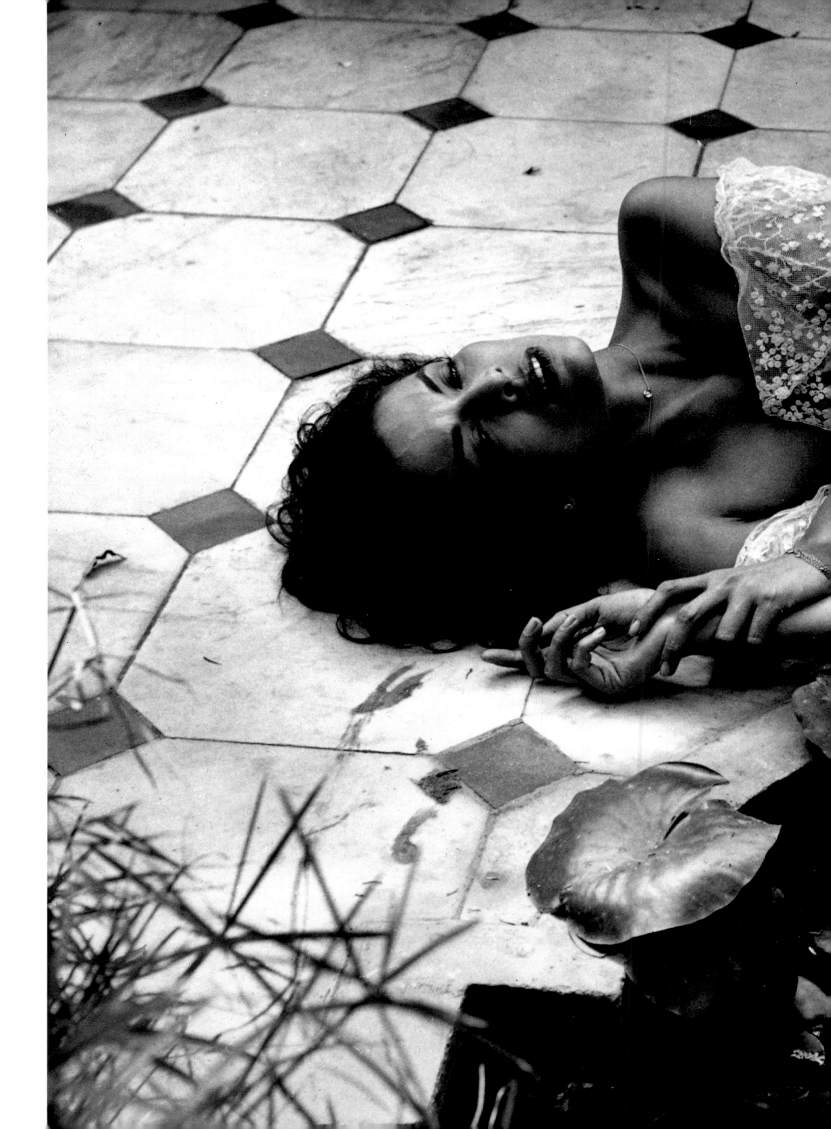

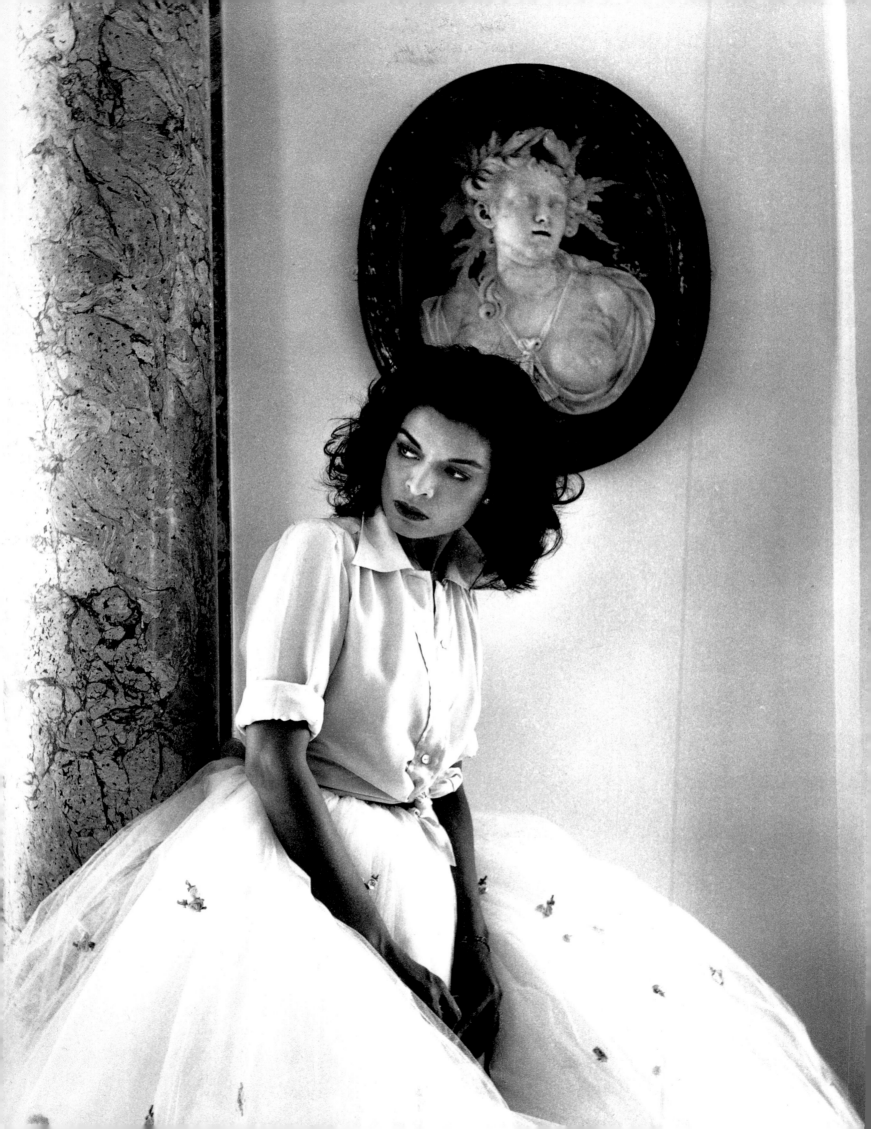

Previous pages:
Bianca Jagger,
the conservatory,
Reddish House,
1978

Left: **Bianca
Jagger,** 1978

**Cecil Beaton
dressed as
Nadar for the
Rothschild
Proust Ball,**
1971

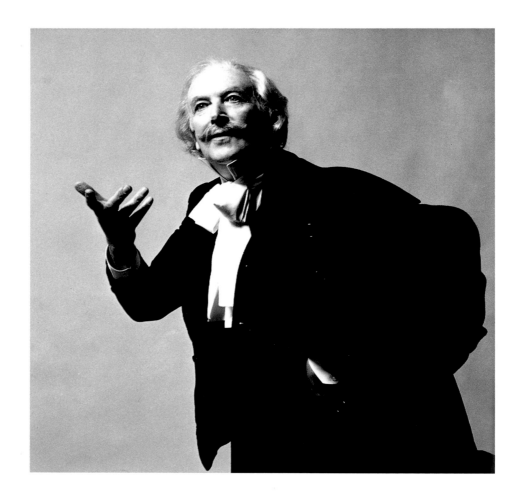

A Chronology

1904 Born on 14 January at 21 Langland Gardens, Hampstead, London.

1916 Boarding school (St. Cyprian's, East-bourne), with George Orwell and Cyril Connolly.

1918 Enters Harrow School and is encouraged in his interests in art by art master, W. Edgerton Hine.

1922 Begins studies at St. John's College, Cambridge University. Joins Amateur Dramatic Society and participates in several productions over next three years, including the *Footlights* revue. Publishes theatrical caricatures in *Granta*.

1925 Finishes his studies without taking a degree.

1926 Breaks into London's nascent media and 'Bright Young People' worlds after finding office life in the City uncongenial. Photographs Edith Sitwell for the first time.

1927 Starts regular work for British *Vogue* (August) and has first major exhibition at the Cooling Galleries, London (November).

1928 After a spate of designing costumes for charity matinées, he visits New York and undertakes first American commissions for Condé Nast.

1929 Sole British exhibitor at the landmark *Film und Foto* exhibition of modernist photography in Stuttgart (May). Portrays Hollywood stars for *Vanity Fair*.

1930 Publishes *The Book of Beauty*, a mix of Society heroines and entertainment stars (November). Takes lease on Ashcombe House,

Wiltshire. Close friendship with connoisseur and patron Peter Watson commences.

1931 Settles into a pattern of trans-Atlantic professional commuting for *Vogue*, which lasts until 1938.

1932 First meeting with Greta Garbo.

1933 Visits to Paris lead to contact with Cocteau and collaborations with the neo-Romantic circle of Christian Bérard and Pavel Tchelitchew. With fellow fashion photographer George Hoyningen-Huene he travels to North Africa.

1935 Designs costumes and decor for the Walton-Sitwell ballet, *The First Shoot*, for Cochran's revue, *Follow the Sun* in London.

1936 On the eve of Edward VIII's abdication crisis he photographs and sketches Mrs Wallis Simpson (November). Exhibits his ballet designs at The Redfern Galleries, London.

1937 Photographs the Duke of Windsor's marriage. Also takes many pictures of the aristocracy and royalty for the coronation of George VI for *Vogue*. His pot-pourri of photos and essays, *Cecil Beaton's Scrapbook*, is published (September).

1938 Forced resignation from *Vogue* following finding of minute anti-Semitic scribbles in one of his decorative illustrations. Completes *Cecil Beaton's New York*.

1939 Photographs Queen Elizabeth in Buckingham Palace and its gardens.

1940 Commissions from the British Ministry of Information to photograph

Churchill and War Cabinet members. Documents Blitz victims and damage to historic buildings in London. The latter are published as *History under Fire*. *Vogue* re-employs Beaton.

1941 Undertakes further official governmental propaganda photography for the Royal Air Force, images which are widely reproduced and then gathered in two books, *Air of Glory* and *Winged Squadrons*. An anthology of his career's photographs is published. *Time Exposure*.

1942 As an RAF photographer he documents the Near East theatre of war in Egypt, Iran, Iraq, Syria and Jordan.

1944 Writes *British Photographers*, a pioneering history of the medium. On assignment for the Ministry of Information he makes a large documentary series in India and the war zones of China.

1945 His far eastern war photography is published by Batsford as *India Album*, *Chinese Album* and *Far East*. Commences designs for London production of *Lady Windermere's Fan*.

1946 Spends time in US, courting Garbo and playing in *Lady Windermere's Fan*. Loses lease on Ashcombe House.

1947 Designs sets and costumes for two Victorian and Edwardian revival films produced by Korda – *Anna Karenina* and *An Ideal Husband*. Buys Reddish House in Wiltshire.

1949 Produces set and costume designs for the Old Vic version of *The School for Scandal*.

1951 Publication of his autobiography, *Photobiography*. Covers and participates in the first great post-war costume ball in Venice – the Beistegui Ball. Failure of his first play *The Gainsborough Girls* on its provincial run in Brighton.

1953 His official portraits at the coronation of Queen Elizabeth II usher in the romanticism of the New Elizabethan Age. Publication of his collaboration with Kenneth Tynan, *Persona Grata*.

1955 Begins preparations for designing the US version of *My Fair Lady*.

1956 Leaves *Vogue* for its rival, *Harper's Bazaar* and begins his important portrait series of American figures such as Marilyn Monroe, Grace Kelly and Joan Crawford. *My Fair Lady* opens to immediate success.

1957 Honoured by HM Queen Elizabeth with the award of Companion of the British Empire, CBE. Designs sets and costumes for *Gigi*, in Paris.

1958 *My Fair Lady* opens in London (April). Exhibits designs at Redfern Gallery.

1960 Commissioned to decorate the Gala Performance at Covent Garden held in honour of the state visit of President de Gaulle. Beaton uses 25,000 pink carnations and 600 metres of silk.

1961 Publication of the first volume of his diaries, *The Wandering Years*. Mammoth design responsibilities for the New York Met production of *Turandot*.

1963 Designs costumes and photographs the film version (directed by George Cukor) of *My Fair Lady*.

1965 Inclusion in David Bailey's *Box of Pin Ups* ensures his status in the pantheon of father figures for the emergent 'Swinging London'.

1966 Exhibition at Redfern Gallery of oil portraits based upon press photographs of contemporaries both notorious — the spy George Vassall — and pop-cultural, such as Mick Jagger.

1967 Extending himself more fully into the territory of 'Swinging London', he photographs the model Twiggy, Keith Richard and Mick Jagger.

1968 Photographs on the set of the Nicholas Roeg-directed film, *Performance*.
Another compendious anthology of his photography, *The Best of Beaton*, is published. Curates his own retrospective exhibition at the National Portrait Gallery at the behest of Roy Strong.

1969 Works on costumes for Vincente Minnelli's musical, *On a Clear Day You Can See Forever*.

1971 Curates the extensive *Fashion – An Anthology* exhibition at the Victoria and Albert Museum. Photographs for *Vogue*, and participates in the Proust Ball organized by the Rothschilds.

1972 Knighted by H. M. Queen Elizabeth at Buckingham Palace (June).

1973 Begins writing *The Magic Image*, an extensive history of photography, together with co-author, Gail Buckland.

1974 His incapacitation after a stroke is short-lived; Beaton makes a spirited recovery.

1977 Begins to accept fashion and portrait photography commissions for *The Daily Telegraph* and *The Sunday Telegraph*.

1979 *Vogue* commissions him to photograph the Paris Collections.

1980 Dies on 18 January.

Index of persons portrayed

Design: Richard Smith, Area, London
Separations: O.R.T. Kirchner, Berlin
Typesetting: Gerber Satz, Munich
Printing and binding: EBS, Verona

ISBN 978-3-8296-0610-3
A Schirmer/Mosel Production

DATE DUE

PRINTED IN U.S.A.